Geoheritage, Geoparks and Geotourism

Series Editors

Wolfgang Eder, GeoCentre-Geobiology, University of Göttingen, Göttingen, Niedersachsen, Germany

Peter T. Bobrowsky, Geological Survey of Canada, Sidney, BC, Canada

Jesús Martínez-Frías, CSIC-Universidad Complutense de Madrid, Instituto de Geociencias, Madrid, Spain

Spectacular geo-morphological landscapes and regions with special geological features or mining sites are becoming increasingly recognized as critical areas to protect and conserve for the unique geoscientific aspects they represent and as places to enjoy and learn about the science and history of our planet. More and more national and international stakeholders are engaged in projects related to "Geoheritage", "Geo-conservation", "Geoparks" and "Geo-tourism"; and are positively influencing the general perception of modern Earth Sciences. Most notably, "Geoparks" have proven to be excellent tools to educate the public about Earth Sciences; and they are also important areas for recreation and significant sustainable economic development through geotourism. In order to develop further the understanding of Earth Sciences in general and to elucidate the importance of Earth Sciences for Society, the "Geoheritage, Geoparks and Geotourism Conservation and Management Series" has been launched together with its sister "GeoGuides" series. Projects developed in partnership with UNESCO, World Heritage and Global Geoparks Networks, IUGS and IGU, as well as with the 'Earth Science Matters' Foundation will be considered for publication. This series aims to provide a place for in-depth presentations of developmental and management issues related to Geoheritage and Geotourism in existing and potential Geoparks. Individually authored monographs as well as edited volumes and conference proceedings are welcome; and this book series is considered to be complementary to the Springer-Journal "Geoheritage".

Elena Panova
Editor

The History of Natural Stone in Saint-Petersburg

Editor
Elena Panova
Saint Petersburg State University
Saint-Petersburg, Russia

ISSN 2363-765X ISSN 2363-7668 (electronic)
Geoheritage, Geoparks and Geotourism
ISBN 978-3-031-18860-2 ISBN 978-3-031-18861-9 (eBook)
https://doi.org/10.1007/978-3-031-18861-9

© The Editor(s) (if applicable) and The Author(s), under exclusive license to Springer Nature Switzerland AG 2023

This work is subject to copyright. All rights are solely and exclusively licensed by the Publisher, whether the whole or part of the material is concerned, specifically the rights of translation, reprinting, reuse of illustrations, recitation, broadcasting, reproduction on microfilms or in any other physical way, and transmission or information storage and retrieval, electronic adaptation, computer software, or by similar or dissimilar methodology now known or hereafter developed.

The use of general descriptive names, registered names, trademarks, service marks, etc. in this publication does not imply, even in the absence of a specific statement, that such names are exempt from the relevant protective laws and regulations and therefore free for general use.

The publisher, the authors, and the editors are safe to assume that the advice and information in this book are believed to be true and accurate at the date of publication. Neither the publisher nor the authors or the editors give a warranty, expressed or implied, with respect to the material contained herein or for any errors or omissions that may have been made. The publisher remains neutral with regard to jurisdictional claims in published maps and institutional affiliations.

This Springer imprint is published by the registered company Springer Nature Switzerland AG
The registered company address is: Gewerbestrasse 11, 6330 Cham, Switzerland

Preface

Natural stone plays an important role in the history of civilization. The formation of the cities' appearance and their architecture is determined by the availability of affordable, aesthetically attractive and suitable materials for processing stone. The image of any city, along with its socio-economic conditions, depends on the geological situation around it. The presence of a building stone determined the preservation of traces of its existence in time. Wooden, clay, brick buildings turned out to be short-lived. Buildings made of stone preserved for centuries. They silently keep the history imprinted in stone.

The emergence of new architectural styles took place in areas with the most suitable stone for this. The spread of these styles in other geological conditions led to its distortion. Underestimating the role of the traditional stone for each city leads to mistakes in restoration work that distorts the appearance of cities. The history of civilization largely determined by a person's attitude to stone as one of the fundamental factors in the development of culture and one of the foundations of historical memory. The Gothic cathedrals of France appeared due to the wide manifestation of Paleozoic limestones. The European part of Russia is located within the Russian Plain. Therefore, the first temples were built of limestone slabs. The first stone cities of Russia appeared in places of distribution of stone suitable for construction.

St. Petersburg plays an important role in the architectural history of Russia. In 1703

Peter the Great decided that the new capital should become a "stone" city. In 1714, he issued a decree prohibiting stone construction in other cities and towns of Russia. Masons and masons brought to the capital from all over the country. The heterogeneity of the geological structure of the territory and the wide variety of stone material made it possible for such a plan. St. Petersburg is located in the junction zone of the Baltic Crystal Shield and the Russian Plain. The abundance of waterways made it possible to deliver various rocks for its construction. Red, pink, gray granites, granite-gneiss and quartzite-sandstones came from the north. Yellow limestone slabs delivered from the south. Thanks to the wide color spectrum of rocks, the appearance of the city turned out to be unique.

This book is a continuation of the series of books by A. G. Bulakh "Stone decoration of St. Petersburg". Initially, he began this work in collaboration with N. B. Abakumova (1935–1991). Later he joined other geologists interested in the history of stone in architecture—V. Gavrilenko, I. Borisov, E. Panova, E. Olhovaya, A. Savchenok, M. A. Ivanov, G. Popov, Hariuzov, A. Tutakova and many others.

Saint-Petersburg, Russia Elena Panova

Thanks

The emotional and driving factor in writing this book was our teacher A.G. Bulakh. We started the work together and considered it our duty to finish it.

This topic supported within the framework of the program of South-East Finland-Russia Cross-border cooperation program (History and future of natural stones in architecture—bridge between South East Finland and Russia, KS1528).

Analytical work done in Chemical lab of All Russian Geological Institute named after A. P. Karpinsky (VSEGEI), Research Park of Saint Petersburg State University ("Geomodel", "Center for Chemical Analysis and Materials Research", "Microscopy and microanalysis", "Nanotechnology"), at the University of Wroclaw (Poland) and the Federal Institute of Geosciences and Natural Resources (departments in Berlin and Hannover).

The photo collection in part 1—of Andrey Bulakh and Joseph Romanovsky are used.

In the other chapters, the photos copyrighted.

Translation is by E. Kravtsova (Part I), E.Savva (Parts II and III), A. Vlasov (Part IV).

Layout part 1 is Alexander Spiridonov.

Thanks to our loved ones who endured our busy weekends.

To all those who contributed to the writing of this book, the authors bring their gratitude.

Contents

Walking Around the Stone City

Stone in the Architecture of St. Petersburg 3
Andrey Bulakh and Elena Olhovaya

The History of St. Petersburg Stones

St. Petersburg Decorative Stones 101
Andrey Bulakh and Elena Olhovaya

The Bronze Horseman and Thunder Stone: History and Nowadays 105
Georgy Popov, Mihail Ivanov, and Svetlana Janson

The Alexander Column—From Finnish Friedrichsham to Palace Square in St. Petersburg 117
Nikolay Filippov and Svetlana Tochanskaya

The Alexander Column: Life After Installation 125
Mihail Ivanov and Georgy Popov

Rapakivi Granite—Symbol of St. Petersburg 133
Andrey Bulakh and Elena Panova

Valaam Monastery Granite 137
Elena Panova and Vladimir Gavrilenko

Atlantes Hold Sky on Stone Shoulders 141
Igor Borisov

Old Stories of Ruskeala 151
Igor Borisov

Putilovo Limestone—First in St Petersburg 157
Leonid Hariuzov and Anton Savchenok

Such Different Sandstones 167
Anton Savchenok

Soapstone (Talc-Chlorite Schist) 177
Anton Savchenok and Leonid Hariuzov

Natural Stone in Modern St. Petersburg 183
Anna Tutakova

Where and How Did Stone Mine Near St. Petersburg

Where and How Did Stone Mine Near St. Petersburg 193
Andrey Bulakh and Elena Panova

Master of Columns . 195
Valentina Stolbova

Granite Industry (End Nineteenth–Early Twentieth Centuries) 203
Maria Svetoch (Ivanova)

Granite Weathering Under Urban Condition

Granite Weathering Under Urban Condition . 211
Elena Panova, Dmitry Vlasov, Marina Zelenskaya, and Alexey Vlasov

Walking Around the Stone City

Stone in the Architecture of St. Petersburg

Andrey Bulakh and Elena Olhovaya

Natural stone is a strong building material. Buildings lined with stone convey to us architectural forms created several centuries ago. Natural stone from deposits near the city played an important role in the unique appearance of St. Petersburg.

The use of natural stone in the architectural decoration of St. Petersburg was subject to three factors. (1) Fashion and traditions of stone usage in European cities, whose images were transferred to St. Petersburg. (2) The possibility of mining a similar natural stone near St. Petersburg. (3) The development of the railway network and the cancellation of customs duties for the stone transportation after the 1860s.

There are three periods in the history of natural stone used as building and decorative material in St. Petersburg (Table 1). During 1703–1760, the Putilovo plate and the Pudost stone began to be used. During 1760–1850, along with them, Ruskeala and Tivdiya marbles, red-pink rapakivi granites, grey Serdobol granites were used. The period 1850–1910 was the time of the Valaam granite, sandstones from Poland and Germany, talc–chlorite shale from Finland and new varieties of granite from the Karelian Isthmus and Sweden.

Three main architectural styles (Baroque, Classicism and Moderne) are the main ones in the history of architecture of St. Petersburg.

The first period of natural stone usage in St. Petersburg (1703–1760). The architecture of this period was dominated by early Baroque and high Baroque. The first architect of St. Petersburg, Domenico Trezzini, was invited from Copenhagen, and he transferred the style of this city to St. Petersburg. The simplicity of the exterior architectural decoration of the St. Petersburg buildings was typical for the early Baroque.

The transition from early Baroque to high Baroque took place in St. Petersburg architecture in the 1740s. This period is associated with F. B. Rastrelli and the beginning of palaces and temple construction. The distinctive features of this style are monumentality, a variety of facade decorations, an abundance of moulding, a combination of bright facade wall colouring and white decorative elements, and the presence of sculptures in the exterior building designs.

The first and irreplaceable natural building stone was a limestone plate from the Putilovo deposit. A number of deposits are located at a 40–60 km distance from St. Petersburg. The stone was used for foundations, basement floors, stairs, floors, sidewalks and as a rubble stone. It was useful for palaces and temple constructions, bases for columns and pilasters, capitals, cornices and other architectural elements. Lime tuff from Pudost was used as a paving stone, for the interior decoration of buildings and the construction of fountains.

The granite usage was limited. It was used in the construction of piers and shipyards on the Neva River and Kronstadt, defence forts in the Gulf of Finland and less often in the construction of temples and public buildings.

Palaces, temples, public buildings and industrial enterprises were built in the city and surrounding areas during this period. Unique Peterhof, Tsarskoye Selo and Oranienbaum palace and park complexes were created in the suburbs. The local natural stone—the irreplaceable Putilovo limestone slab—was always used during construction.

The second period of natural stone usage in St. Petersburg (1760–1850). The classicism style (early, strict, high and late) dominates the architecture of St. Petersburg during this time. Along with the Putilovo plate and Pudost stone,

A. Bulakh
Department of Mineralogy, Saint-Petersburg State University, Saint-Petersburg, Russian Federation
e-mail: a.bulakh@spbu.ru

E. Olhovaya (✉)
Scientific and Educational Department, The State Hermitage Museum, Saint-Petersburg, Russian Federation
e-mail: e.olhovaya@mail.ru

Table 1 Examples of architectural styles in St. Petersburg

Building	Architect
1. Baroque period	
Early Baroque	
Summer Palace of Peter the Great (1710–1714)	Domenico Trezzini
Menshikov Palace (1710–1716)	Giovanni Fontana, Gottfried Schadel
"Twelve Colleges" (1722–1741)	Domenico Trezzini, Theodor Schwertfeger
Mature Baroque	
Smolny Cathedral and Convent (1748–1764)	Bartolomeo Rastrelli
Nikoskly Naval Cathedral (1753–1762)	Savva Chevakinskiy
Winter Palace (1754–1762)	Bartolomeo Rastrelli
2. Classicism period	
Early classicism	
*Marble Palace (1768–1785)	Antonio Rinaldi
Mature classicism	
Tauride Palace (1783–1789)	Ivan Starov
*Academy of Sciences (1783–1787)	Giacomo Quarenghi
*Mikhailovsky (Engineers') Castle (1796–1800)	A.-F.-G. Violliet, Vasiliy Bazhenov, Vincenzo Brenna
*Smolny Institute (1806–1808)	Giacomo Quarenghi
Late classicism	
*Stock Exchange (1805–1810)	Thomas de Thomon
The Admiralty (1806–1823)	Adrian Zakharov
*The Senate and Synod (1829–1834)	Carlo Rossi
3. Period of eclecticism (historicism)	
Neo-Baroque style	
Beloselskiy-Belozerskiy Palace (1846–1848)	Andrey Stakenschneider
Church of the Exaltation of the Holy Cross, 128 Ligovsky Prospekt (1848–1852)	Egor Dimmert
Russian style	
Church of the Holy Martyr Myron of the Life Guards Chasseur Regiment, 99 Obvodny Canal Embankment (1849–1854)	Konstantin Ton
*The Cathedral of the Resurrection of Christ (1883–1907)	Ignatiy Malyshev, Alfred Parland
Novodevichy Convent of Holy Resurrection, 100 Moskovsky Prospekt (1849–1861, bell tower, 1891–1895)	Nikolay Efimov, Leontiy Benois, Vladimir Zeidler
Imitation of renaissance	
Nikolayevsky (Moscow) Railway Station (1844–1851)	Konstantin Ton
*Nikolayevsky Palace (1853–1861)	Andrey Stakenschneider
*Mansion of Count Nikolay Kushelev-Bezborodko, 3 Gagarinskaya Street (1857–1862)	Eduard Schmidt
*Palace of Grand Duke Vladimir Alexandrovich, 26 Palace Embankment (1867–1872)	Alexander Rezanov
Canteen of the Society for Aiding Students, 6 Birzhevaya liniya (1901–1902)	Ivan Kokovtsev
Moresque style	
Muruzi House, 24 Liteiny Prospekt (1874–1876)	Alexey Serebryakov, Pyotr Shestov, Nikolay Sultanov
Byzantine style	
Church of the Our Lady the Merciful, 100 Bolshoy Prospekt of Vasilyevsky Island (1889–1898)	Vasiliy Kosyakov, D. Prusak
The Church—Burial Vault of Our Lady of Kazan, 100 Moskovsky Prospekt (1908–1915)	Vasiliy Kosyakov

(continued)

Table 1 (continued)

Building	Architect
Egyptian style	
A. I. Nezhinskaya's House, 23 Zakharievskaya Street (1911–1913)	Mikhail Songailo
4. Period of style Moderne	
Northern modern style	
*Ida Lidval's house, 1/3 Kamennoostrovsky Prospekt (1902–1904)	Fyodor Lidval
*Nikolay Meltzer's dwelling house, 19 Bolshaya Konyushennaya Street (1905–1906)	Fyodor Lidval
*Alexei Bubyrs House, 11 Stremyannaya Street (1906–1907)	Nikolay Vasiliev, Alexei Bubyr
Style Moderne proper	
*The Singer Company Building (1902–1904)	Pavel Syuzor
*Pavel Forostovsk/s Mansion, 9, 4th Liniya of Vasilyevsky Island (1900–1901)	Karl Schmidt
Romantic imitations of national styles	
Church of the Holy Sign of the Pomorskaya Hierarchy Old Believers, 8 Tverskaya Street (1906–1907)	Dmitriy Kryzhanovsky
*Roman Catholic Church of Notre Dame de France, 7 Kovensky pereulok (1908–1907)	Marian Peretyatkovich, Leontiy Benois
Neoclassical style	
*Azov-Don Trading Bank, 3/5 Bolshaya Morskaya Street (1908–1909)	Fyodor Lidval
*German Embassy Building, 11 St. Isaac's Square (1910–1912)	Peter Berens
*Ethnographic Department of the Russian Museum (1901–1911)	Vasiliy Svinyin
Neo-renaissance	
*Trade House of F. L. Mertens, 21 Nevsky Prospekt (1911–1913)	Marian Lyalevich
*Russian Trading and Industrial Bank, 15 Bolshaya Morskaya Street (1912–1914)	Marian Peretyatkovich
*House of Emir of Bukhara, 44b Kamennoostrovsky Prospekt (1913–1914)	Stephan Krichinsky
New Petrine Baroque	
Peter the Great Hospital, 47 Piskarevsky Prospekt (1910–1914)	Lev Ilyin, Alexander Klein, Alexander Rosenberg
Mansion of Motavkin-Botkin, 9 Potemkinskaya Street (1860; 1903–1905)	Adam Dietrich

*Buildings decorated with stone

pink rapakivi granites, grey Serdobol granites, Karelian marbles (Ruskeala, Tivdiya and Yuvensky) and Shokshinsky quartzites are used.

The period of early classicism (1760–1770) is associated with J. B. Vallin-Delamot's, A. Rinaldi's and Y. M. Felten's works. The main features of early classicism are strict forms, clarity and laconism of the composition, and porticos of columns and pilasters.

The representatives of strict classicism (1780–1800) were architects D. Quarenghi, C. Cameron and Russian architects I. E. Starov and N. A. Lvov. The main features of this style are monumental simplicity, geometric clarity of forms and walls without details.

High classicism appeared in St. Petersburg at the beginning of the nineteenth century. It characterizes by the spatial scope of structures, clear geometric volumes, continuous colonnades and the synthesis of architecture with monumental sculpture. This period is associated with the names of the architects A. N. Voronikhin, A. D. Zakharov and J.-F. Tom de Tomon.

Late Classicism or Empire style (1810–1830) appeared after the victory in the Patriotic War of 1812. The theme of triumph sounded in St. Petersburg architecture. Solemnity, grandeur, monumental grandeur and expressiveness of sculptural decor are characteristic features of the Empire style. This is the time of the highest rise in St. Petersburg's

urban planning. The largest architect in Russia at that time was K. I. Rossi, the master of the architectural ensemble. He created ensembles of the Mikhailovsky Palace, the Alexandrinsky Theatre, the General Staff, etc. O. Montferrand is another outstanding representative of the Empire, the creator of St. Isaac's Cathedral and the Alexander Column.

During the classical period, architects used Finnish pink rapakivi granite for the decoration of embankments, bridges, in the pedestals of fences and other structures. This granite was used in stylobates and building high podiums, columns and other things. This stone has become a stone symbol of St. Petersburg. The Putilovo plate and Pudost limestone are still used. Domestic marbles were widely used. Foreign marbles and other coloured stones are used to a lesser extent. Serdobol granite was used for stylobates and podiums, for facing buildings and columns as in the previous period.

The third period of natural stone usage in St. Petersburg (1850–1910). Three architectural trends consistently manifested in the architecture of the city: Eclecticism (Historicism), Moderne, Neoclassicism. Limestone slab, rapakivi granite and Serdobol granite were used as building and facing stone at this time. New varieties of granite from Karelia (Valaam granite) and Sweden, sandstones from Poland and Germany, talc–chlorite shale from Finland, Kirnovsky dolomite and Revel limestone from Estonia appear in St. Petersburg. Natural stone was used to decorate palaces, mansions, trading houses, banks, buildings of insurance companies, joint-stock companies, apartment buildings and temples of different faiths.

During 1830–1890, Eclecticism (Historicism) replaced late classicism. The basic principles of this direction were the free choice of any historical style. The early period of Eclecticism (1830–1860) is associated with architects named A. I. Stackenschneider, N. E. Efimov, A. K. Kavos, L. L. Bonstedt and N. L. Benois. They used forms of Rococo, Baroque, Renaissance and antiquity in the palaces and mansions they built. During the period of mature Eclecticism (1860–1890), variants based on Renaissance, Baroque and "Louis XIV style" prevailed in architecture. M. E. Mesmacher built buildings in the neo-Renaissance style. The Russian style is becoming popular. K. A. Ton and A. M. Gornostaev erected temples in the Old Russian and Byzantine styles in the north-west of Russia. A. A. Parland built Orthodox churches in Moscow and Yaroslavl.

Around 1900, a new style—Moderne—came from the West to St. Petersburg. The architects V. V. Shaub, V. I. Shene, K. K. Schmidt, G. V. Baranovsky and others stood at the origins of the St. Petersburg Moderne style. F. I. Lidval laid the foundation of Northern Moderne in St. Petersburg. This style originated under the influence of Swedish and Finnish national romanticism.

In the early 1900s, architects returned to Classicism. Neoclassicism in St. Petersburg called the St. Petersburg Renaissance. Its framework covered a wide range of styles from Renaissance and Baroque to Empire. Neoclassicism at the beginning of the twentieth century set the task to revive the ensemble integrity of the architectural appearance of St. Petersburg. The neo-Renaissance direction was represented by architects V. A. Shchuko, M. M. Peretyatkovich, M. S. Lyalevich and F. I. Lidval.

Excursion 1. Along Bolshaya Morskaya Ulitsa (Big Naval Street)

Start Point—the Arch of the General Staff
End Point—The Nabokova House
Route length—1.6 km

Bolshaya Morskaya (Great Naval) street is located in the very centre of the city of St. Petersburg. It attracts the attention of architecture-lovers over and over again. In spite of the fact that buildings situated in this and adjoining streets do not represent any unified ensemble because of differences in their styles, ages and used materials, nevertheless, being observed all together, they compose the specific harmony. In many respects, such congruousness results from a great deal of stone decoration that often completely covers facades of buildings where former banks and joint-stock companies were housed lately in the nineteenth–early in the twentieth centuries.

Excursion №1

TOWN GUIDE
St PETERSBURG

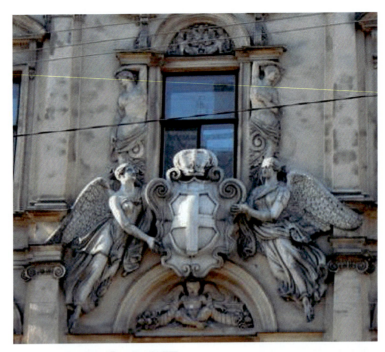

STONE TOWN GUIDE

St PETERSBURG

Excursion №1

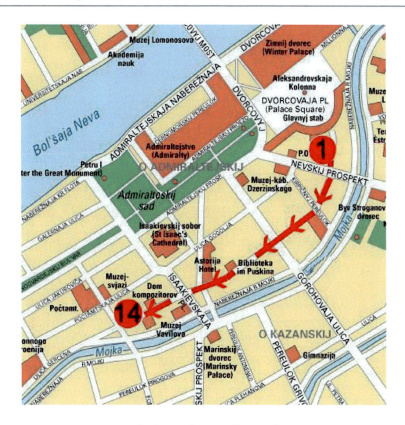

St Petersburg - Excursion 1
Along by Bolshaya Morskaya Ulitza
(Big Naval Street)
Start Point - the Arch of the General Staff
End Point – The Nabokova's House Route
length - 1,6 km

№ 1
AZOV-DON TRADE BANK
1907–1910, F. I. Lidval

The building of the former Azov-Don Trading Bank is faced with grey granite from somewhere at the Vuoksa River. That was erected in 1907–1910 by the architect F. I. Lidval in Modern Neoclassical style. The building has an asymmetrical facade typical of this style. It is decorated with four columns fluted at the bottom and with six pilasters. Of particular interest are oval medallions fixed between windows of the third floor and stylized multifigured bas-reliefs by the sculptor V. V. Kuznetsov that are arranged on the level of the ground floor. The main entrance to the bank is decorated outside with glassy-polished, motley-banded, white-black stone. We suppose it to be plagiogneiss. For the decoration of the interiors of the Azov-Don Bank, green and brownish-green marbles from Sweden were applied.

AZOV-DON TRADE BANK
1907-1910 F.I. Lidval

№ 1

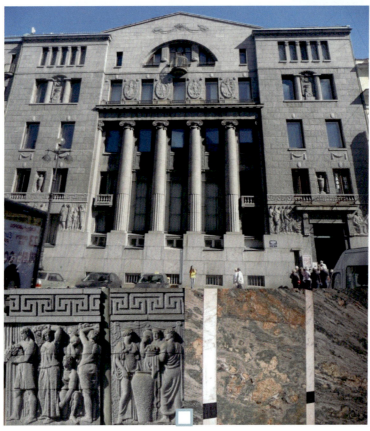

№ 2
RUSSIAN TRADING AND INDUSTRIAL BAN
1912–1914, M. M. Peretyatkovich

Grey Nystad granite was used for the entire facing of the majestic edifice of the former Russian Trading and Industrial Bank built to the design of M. M. Peretyatkovich. Blocks of the granite have "rocky" or pointed surface structures. Key-stones of windows of the second storey of the building are adorned with masks of the same granite. The third and fourth storeys are united by massive round columns, especially attracting our attention to the stone balustrade on the third floor. The relieved frieze is decorated with mascarons in the form of male profiles and heads of rams, as well as with cartouches and compositions of armour. All those sculptural details of the bank building had been carved by L. A. Ditrich and V. V. Kozlov constantly co-operating with M. M. Peretyatkovich. The diversity of the finishing and variety of the stone decor reliefs make light and shade play on the plastic architectural details of the building and yet more accentuate its monumental bottom part supporting the upper storey colonnade up.

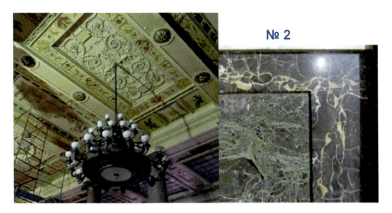

RUSSIAN TRADING AND INDUSTRIAL BANK

1912-1914 M.M. Peretyatkovich

№ 3
CENTRAL TELEPHONE STATION
1903–1904, K. V. Baldi

The rich and complex decoration of stone is shown in this house. Two-coloured sandstone from Poland was used for its facing. The ground floor is faced with red sandstone worked up in different manners. One can see the stone surfaces that are either roughly uneven, or wavy (fluted or corrugated), or speckled with small points. The upper storeys are faced with grey sandstone. The same stone was used for carving ornaments over the windows, complex garlands disposed on each side of the big window of the clock-tower and the emblem (coat of arms) of Petersburg that represents a crossed sceptre and two anchors: one of which is marine (with 2 flukes) and another—river (with 4 flukes). The stone ornaments were complemented with small details of ceramics.

№ 3
CENTRAL TELEPHONE STATION

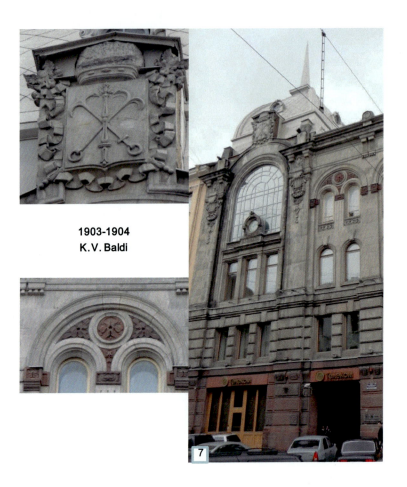

**1903-1904
K. V. Baldi**

№ 4
FABERGE'S HOUSE
1899–1902, K. K. Schmidt

The building was a well-known jewellery firm—the Faberge House. The whole of the facade of the house was clad with nothing but red Gangut granite. However, the granite was worked up in different techniques, so at least three shades can be distinguished in the colouration of the building. The facing was executed in a highly masterly way, the slabs being brought to conformity in the stone pattern with extreme precision and delicacy. Slabs facing the ground floor embellished with massive columns have polished surfaces. The polish had intensified the deep red colour of the granite. Slabs of dark-red colour are placed above the columns. The upper storeys were faced with slabs having a fine-pointed surface structure giving rise to the smoky light-rosy colouration of the granite, while the outstanding window frames and some other details have the "rocky" facture and, as a consequence of it, the darker rosy colour.

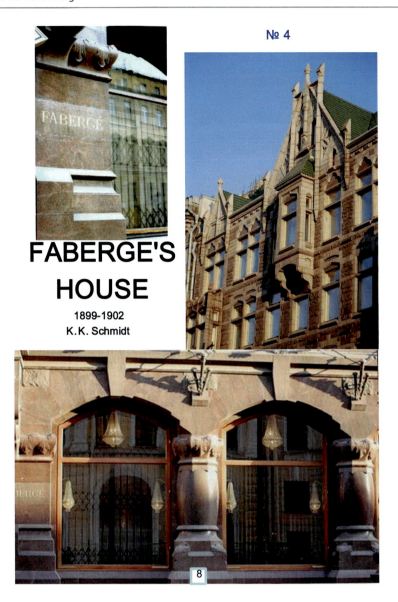

№ 4

FABERGE'S HOUSE
1899-1902
K.K. Schmidt

№ 5
RUSSIAN FOREIGN TRADE BANK
1887–1888, V. A. Shreter

Coloured sandstones from Germany were applied for the cladding of the house. This building intended for the Russian Foreign Trade Bank was erected in 1877–1888 to the design of architect V. A. Shreter. Both the socle floor and high, carved portal with two columns were faced with slabs of red sandstone. The first floor was finished with rustication of green sandstone. The two upper storeys are cased with yellow sandstone and united with Corinthian pilasters cut from the yellow sandstone as well. The stone decor is complemented with complex ornamental details made of ceramics.

№ 5

RUSSIAN FOREIGN TRADE BANK
1887-1888
V.A. Shreter

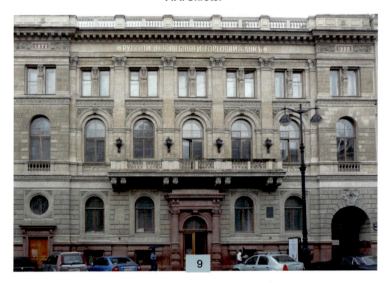

№ 6
DWELLING HOUSE OF THE RUSSIA INSURANCE COMPANY
1905–1907, Architects A. A. Gimpel, V. V. Il'yashev

Blocks of the red Gangut granite finished in the "rocky" techniques were also used for the revetment of the ground floor of the house N 35 built in the style of Modern in 1910. The upper storeys were covered with the smoky-pink granite from the deposit Kovantsaary, while for the bottom of the edifice black polished slabs of the specific small-spotty rock known as gabbro were applied. The combination of the black, red and greyish-pink stones makes the whole construction very effective. Together with the stone decor of the building, majolica compositions created after drawings of N. K. Roerich on the subject of Russian North play an important role here.

№ 7
DWELLING HOUSE OF THE RUSSIA INSURANCE COMPANY
1905–1907, Architects A. A. Gimpel, V. V. Il'yashev

The house is built for the Insurance Company "Russia" at the beginning of our century the upper storeys were plastered and only the plinth, cornices and portals were faced with the red Gangut granite. The granitic decor was complemented by the light-yellow Württemberg sandstone, the outside frames of huge windows having been cut from the rock.

№ 6-7

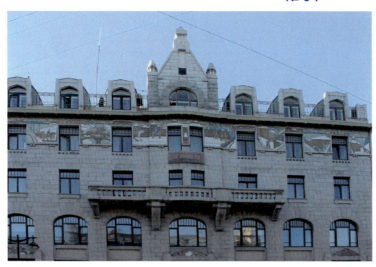

DWELLING HOUSE OF THE RUSSIA INSURANCE COMPANY
1905-1907 Architects A.A. Gimpel, V.V. Il'yashev
Artist N. Roerich

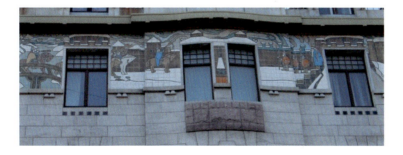

№ 8. At the corner of the Great Naval str. and Isaac Square

Here is the building of the Astoria Hotel. It was one of the biggest hotels in Petrograd set up by the architect F. I. Lidval in 1914. The edifice was built in Moderne style with the use of some elements of Classicism. The two lower storeys are faced with pink and pink-grey granite from the deposit near Antrea. The facades are decorated with oval medallions with masks, garlands and stylized vases cut out of the same granite.

№ 8

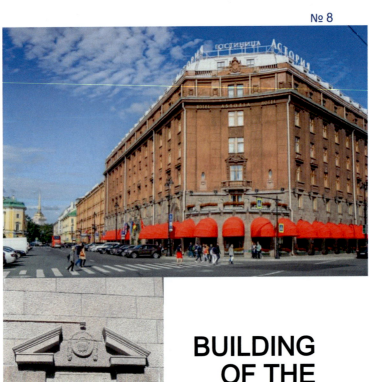

BUILDING OF THE ASTORIA HOTEL

1914 Architect F.I.Lidval

№ 9

The casing of the house (№ 40) is made of sandstone. It is the former building of the First Russian Insurance Company erected in 1889–1901 after the project by L. N. Benois. The basement of the building is finished with well-polished pink-red Valaam granite having a very heterogeneous, spotted or banded structure and turning in places into gneissoid granite. The upper storeys are faced with pink and yellow sandstones and covered with a complex ornament carved of light-grey sandstone.

№ 9

BUILDING OF THE FIRST RUSSIAN INSURANCE COMPANY

1889—1901
project by L.N.Benois

№ 10

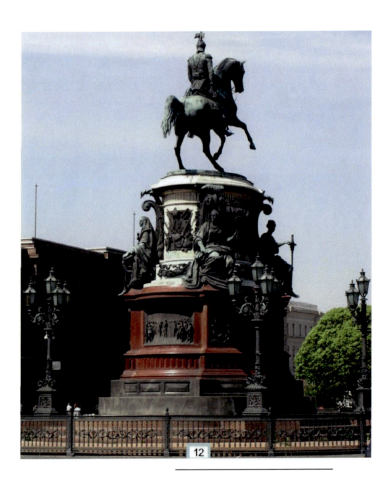

№ 10
MONUMENT TO NICHOLAS I
1859, Architect Au. Montferrandt
Sculptors P. K. Klodt, N. A. Ramazanov, R. K. Zaleman

The equestrian statue of Nicolas I stands in the centre of St. Isaac's Square. The monument was designed by the sculptor Pyotr Klodt and by architect August Monferrand and was erected in 1859. The base of the monument is constructed with pink Rapakivi and grey Serdobol granites. The pedestal is decorated with red Shoksha quartzite and white Italian marble. Four high reliefs and allegories of Justice, Faith, Wisdom and Strength surround the statue. It is worth mentioning that the tomb of Napoleon in the Hotel des Invalides in Paris is also cut from the Shoksha stone.

MONUMENT TO NICHOLAS I
1859
Architect Au. Montferrandt
Sculptors P.K. Klodt,
N.A. Ramazanov, R.K. Zaleman

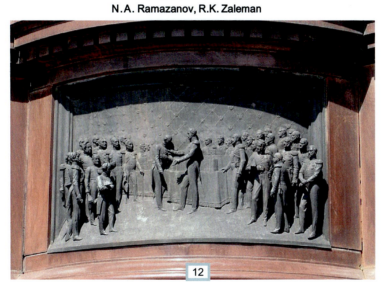

GERMAN EMBASSY

1911-1912
P. Behrens

№ 11
GERMAN EMBASSY
1911–1912, P. Behrens

Through all their, height the facades of the edifice were faced with thick slabs of Swedish granite coloured uniform rich red. Due to the rocky and small-knobby surface structure of the stone, its bright colouration is lusterless. The three-quarter columns of the main (eastern) facade of the building are very impressive. They were clad of rounded blocks of granite, each of them being 0.7 m in height. The building was topped with a heavy sculptural group presenting bronze statues of two youths restraining horses. In 1914, they were thrown down onto the ground and drowned in the river Moika by a crowd of people incited by patriotic sentiments.

DEMIDOV`S HOUSE № 12
1840s Au. Montferrandt

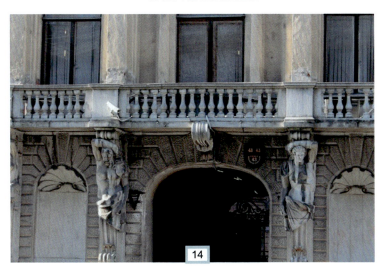

№ 12
DEMIDOV`S HOUSE
1840s, Au. Montferrandt

The house was erected to the design of Au. Montferrand in 1836 for the owner of factories at the Urals P. N. Demidov. The base of the house is faced with polished Serdobol granite, and the ground floor is finished with rustics of white Italian marble. The marble slab surface was worked up in an original manner, so that it was speckled with rare small holes of round or elongated forms. Such a technique of finish made smooth stone look like porous tuff. Carved of white marble are six germae with male and female half-figures propping up a marble balcony of the first floor. The marble bas-relief group "Glory" created after a model of the sculptor T. Jacquot is fixed above the balcony in the centre of the facade. On each side of the gate, there are two niches for fountains. The niches are lined with slabs of white polished marble. The asymmetrical facade of the mansion is decorated with a large open balcony adorned with four marble busts wrecked rather considerably at present.

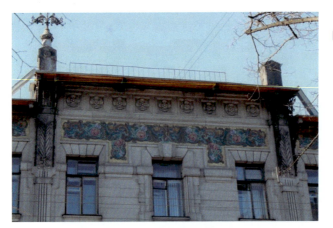

№13-14

NABOKOVA'S HOUSE

1901-1902
M. F. Heisler, B.F. Guslistiy

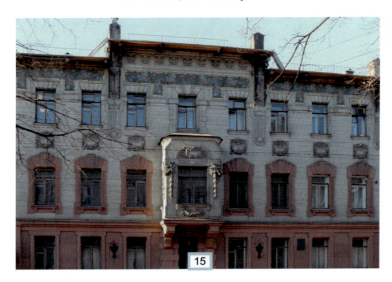

№ 13–14
NABOKOVA'S HOUSE
1901–1902, M. F. Heisler, B. F. Guslistiy

Appearing smart is the former house of Nabokova the ground storey of which is faced with red sandstone and the upper storeys are faced with grey sandstone. The facing slabs of sandstone are finished in such a way that some of them are smooth while others have rocky surfaces. Garlands carved of sandstone and a mosaic frieze of majolica that depicts red tulips and light-blue lilies against a golden background embellish the top of the building facade.

№ 13-14

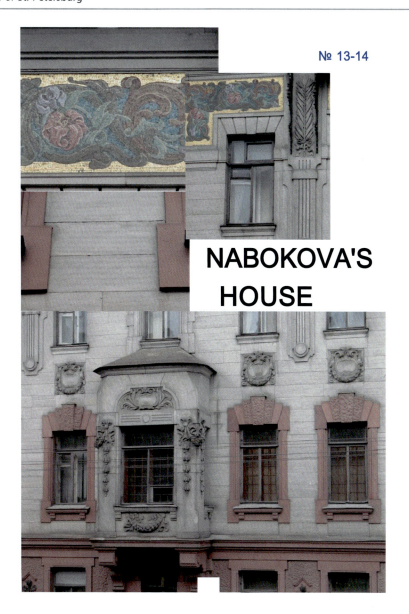

NABOKOVA'S HOUSE

Excursion 2. From the House of Lobanov-Rostovsky to St. Isaak's Cathedral

Start Point—the Lions Palace Hotel
End Point—the Admiralty Garden Route, length—1.5 km

Excursion №2

TOWN GUIDE
St PETERSBURG

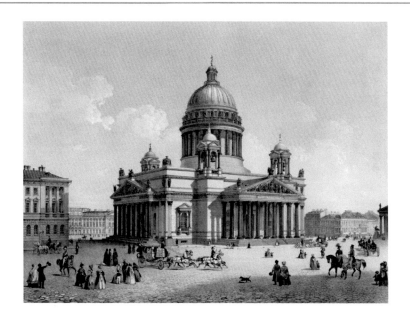

STONE
TOWN GUIDE
St PETERSBURG
Excursion №2

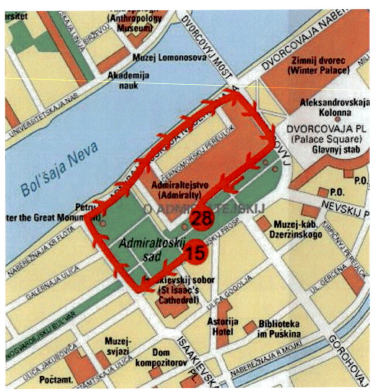

Excursion 2
From the House of Lobanov-Rostovsky to St Isaak's Cathedral and along by Admiralty Embankment
Start Point – the Lions Palace Hotel
End Point – the Admiralty garden
Route length - 1,5 km

№ 15
HOUSE OF LOBANOV-ROSTOVSKY (THE LION PALACE HOTEL)
1817–1820, Au. Montferrandt

It is the former residence of Prince Lobanov-Rostovsky. Now a hotel place occupies the building. The central parts of the facades of the house looking out onto the Neva and St. Isaac's Cathedral were created as powerful porticos of many columns with arcades. They rest on massive stylobates faced with slabs of rapakivi granite. The plinth of the building along all its perimeter had been revetted with slabs of the same kind. Two marble guard lions by the sculptor Paolo Triscorni adorn the entrance from the Admiralty side. During the Great Patriotic War (1941–1945), several pits resulted from fragments of shells that appeared on a ball under the paw of one of the lions. Those pits have been blocked up with stone patches today. In 2014, the Lion Palace Hotel was opened in the building. Its interiors are decorated with a lot of types of nice decorative stones from all the world deposits.

№ 15

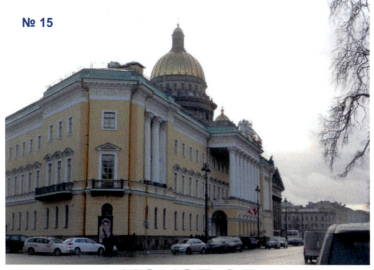

HOUSE OF LOBANOV-ROSTOVSKY

1817-1820 Au. Montferrandt

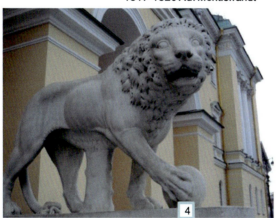

Lion Palace Hotel

№ 15
THE LION PALACE HOTEL

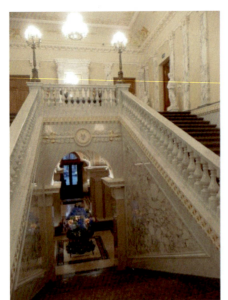

5

№ 16
ST ISAAC'S CATHEDRAL
1817–1820, Au. Montferrandt

This cathedral is one of the most grandiose dome constructions in the world and the main architectural dominant of the centre of the city of St. Petersburg. Columns of dark-pink rapakivi granite arrest our attention first and foremost among the exterior decorations of St. Isaac's Cathedral. Particularly grandiose columns had been installed on the massive granitic stylobates of the four majestic porticos of the cathedral: sixteen at a time—in the northern and southern porticos and eight at a time—in the eastern and western ones. The columns are crowned with the entablature, the frieze of which is also cut out of dark-pink rapakivi granite.

Wide granitic steps lead down from the columns to the basement of the cathedral. These 48 columns, each weighing 114 tons, are 17 m high, with a diameter of 1.85 m. They are among the most gigantic columns in the world and are second in the size only to the Alexander column, also set up after the design by Au. Montferrand. Above the portico, in the drums of cupolas and belfries, as well as on each side of every window, the rows of columns of the same pink granite are as if in the clouds over the city. Altogether 112 granitic columns adorn the cathedral.

The walls of the cathedral were constructed after the columns of the porticoes had been established. Outside, they are faced with large slabs of light-grey Ruskeala marble. The carved porticos of doors with bronze reliefs ornamented with many figures had been cut out of the same marble. The

Ruskeala marble proved to be very unstable and began to decay rather soon. Therefore, during the 1870–1890-s, during the first restoration of the cathedral not a. few slabs of Ruskeala marble were replaced by insertions of more homogeneous pale-grey Italian marble Bardiglio from the deposit near Serravezza.

The huge St. Isaac's Cathedral can hold 15 thousand people at one time. Its interior is lined with coloured stone in plenty and looks triumphantly rich. Especially impressive is the iconostasis the cost of which amounted to one tenth of the total cost of the cathedral building. The iconostasis had been cut out of white statuary marble quarried in Serravezza in stone pits of La Vinkarella, Falkovaya and Monte Altiesimo. It is embellished with eight columns and two pilasters made of malachite in the manner of a "Russian mosaic".

These columns 9.7 m high and 0.62 m in diameter are unique in that their curiosity. The two central columns of the iconostasis, 4.9 m high and 0.43 m in diameter, are faced with dark-blue Badakhshan Lazurite in the manner of a "Russian mosaic" too. Favourite Ancient Greek ornament—that is meander, or bordure a la grecque is also lined of lazuritic plates in the arches of the side chapels of the iconostasis.

Steps to the altar and the bottom part of the iconostasis were hewn out of dark-red Shoksha quartzite. Made of the same stone is the cornice topping the whole interior stone decor. The wide frieze of that quartzite fringes the floor of the cathedral around its periphery.

The floor is composed of slabs of dark-grey and light-grey Ruskeala marble arranged in a chess-board fashion.

The central part of the floor, situated under the cupola of the cathedral, represents the splendid mosaic in a huge circle form called "rosas" which is a rose. It is inlaid of pink and cherry-red Tivdiya marble and put in a frame of a border "a la grecque".

The lower part of the walls and enormous pylons are faced with slabs of black slate. The upper part of the cathedral's walls is lined with white Italian marble and embellished with pilasters and columns of Tividiya pale-rosy and cherry-red marble. Altogether, there are 8 columns and 172 pilasters, half-pilasters and quarter-pilasters of Karelian marbles in the cathedral. The columns and pilasters, decorated with cannelures, are pale-rosy of warm tint, while the dark cherry-red pilasters, standing at the corners of the cathedral, have a smooth surface.

In some slabs, for instance in those situated at the south-west corner of the cathedral, we can see how the delicate rosy colour of the marble grades into cherry-red and in places the stone turns ash-pink, almost grey. Installed in frames of Tivdiya (Belogorsky) marble arranged below the pilasters are round medallions and narrow ornamental boards made of perfectly polished Solomino Breccia. Huge plates of marble of different colours, brought from various places, are fitted in the recesses between the pilasters: green rock from Genoa, or Verde di Levanto; red one—Rosso di Levanto; yellow marble from Siena. Large tables of French marble Griotto, placed under the mural icons that are ornamented with white carved Italian marble, attract our attention. Indeed, this very valuable marble is picturesque because of its rich red colour contrasting with white round spots of fossilized shells.

In the southern nave, the bust of Auguste de Montferrand—the author of the project and builder of St. Isaac's Cathedral—stands. The disciple of the famous architect, sculptor A. Foletti, had created that bust from all kinds of stones used by Montferrand for the finish of the cathedral. He carved out the face of Montferrand of white Carrara marble, the hair—of grey granite, the collar of the uniform—from slate, the cloak—of crimson Shoksha sandstone, the cordon—of green marble and the orders—of yellow Siena marble and crimson quartzite. Pink Tivdiya marble served as the pedestal of the bust.

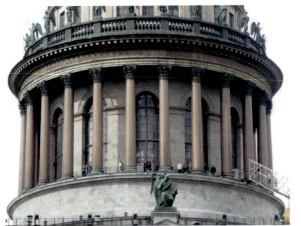

№ 16

ST ISAAC'S CATHEDRAL

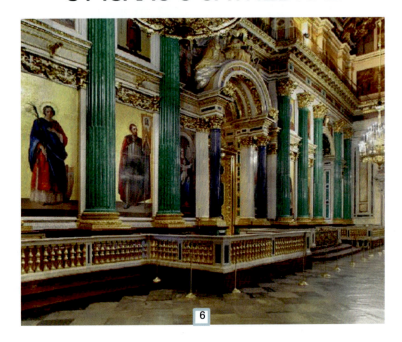

6

№ 16

ST ISAAC'S CATHEDRAL
1818-1848
Au. Montferrandt

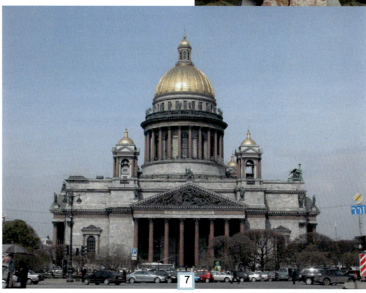

№ 17
MANEGE OF HORSE GUARD REGIMENT AND DIOSKURS
1807, G. Quarenghi

Behind St. Isaac's Cathedral, Admiralty Avenue is closed with the fine, tersely simple in adornment portico of the Horse Guards Manege (Riding School). It was designed by G. Quarenghi and represents one of the models of Strict Classicism. The basement of the building was made of Putilovo limestone slabs. The pedestals of columns of the portico, steps and stylobate are granitic. The designation of the building was emphasized by sculptural bas-reliefs fixed over the entrance. Carrara marble groups of Dioscuri are established in front of the portico. The sculptures are designed by Paolo Triscorni on the antique originals standing on the way up to the Quirinal Palace in Rome.

№ 17

MANEGE OF HORSE GUARD REGIMENT AND DIOSKURS

1807, G. Quarenghi

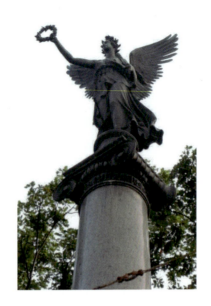

№ 18
TWO COLUMNS WITH STATUES OF NIKE
1854–1856, N. E. Efimov

They stay between the Manege and Synod buildings, in the very beginning of the Konnogvardeisky (Horses were erected by the architect N. E. Efimov put on the tops of columns bronze sculptures of Goddess Nike which were created by T. D. Rauh in Berlin in 1837. Friedrich Wilhelm IV of Prussia presented them to Nicholas I in 1845. The total height of a column is 12.5 m including both a pedestal and a statue.

Romanian prototype is pictured here

№ 18

TWO COLUMNS WITH STATUES OF NIKE

1854-1856
N. E. Efimov

9

№ 18

TWO COLUMNS WITH STATUES OF NIKE

1854-1856
N.E. Efimov

№ 19
SENATE AND SYNOD (now the President Library after B. Eltzin and the Constitution Court Yard of the Russian Federation)
1829–1834, C. Rossi

These two buildings set western boundaries of the Ploshchad Dekabristov (Decembrists' Square) and are connected with the Admiralty through a similar compositional peculiarity: the relatively low plinth of the Senate and Synod buildings is the basement of the colonnade. The socle is faced with three rows of slabs of pink granite rapakivi, a narrow cornice of Putilovo limestone running along above the slabs separates them from the wall surface. Outside staircases and kerbstones of the widespread pente douces are also made of granite rapakivi, and the descents themselves are paved with pieces of diabase.

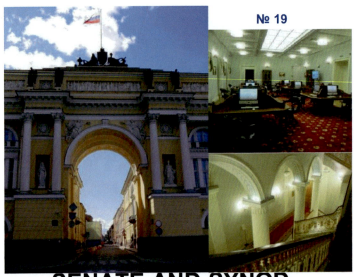

SENATE AND SYNOD
(now the President Library after B. Eltzin and the Constitution Court Yard of the Russian Federation)

1829–1834
C. Rossi

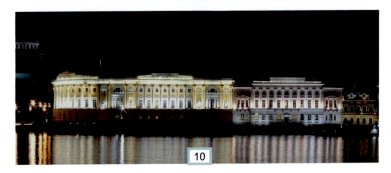

10

№ 20
BRONZE HORSEMAN
1768–1782, E. Falconet

This famous Bronze Horseman was designed by the French sculptor Etienne Falconet. The head of Peter the Great was sculptured by Maria Anne Collo. The pedestal is shaped as a crest of wave cut out of three blocks of pink coarse-grained microcline granite. They are parts of a huge glacial boulder which was found near the settlement of Lahta at the North beach of the Finnish Gulf. It is traditionally named Rapakivi but has another structure.

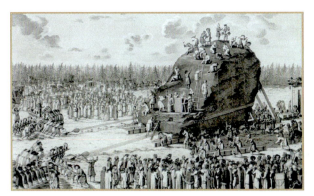

№ 20

BRONZE HORSEMAN
1768-1782 E. Falkonet

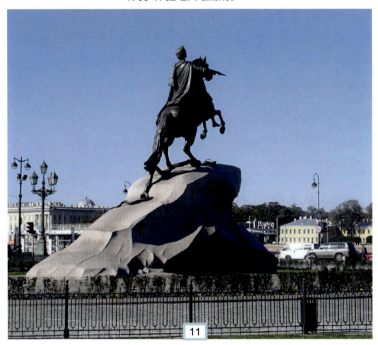

11

№ 21–22
ADMIRALTY EMBANKMENT AND TWO SWEDISH VASES
1818–1874

It is an embankment along the Big Neva River between the Synod building and the Palace bridge, or in other words, between Petrovskaya and Admiralteyskaya landing stages. The Embankment and landing stages were constructed and reconstructed part after part in 1816-1821s, 1873–1874s and 1914-1916s. Granite rapakivi blocks for the embankments were cut in quarries at islands and sea bluffs between Vyborg and Kotka. A dark grey vase of Äsbo diabase was manufactured in Älvdalen, Sweden, in the 1830s. By the way, the second one cracked because of frosts; relics lie at a store now.

TSAR AS CARPENTOR
1910, Sc. L. A. Bernschtam (Recreated in 1996)

The monument after Peter I (so-called Tsar as a carpenter) tells about his visiting Holland where he was trained at shipyard near Amsterdam in 1697. Bronze carpenter stands on a pedestal of grey granite rapakivi from the Vozrozhdeniye quarries near the city of Kamennogorsk (former Antrea).

№ 21-22

ADMIRALTY EMBANKMENT AND TWO SWEDISH VASES
1818-1874

12

A SWEDISH VASE
1818-1874

№ 21-22

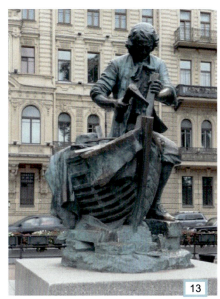

TSAR AS CARPENTOR

1910
Sc. L.A. Bernschtam
Recreated in 1996

13

№ 23
THE PALACE OF GRAND DUKE MICHAEL
1885–1891, M. Messmacher

Grand Duke Mikhail Mikhailovich's Palace stands here. The basement is covered with rapakivi granite. Walls at the Neva façade are covered with ochre-red and mustard-green sandstones from the Stuttgart region, and other facades are plastered. A little gala courtyard is placed at the left part of the building. Its fence and gate are decorated with red Stuttgart sandstone.

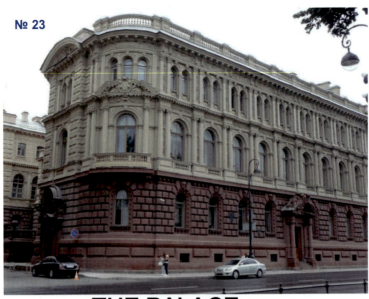

THE PALACE OF GRAND DUKE MICHAEL

1885-1891
M. Messmacher

№ 24
ADMIRALTY
1806–1823, A. D. Zakharov

The building had acquired its face after the reconstruction and rebuilding in 1806–1823. The architect A. D. Zakharov had not managed to complete the works that were continued in accordance with his ideas and his drawings by A. G. Bezhanov, D. M., Kalashnikov and I. G. Gomzin. The stone sculptures had been executed by F. F. Shchedrin, V. I. Demut-Malinovsky, S. S. Pimenov and A. A. Anisimov, and plaster high reliefs on friezes, attics and walls by I. I. Terebenev.

Of stone—Pudost limestone (tufa)—F. F. Shchedrin had hewn into shape the statues of the antique heroes: Achilles, Ajax, Alexander Macedonsky and Pyrrhus set on the corners of the lower storey of the Admiralty tower. At first, the sculptures of the upper storey carved by F. F. Shchedrin and S. S. Pimenov were stone as well. The total number of them was 28. They were pair statues personifying four elements: Fire, Water, Air and Earth; four seasons: Spring, Summer, Autumn and Winter; four winds: South, North, East and West; and two pair figures: the Muse of Astronomy Urania and Isida Egyptian, who, from the traditional story, was the first to build a ship and to navigate on its board looking for her husband.

At the present time, 24 of those statues are metallic, as the stone had rapidly weathered and begun to crumble into small pieces. Four statues lost through bombing during the siege (1941–1945) had been reconstructed of cement. Along either side of the archway of the tower with the spire on the top, on high pedestals of rapakivi granite, the groups of sea nymphs

supporting the terrestrial and celestial spheres stand. They are cut out of Pudost limestone by F. F. Shchedrin.

In the first half of the nineteenth century, the porticoes and pediments of the Admiralty were decorated with many additional sculptures carved of limestone standing on granitic pedestals.

In 1860, all those statues were taken off and huge cast iron anchors were put instead of some of them. Apart from the stone sculpture, granite was skillfully used for building decoration. Coarse-grained rapakivi granite with crystals up to 5–7 cm in size was used for making plinths, sandriks and pediments of front doors, pedestals of columns, facing slabs of the porticos foundation and steps of entrances. Recently, the socle of long buildings situated between the porticos was clad with thin slabs of pink coarse-grained banded gneissoid granite.

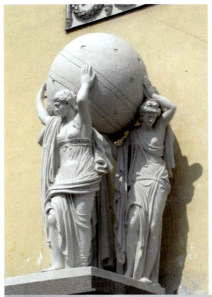

№ 24

ADMIRALTY

1806-1823
A.D. Zakharov

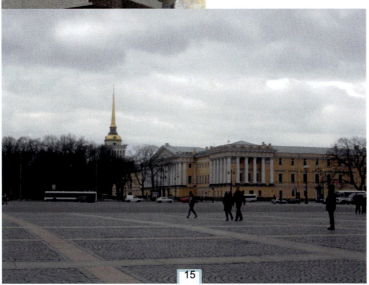

№ 25–26
FLORA AND HERCULES (two antique sculptures)
2012, after restoration and before restoration

The antique sculptures of Flora and Hercules carved of marble are of special interest in the garden. They were set up at the corners of the Admiralty boulevard in 1832. The figure of Flora continues to stand at the side of the alley, while the statue of Hercules proved to be in the middle of the garden that today occupies a part of Decembrists' Square. At the present time, both the statues are standing on tall rectangular pedestals cut out of pink rapakivi granite.

Nymphs with earthly spheres. Two sculpture compositions flank the arch above the main entrance into the Admiralty yard. They are composed by F. F. Shchedrin in 1812. The material is Pudost stone while the pedestals are of granite rapakivi.

№ 25-26
FLORA AND HERCULES

2012, after restoration

2012, before restoration

№ 27
Fountain and monuments

In front of the tower of the Admiralty, the big fountain was erected of slabs and shaped blocks of grey Serdobol granite almost instantly after laying of the garden out in 1872–1874. In 1896, the busts of the poet M. Ju. Lermontov, writer N. V. Gogol and composer M. I. Glinka executed by the sculptors V. P. Kreitan and V. M. Pashchenko were mounted on the stone pedestals near the fountain. In 1998, the bust of the renowned Russian diplomat of the nineteenth century A. M. Gorchakov appeared here. The pedestals of the busts are made of rapakivi granite.

N 27 Fountain

№ 28
The monument to N. M. Przhevalsky

In 1892, closer to the St. Isaac Cathedral, the sculptor A. G. Bilderling put up the original monument to N. M. Przhevalsky: at the pedestal with the bust of the famous traveller and researcher of Asia, a loaded camel is lying near a high rapakivi granite rock.

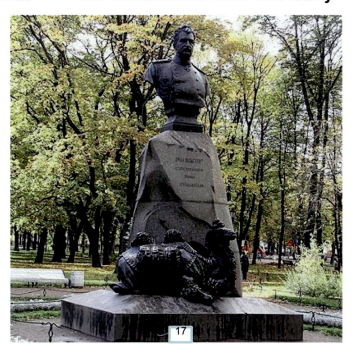

N 28 The monument to N.M.Przhevalsky

Excursion 3. From the Palace Square to the Marble Palace
and Field of Mars

Start Point—the Arch of the General Staff
End Point—Field of Mars
Route length—1.6 km

Excursion No.3

TOWN GUIDE
St PETERSBURG

STONE
TOWN GUIDE
St PETERSBURG
Excursion №3

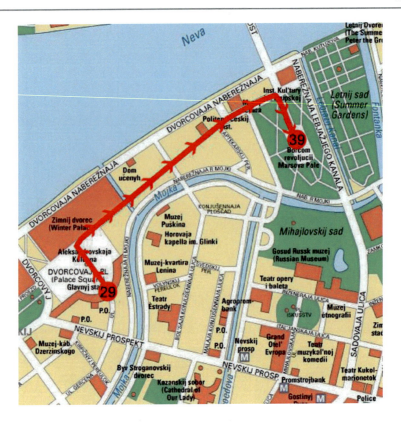

St Petersburg - Excursion 3
**From the Palace Square
to the Marble Palace and Field of Mars**
Start Point - the Arch of the General Staff
End Point – Field of Mars
Route length - 1,6 km

№ 29
ENSEMBLE
OF GENERAL STAFF and Ministry of Interior Affairs
1819–1929 C. I. Rossi

The edifice of the former General Headquarters consists of buildings united by the common façade and the Triumphal Arch. The scale of the edifice as a whole, its monumental and grandiose character are emphasized by the massive socle, 2.5 m high, faced along the perimeter with three rows of rapakivi granite slabs. A slab length approximates 2.2 m its width which may be as much as 15–17 cm. The granite ranges in colour from pink to rather rare for such a rock light grey and whitish grey. The pink stone was applied in the facing of the left part of the main semi-circular edifice, and the grey granite can be seen to the right of the Archway. Bases of columns decorating the semi-circular part of the facade are made of pink rapakivi granite; four balconies of the first floor are constructed of thick slabs of the same type, and granitic consoles and balusters for lattices. Curiously, an opening for runoff of rainwater from every balcony slab had been drilled.

A pavement along the buildings was constructed in 2003. Two granites are used. They are Baltic Brown and from the Vozrozhdeniye quarries. At last, the building for the departments of Ministries for Foreign Affairs and of Finances looks onto the Moyka River. Its low socle is covered with plates of Putilovo Ordovician limestone. A corner-

house stands both at the very beginning of Nevsky Avenue (odd side) and Palace Square. It flanks the main building of the former General Headquarters at the Palace Square. The house was added to the latter at the expense of the reconstruction of a three-storey house of the Russian Free Economic Society. The added house is almost indistinguishable in the facade decoration from the General Headquarters.

However, the socle of this part of the common facade is faced with slabs of pink rapakivi granite, while grey rapakivi granite covers the basement of the General Headquarters. Door-cases are embellished with red, glassy polished rapakivi granite. Facing of entrances comes to the meander frieze and looks very festive at a distance, and the appearance of the doors with their hard folds decorated with reliefs is enhanced by it. The height of the doors comes to 7 m.

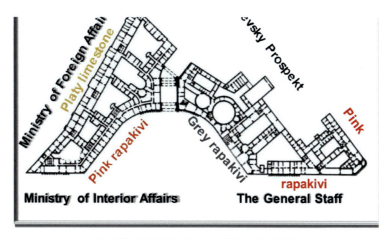

GENERAL STAFF
1819-1929
C.I. Rossi

№ 29

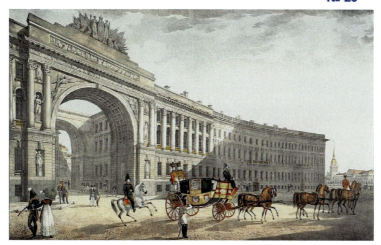

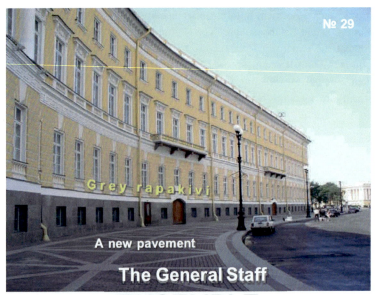

ENSEMBLE OF GENERAL STAFF
1819-1929
C. I. Rossi

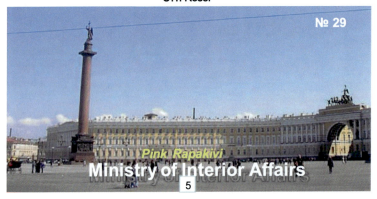

№ 30
ALEXANDER COLUMN

The 704-ton monolith of the Alexander monument is 84 (83.85) feet high. It is cut out of pink rapakivi granite at Piterlaks quarries. Au. Montferrand tried to use proportions of Trojan's column in Roma to give forms that Peterlaks monolith. They are 8:1 (height: bottom diameter) and 8:9 (top diameter: bottom diameter), so the sizes of the Alexander column are as follows: 84 feet:10 feet 4 inch:12 feet, or the same as 25.58: 3.19:3.66 m. The column is not attached to the pedestal, only the force of gravity keeps it in place. The pedestal is made of granitic blocks and rests on a thick fundament constructed of stone and lying, in its turn, on a piled basement. The fundament and pile basement lie down the level of the square and hide under huge, massive granitic slabs. The stone pedestal of the column is covered with bronze at the top and decorated with four bas-reliefs. From the bottom, it is faced with smoothly polished slabs of granite and has a rectangular low stylobate with three stone steps and kerbstones on the corners.

The column is crowned with the square bronze capital that is combined with the cylinder and semi-sphere on which the angel with the cross is standing.

A foundation pit 5.1 m deep (5.25 m on other evidence) had been dug out for the column. 1250 wooden piles 26 cm in diameter and 6.4 m in length had been driven into the bottom. of the pit. A wooden tower with a monkey that weighed 830 kg (1200 kg—on other evidence) had been

built for it. The monkey was being risen with the help of a capstan and horse attractive force. It took three months to drive all piles in the ground over the area that occupied 23 m × 23 m. On that pile basement, the foundation constructed of 12 rows of granite blocks, each 40–60 cm thick, was laid. The foundation was encircled with stonework consisting of waste of granite, marble and rubble slab packed up with the addition of mortar. A granite monolith 6 × 6 m^2 in size, weighting as much as 410 tons, was put on the foundation. The monolith represented the pedestal of the column. It was pulled to the edge of the platform and carefully thrown down on the sand. Then it was taken 90 cm up in order to put the mortar between the monolith and foundation.

The stone lay down inexactly and had to be shifted with two capstans. Still, two more monoliths, 203 and 215 kg in weight, together with smaller blocks, had been set on the base stone later. Today, they are covered with bronze and concealed behind the bas-reliefs. Just on that pedestal, the column was installed with the help of the portal crane. The model of the acting crane during the process of the column rising is exposed at one of the departments of the Museum of the History of St. Petersburg in the Peter and Paul Fortress. After the installment, the prominences of the column were hewn off, and two hundred men were polishing the monolith daily for five months.

№ 30

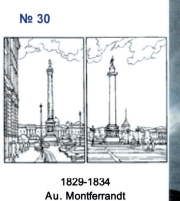

1829-1834
Au. Montferrandt

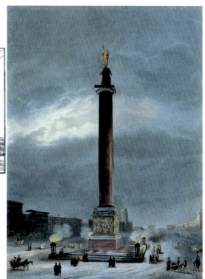

ALEXANDER COLUMN

№ 31
PAVEMENT OF THE PALACE SQUARE
1976–1977, G. N. Buldakov

In 1976–1977, pavements of the Palace Square were designed by architects G. N. Buldakov, G. A. Baykov, F. Romanovsky and the artist V. A. Petrov. Quadrangles were lined with pink granite from the quarry Vozrozhdeniye, and those with grey granite from Kamennogorsk quarry are artistically paved with grey-black diabase stones. Later, before the 300th anniversary of St. Petersburg, pavements were renovated.

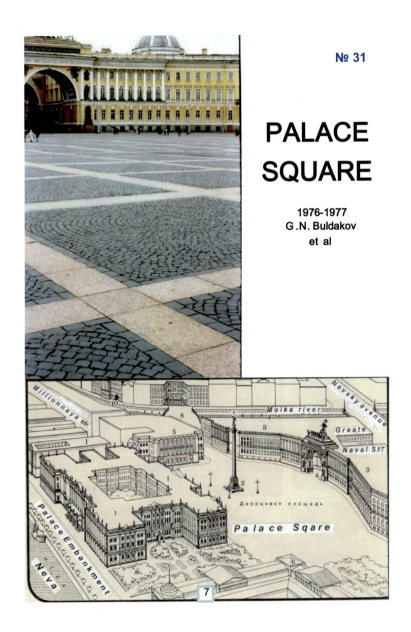

№ 31

PALACE SQUARE

1976-1977
G.N. Buldakov
et al

№ 32
WINTER PALACE
1754–1762, B. Rastrelli

Stone decoration of the Winter Palace is very modest and unpretentious, as well as of all edifices built in the Baroque style. At the foundation of the palace facades, simple, dull slabs of Putilovo limestone are seen, and the same material was used for the pedestals of the columns and for their cubical parapets (in the 2000s, they were unsuccessfully restored and replaced with new slabs; they were destroyed again soon). Earlier, 128 statues hewn out of limestone were standing on the roof of the building along the perimeter of it, but they were quickly broken up and in 1892 were replaced by bronze replicas. Besides the Putilovo limestone, pink rapakivi granite had been used for the Winter Palace decoration. In the 1880s, pente douces of the main entrances from the Palace Square were clad with granitic slabs. Massive rectangular small posts of the cast iron railing of the pente douces were also cut from the same stone.

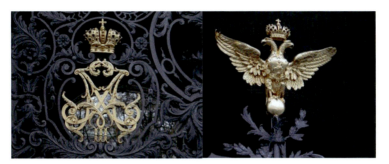

WINTER PALACE
1754-1762
B. Rastrelli

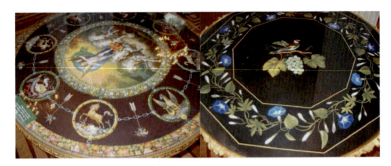

WINTER PALACE
INTERIORS № 32

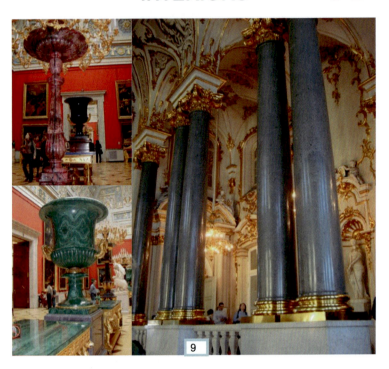

№ 33
THE NEW HERMITAGE
1839–1852, L. Klenze

The building was erected in the very beginning of Millionnaya (Million) Street to the design of the architect L. Klenze. It is decorated on the ground floor with stone door-cases and outside window frames made of slabs of yellow fine-grained, dense Kirna limestone and with metallic figures of great masters of the past mounted in niches of the plastered walls and on the consoles. The of the New Hermitage with wonderful sculptures of atlases is particular beautiful and triumphal. The atlases are carved from grey Serdobol granite by the sculptor A. I. Terebenev.

The pedestals of the atlases, parapets of the pente douces, steps and facing slabs of the building socle were made of pink rapakivi granite, the driveways of the pente douces being paved with stone too. The columns and architrave of the portico, and small columns of the balcony are constructed of blocks of dense yellow limestone. Slabs of the same rock are lying on the socle of the edifice drawing a line around the wall base.

THE NEW HERMITAGE
1839-1852 L. Klenze

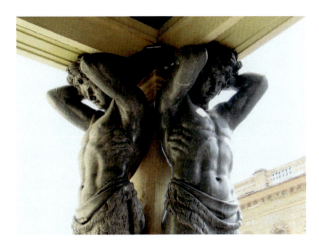

№ 33

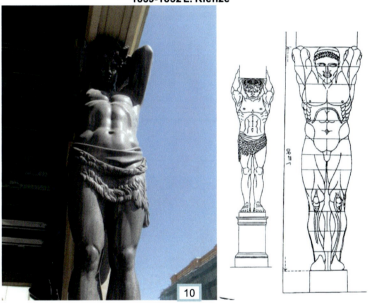

10

№ 34
Venice–St. Petersburg
Drawn by J. A. Ivanov, the 1810s

The Hermitage Bridge was the first one in St. Petersburg which was made of bricks and faced with granite rapakivi in 1763–1768. Only sometime earlier, the Palace Embankment and wall of Winter Canal (Zimniaya Kanavka) were clad with rapakivi. In 1783, arch. J. Felten constructed an arch and gallery to join the Hermitage buildings. It replies the Bridge of Sighs in Venice.

№ 34 Drawed by J.A. Ivanov, 1810s

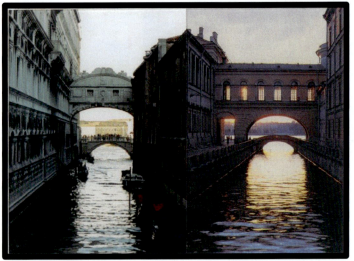
Venice St Petersburg

№ 35
1770s
22–24, MILLIONNAYA STREET, HOUSE OF THE COUNT F. A. APRAKSIN

It has come down to us with considerable changes. In the 1770s, added to the mansion was a portico with four columns of the Ionic order. They were cut from Joensuu marble that showing a distinct pattern of contrasting white and black bands.

№ 35
HOUSE OF APRAKSIN
1770s

№ 36
MARBLE PALACE
1768–1785, A. Rinaldi

It was presented to Count G. Orlov by Catherine II. He died and Catherine bought the Palace for Romanov's family. For the construction of the Marble Palace, special search for marbles and "agates" was undertaken over the Urals and other regions of Russia. Marble was brought to the building site from stone quarries discovered on Ladoga Lake shores, in Karelia and Eastland just at that time. "Wild stone", as granite was then called, arrived from Finland. White and coloured marble was carried from Italy and Greece. Some part of the marble was conveyed from the Office of Isaac's Cathedral buildings. The monumental ground lower floor of the Marble Palace is faced with pink rapakivi granite. It serves as a basement for the more light-coloured upper part of the palace, two floors of which are united by pilasters and columns of Corinthian order. Walls of the first and second storeys are faced with grey Serdobol granite. The architrave, upper cornice and outside window frames of the ground floor are made of the same rock. Outside window frames of the first and second storeys are cut out of light-grey Ruskeala marble.

The pilasters and columns are hewn of rosy Tivdiya marble, and their capitals and bases are carved of a white Uralian one. Garlands placed above the windows of the first floor are carved of the same marble. Slab-panels, on which the garlands are fixed, are made of Juven marble brought from the island Joensuu situated near Serdobol. The frieze

and high attic of the edifice are faced with rosy Tivdiya marble. Set up on the roof of the Marble Palace were vases of light-grey Revelsky dolomitic marble (some of them had been replaced by rude concrete mouldings in the 2000s). Carved of white Italian marble from Serravezza were cartouches on the northern and southern facades, a vase on the clock-tower and two figures standing on each side of the tower. The same rock was used for vases and compositions of armour installed on pillars of the garden railing. The inner decoration of the palace was carried out in stone as well. The steps of the Grand Staircase are made of dark-green, almost black, Brusna sandstone. The bannisters and balustrade, pilasters and columns of the Staircase, as well as niches for sculptures, are made of grey, patterned marble from the Urals. Marble statues are standing in niches.

Made of yellowish-grey marble are massive outside window frames in window niches on staircase landings. The grandeur of the staircase is accentuated by rich fretted cases of doors leading to the private apartments of the palace. The material for them served the same anded black-white Juven marble that was used for the panels established on the facades of the building. Rather thick zigzag black and greyish-white layers in this marble have sharp contacts and are clearly defined. Stone-cutters hewed out the door-cases intricate in their design and profile. It was done in such a way that bands have generally vertical orientation, therefore the stone decoration produces the impression of the aspiration upward. The effect of the just proportion, harmony and elegance in the refinement of the Grand Staircase had been accomplished by those means. Garlands above the doors, rosettes of the capitals and bases of the columns are cut out of white marble. Most likely, it is the same rock that was used for the analogous garlands fixed on the facades of the palace.

Among other apartments of the Marble Palace, the Marble Hall produces much more impression. Walls of the hall through the height of the lower storey are lined with the natural stone of different colours, adorned with gilded bronze and embellished with bas-relief panels performed of white marble. Grey and yellowish-grey coarse-grained Uralian marble identical to that used for the Grand Staircase decoration is of minor importance in the Marble Hall. The rock serves as the background for other marbles and is used rather miserably: in the piers between pilasters, near the doors, as frames of panels made of brightly coloured marbles. In some places in the grey and yellowish-grey marble, fine concentric banding of grey and brown-yellow colours is observed. Its pattern resembles a cut of a tree's trunk. The marble of such a type was quarried at the Fominsk deposit, and sometimes it is used for the decoration of modern buildings.

Pale-rosy, of very delicate shade, in places with dark-red veinlets Tivdiya marble is applied for pair-pilasters covered with cannelures and standing along all the walls, for frames of panels cut of white marble and fixed above the doors, and for the lining of the window niches. Cherry with white and rosy veinlets Tivdiya marble, often very dark, was used for decoration of the lower part of the walls. The wide plinth along the perimeter of the floor under the pilasters is performed of the same rock. Green serpentine Italian marble with white calcite veinlets represents almost a breccia. Such a marble was called Verde Antico (Green Antique) and most likely was brought from stone quarries existing in the proximity of the Italian town Levanto, hence is its second name—Verde di Levanto (Green Levantian). Cut out of this rock are slab-panels under the pilasters. Golden-yellow Italian Siena marble is used in combination with blue lazurite from the Slyudyanka river in the South-Baikal area. Lapis-lazuli is the worthy background for the valuable marble bas-relives while the panels of lazurite are framed by golden-yellow Italian marble.

White statue marble imported from Greece was used for the sculpture. Russian sculptors M. I. Kozlovsky, F. I. Shubin and Italian statuary A. Valli had carved both bas-reliefs arranged on the walls of the Marble Hall and sculptural ornaments: branches with leaves and flowers, eagles keeping garlands and vases in their claws. The upper tier of the hall that appeared at the reconstruction of the Marble Palace in the middle of nineteenth century was made of artificial marble.

Among the stone decorations of other premises of the Marble Palace, eight perfectly polished columns of grey Serdobol granite standing in the oval passage room survived until the present time. In 1996, the equestrian statue of Alexander III was put in the cour d'honneur of the palace. Until 1937, it was standing on the huge granitic base in front of the Moscow Railway Station. Granitic monolith was quarried at Syyskuunsari in Finland by Valamo monks.

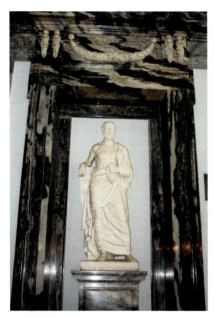
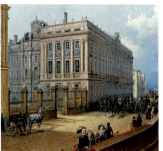

№ 36

MARBLE PALACE

1768-1785
A. Rinaldi

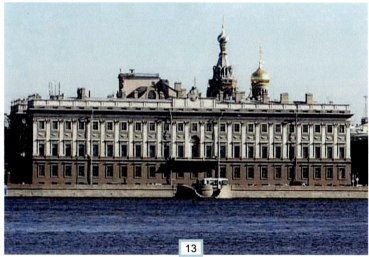

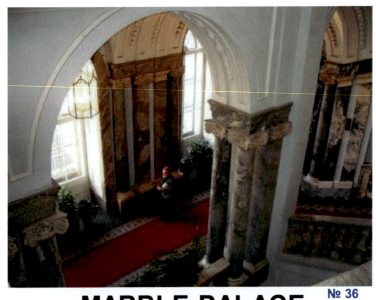

MARBLE PALACE № 36

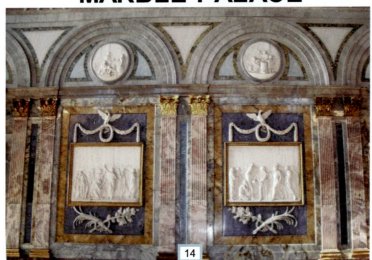

№ 37
MONUMENT TO SUVOROV
1799–1801, M. I. Kozlovsky

The bronze sculpture stands on a monolithic pedestal of Granite Rapakivi.

№ 37

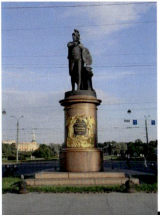

1799-1801
M.I. Kozlovsky

MONUMENT TO SUVOROV

№ 38–39
MONUMENT TO REVOLUTIONARY FIGHTERS
1917, L. V. Rudnev

In the middle of the Field of Mars, a monument to revolution fighters is located. It is one of the first memorial constructions that appeared after October 1917. The memorial was built to the design of the architect L. V. Rudnev. It is composed of large blocks of dark-pink rapakivi granite laid in such a way that they form shelves around graves of heroes of February and October revolutionary events, 1918, and Civil War in Russia. Blocks are from a destroyed old store. Butt-ends of the monument bear lofty epitaphs composed by A. V. Lunacharsky.

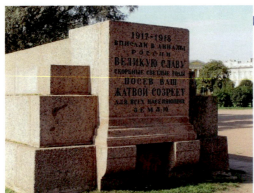

№ 38-39

1917
L.V. Rudnev

MONUMENT TO REVOLUTIONARY FIGHTERS

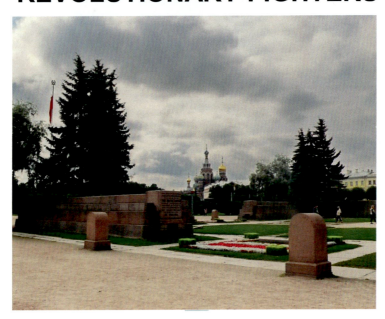

Excursion 4. Around the Vasiliy Island

Start Point—The Rumyantsev Garden

End Point—Stock Exchange House (Naval Museum, 1939–2012)

Route length—1.3 km

STONE
TOWN GUIDE
St PETERSBURG
№4

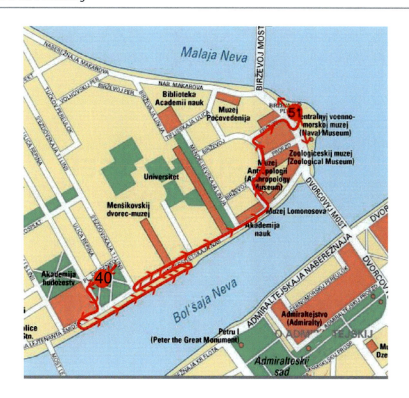

St Petersburg - Excursion 4
The Vasiliy Island
Start Point – The Rumyantsev Garden
End Point – Stock Exchange House
(Naval Museum, 1939-2012)
Route length - 1,3 km

№ 40. RUMYANTSEV GARDEN

There are the famous Rumyantsev's Obelisk and two new monuments to artists I. Repin (1844–1930) and V. Surikov (1848–1916) in the garden.

Field Marshal Pyotr Rumyantsev (1725–1796) was a hero of the Russian-Turkish war 1768–1774, and words "To Rumyantsev's victories" are cut at a plate on the monument. It was designed by V. Brenna in 1799. Serdobol and Rapakivi granites, Ruskeala, Tivdiya and Greek (Italian?) marbles are used. First, it stood on the Field of Mars, and in 1818 it was moved into the garden. Monuments to Great Russian artists Repin and Surikov were opened in 1999. Grey granite from the Karelian Isthmus (nearby Kamennogorsk, or former Kovantsari) is used to cut pedestals.

№ 40

RUMYANTSEV OBELISK

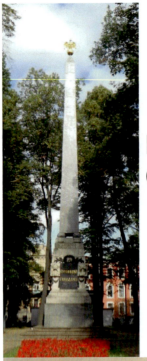

4

№ 41. ST. PETERSBURG ACADEMY OF ARTS (17, UNIVERSITY EMBANKMENT)

Facades. A high socle of the building faced with two varieties of granite rapakivi. At the front, it is rather rare pinkish-grey granite, whilst a socle at the sides of the building is covered with ordinary pink granite. Looking with attention, one can find borders between these two varieties of rapakivi.

Interiors. Floors in all corridors are covered with limestone plates from Putilovo (or Estonia?). The most effective deal is using natural stone in the construction of the main staircase. Unique wide steps and plates are monolithic and cut of granite rapakivi. One can see marbled limestone plates from Öland Island, Sweden, upstairs. The garden behind the building hosts a monument to the 25th anniversary of the Academy of Arts. It was designed by N. Voronichin in 1808 and A. P. Brullov in the 1840s and consists of granite rapakivi (1), Ruskeala marble (2) and limestone basement (4).

Do not forget to have a look at a modern monument to sculptor P. C. Klodt (1805–1867). It is quite near, in the same garden. Granite from a new deposit at the Karelia Isthmus is used in a postament. Klodt created a horse and a horseman in the monument to Nicholas I and the sculptures group "Horse Taming" on Anichkov Bridge.

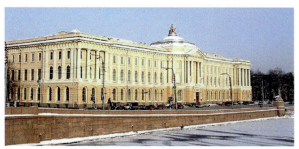

ACADEMY OF ARTS
1832-1834
C. Ton

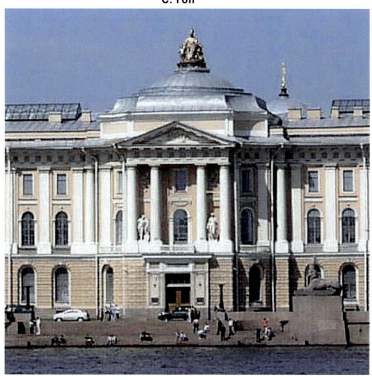

№ 42. PIER WITH EGYPTIAN SPHINXES

Architect C. Ton used old Egyptian sphinxes (with faces of Amenhotep III) to design the granitic pier. These two granite (syenite) monolithic sculptures were found in 1820 and brought to St. Petersburg in 1837. They are the largest stone sphinxes abroad in Egypt. C. Ton put them on the pedestal of granite rapakivi. Compare the colour and texture of these two rock types.

They are similar.

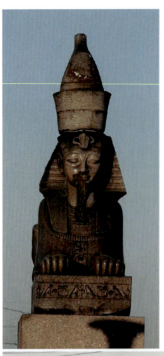

PIERS WITH EGYPTIAN SPHIXES

1832-1834
C. Ton

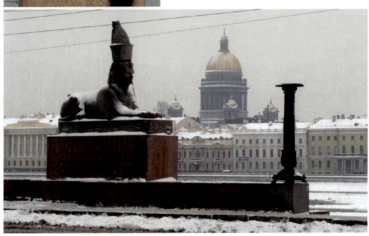

№ 43. UNIVERSITY EMBANKMENT

It is one of the most nice and beautiful places and sight-seeing walks along the Neva.

Constructing began at the so-called Strelka of the Vasiliy Island in 1804, moved step by step to the East, and was finished in 1837. Granite rapakivi was used. In the 1990s, the embankment was repaired. Unfortunately, at that time the city Government had not both money and tradition to buy an original stone in Finland. That is why one will see a lot of other stone materials in parapets.

UNIVERSITY EMBANKMENT
(old and new works)

№ 44. REMAINS OF THE ST. ISAAC BRIDGE

This pontoon spring–autumn bridge acted during 1727–1912. Two granite rapakivi stairs and a bank abutment were built during 1819–1821, and building engineer A. Betankourt of Spain projected them.

In the 1990s, two street-lamps, a stone in memory of Betankourt and "An opened book" were input into the composition of the Remains of the St. Isaac Bridge. The pedestal of street-lamps are blocks of pink gneissoid granite from Kuznechnoe (Kaarlahti) near Priozersk (Käkisalmi), and Betankour's block is Ukranian pink granite rapakivi from the Kapustino deposit. "An opened book" with poetry to Youth by Alexander Pushkin is made with grey granite rapakivi "Vozrozhdenie". So, one can see the same place and compare three different rapakivi rock types.

№ 44

REMAINS OF THE ST ISAAC BRIDGE

and new constructions

№ 45. MENSHIKOV'S PALACE

This typical baroque house is built from bricks, and with a plaster façade. Natural stone is Putilovo slab limestone being used to face a socle, and limestone from Eastland is used to frame doors in the portal.

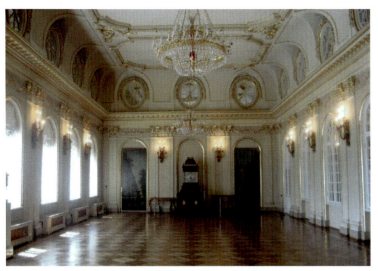

№ 45 MENSHIKOV'S HOUSE
1710-1721
D. Fontana et al

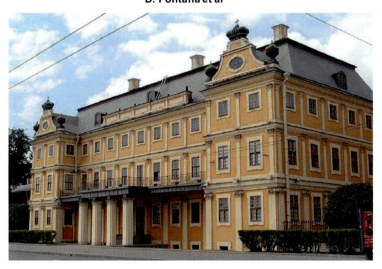

№ 46. TWELVE COLLEGIA BUILDING (7–9, UNIVERSITY EMBANKMENT)

That was the home of Peter the Great's "Ministries". It was designed in the baroque, built from bricks, and with a plaster façade. Ordovician platy limestone from Putilovo (Tosno and some other places) was used for the outside facing of the brick wall at the building's base.

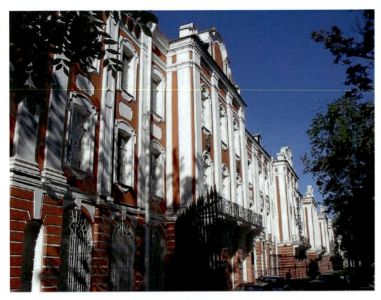

TWELVE COLLEGIA BUILDING
1722-1742
L. Trezini et al

№ 46

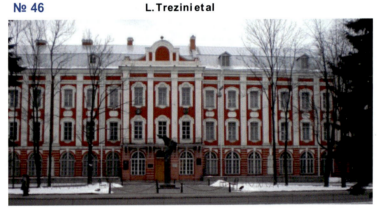

№ 47. MONUMENT TO MICHAEL LOMONOSOV

This modern monument is collected of great blocks of pink gneissoid granite from Kuznechnoe (former Kaarlahti).

№ 47

MONUMENT TO LOMONOSOV 1986

Sc. V. D. Sveshnikov and B. A. Petrov
Arch. I. A. Shahov and E. A. Tyaht

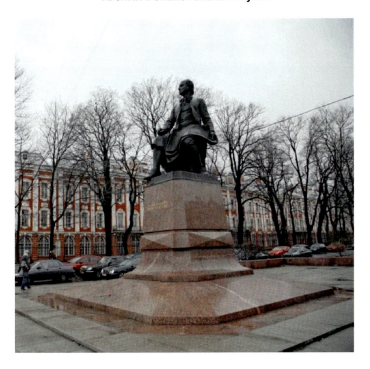

№ 48. THE MAIN HOUSE OF ST. PETERSBURG ACADEMY OF SCIENCES (5, UNIVERSITY EMBANKMENT)

It is a typical building of classic architectural style. The high podium is fully decorated with great quadras of granite rapakivi. We recommend everyone to rise up to the portico to have a look at the Neva River from this position of view. Try to feel yourself in the old times of Ekatherine II without buses and asphalt.

THE MAIN BUILDING OF ST PETERSBURG ACADEMY OF SCIENCES

№ 48

1783-1789
G. Quarenghi

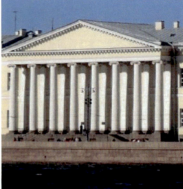

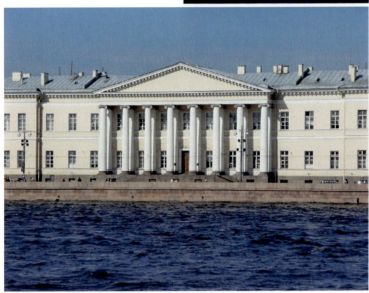

№ 49. KUNSTAKAMMER (3, UNIVERSITY EMBANKMENT)

Now turn, please, to the left into a short and narrow side-street. It lays between Peter's the Great lovely Kunstkammer and some other buildings. Kunstkammer was built by N. F. Gerbel in 1718–1734 and partly reconstructed by S. I. Chevakinsky (1754–1758). Bases of walls are accurately faced with grey and yellowish-grey slabs of Putilovo limestone. Coming through this lane you would find yourself at a semi-circle building and would see an almost real Greek Poseidon classic peristyle in front of you. It is Stock Exchange.

KUNSTKAMMER

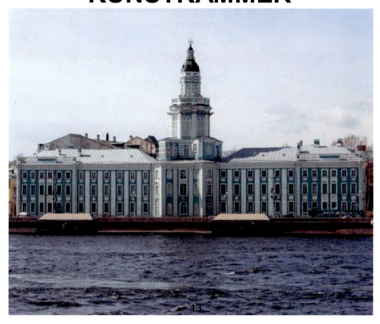

№ 50. STOCK EXCHANGE

Two colour types are used in four rows of plates which cover a high podium of the building. They are pink and grey (Bulakh, Selonen, 2013). Two upper rows are grey, two ground rows are pink. Grey granite plays the role of bases of columns. Look attentively at the granite staircases, the upper steps are grey, lower ones are pink. This play of colours is in harmony with the grey granite rapakivi pedestals of Rostral Columns. A stone high relief decorates each of the two attics. They are cut by S. Sukhanov in joined-together blocks of Pudost stone (tufa) and covered with a lay of lime. The high relief to the Neva River images Neptune and two rivers, whereas Mercury, Navigation and two rivers are at the other high relief.

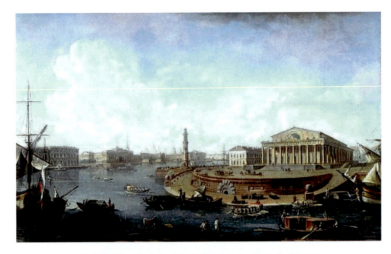

STOCK EXCHANGE
1805-1810
J. F. Tomon

№ 50

№ 51. TWO ROSTRAL COLUMNS

High pedestals are covered with blocks of grey granite rapakivi. Figures of rivers (Neva, Volkhov, Dnepr and Volga) are cut in Pudost stone (tufa). Pavements around columns and between them are covered with Baltic brown and Balmoral red granites in the 2000s. A stone symbol to the memory of the 300th anniversary of St. Petersburg is made of metal and pink gneissoid granite from the Ladozhskoe deposits near Priozersk (former Kaarlahti). At last, two granite rapakivi (pink and grey ones) could be seen in the walls of the way to the Neva River; diabase squared stones cover this way.

№ 51

ROSTRAL COLUMNS
1805-1810
J. F. Tomon

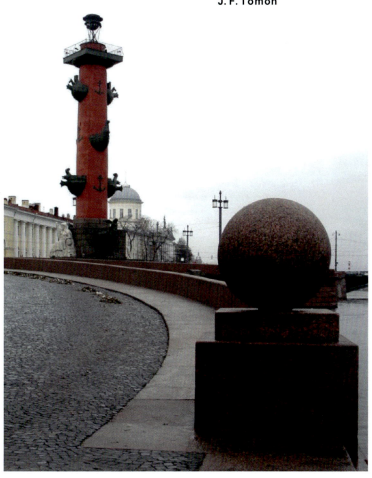

Excursion 5. Architectural stone masterpieces

Some specific architectural stone masterpieces are included in this guidebook.

They stand at different places in the city, so excursions could be independent.

№5

TOWN GUIDE
St PETERSBURG

STONE
TOWN GUIDE
St PETERSBURG
№5

52 St Kazan Cathedral ⟶ 56 Michael's Castle;

57 Bressen ⟶ 58 Voyeykova → 59 Stieglitz ⟶ 60 Bezborodko;

61 Lidval ⟶ 63 Kshesinkaya ⟶ 64 Markov;

65 Buddhist Temple.

Start point: M "Gostiniy Dvor"
End point: Michael's Castle
Length of route: 2,3 km

52 – The Kazan Cathedral
53 – Petersburg division of the Moscow Merchant Bank
54 – The monument to Catherine II
55 – The monument to Peter I
56 – The Michael's Castle

№ 52. THE CATHEDRAL OF OUR LADY OF KAZAN

126 columns surround the church. The height is 14 m, the lower diameter is 1.45 m and the upper one is 1.1 m. They were constructed of Pudost stone. The work was carried out under the direction of Samson Sukhanov. All works on the carving of Pudost stone—bas-reliefs depicting Biblical subjects, and different ornaments—were carried out at the workshop of Karl Galeotti situated on Vasilyevsky Island. Pudost stone is known as a very porous rock having a shelly structure with numerous small and sometimes even large interstices. It is used to repeat the same travertine at facades and colonnades of St. Peter cathedral in Roma. The high plinth of the cathedral and colonnade is constructed of Serdobol granite and red-pink rapakivi granite.

Ruskeala marble is used in the portal of the magnificent northern door of the cathedral. They represent the bronze copy of the famous "Gates of Paradise" in Florentine Baptistery.

The church hall consists of three naves decorated with three rows of 56 columns of red-pink rapakivi granite. Monoliths were obtained from the quarry Saanlahti at the Island Mon-repos, within the city of Vyborg. Their height is 10.8 m. They are 1 m in diameter at the foot.

The mosaic floor is composed of fragments of pink Tivdiya and grey, grey-green banded Ruskeala marbles together with dark-red Shoksha quartzite and black slate. By the south-west central pylon, a tsar's seat is disposed, and there is a pulpit near the north-east pylon. They are not very high daises, with steps of red Shoksha quartzite leading upstairs.

Two corbels are made from grey faintly folded Ruskeala marble. To a height of about 3 m, the pylon is faced with red-pink Tivdiya marble and above is the excellent fretwork frieze with heads of cherubs of grey-white Ruskeala marble.

The pulpit dais is composed of coarse-banded grey-black Juven marble. Marble was behind the preacher's back. Three iconostases stand on a low platform made of Shoksha quartzite. The central iconostasis was decorated with 4 columns of green wavy Revnevskaya Jasper. In the 1940s they disappeared. Now stucco columns are created.

THE KAZAN CATHEDRAL
A.N. Voronichin 1801-1811

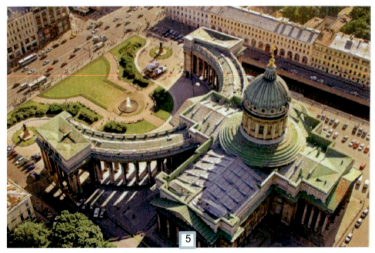

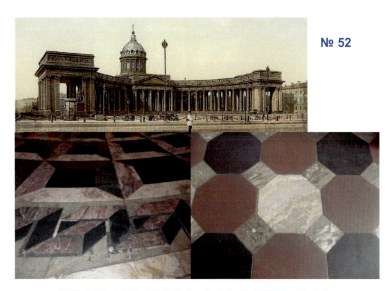

THE KAZAN CATHEDRAL
A.N. Voronichin 1801-1811

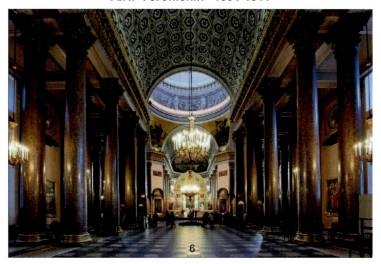

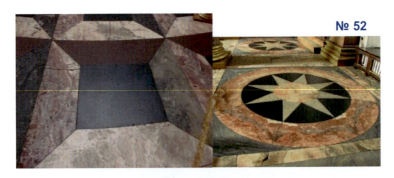

№ 52

THE KAZAN CATHEDRAL
A.N. Voronichin 1801-1811

№ 53. THE MOSCOW MERCHANT BANK (46, Nevskiy Prospect)

It is embellished with natural stone up to the height of 2 lower floors. The stone is the decorative bright-red Valaamsky gneissoid granite, more precisely, it is the granite variety quarried on the Syyskuunsaari Island near the city of Pitkaranta, Ladoga Lake. At the bottom, the facing slabs are perfectly polished, so that the colour and pattern of the stone are clearly seen, but at the top they are only roughly hewn and have a dull lustre and look darker.

THE MOSCOW MERCHANT BANK

№ 53

L. N. Benois
1901-1902

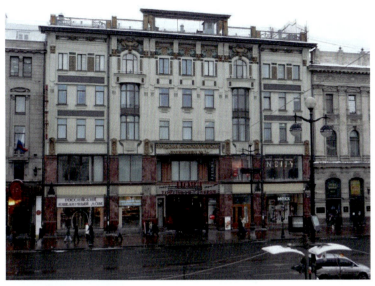

THIS PAVEMENT IS MADE OF FINNISH PINK GRANITE, 2007

№ 54. THE MONUMENT TO KATHERINE THE GREAT (Nevskiy Prospect)

In 1878, the monument to Catherine II was solemnly unveiled in Alexandrinsky Square (Ostrovsky Square today). Its project was fashioned by the artist M. O. Mikeshin and the architects D. I. Grimm and V. A. Shreter took part in the work. The bronze statue of the empress is 4.35 m high and stands on an approximately 10-m pedestal of rather a complex shape—with ledges and steps. The stone-cutters G. A. Balushkin and N. P. Osetrov made the pedestal. It consists of grey fine-grained Serdobolsky granite and grey-pink gneissoid granite from Janisaary Island in the middle of Lake Ladoga.

THE MONUMENT TO CATHERINE II

M. O. Mikeshin, D. I. Grimm, V. A. Shreter 1878

№ 54

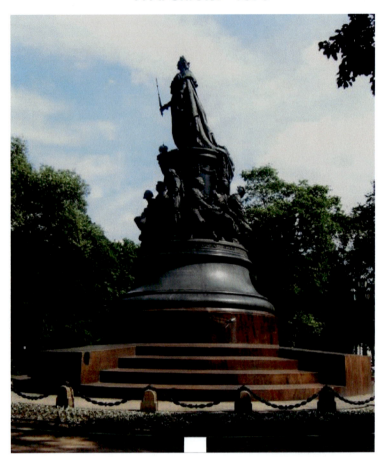

№ 55. MONUMENT TO PETER I

In front of Michael Castle, in the middle of the former Connetable Square, the monument to Peter I had been put up. It was the first equestrian statue in Russia that in 1746 already was cast of bronze by the sculptor Carlo Rastrelli— the father of the well-known architect. The monument was constructed in 1800 and designed by architects F. J. Volkov and A. A. Mikhailov. The pedestal of the monument is faced with rosy and grey Tivdiyskiy (Belogorsky) marbles, Ruskeala and Serdobol granites. Sculptors J. J. Terebenev and V. J. Malinovsky are authors of bronze reliefs.

THE MONUMENT TO PETER I, KLENOVAYA ALLEY

C. Rastrelli

1747, 1800

№ 55

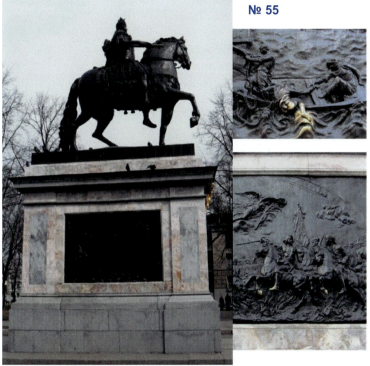

№ 55. MICHAEL'S CASTLE

The Mikhailovsky (Michael's) or Engineers' Castle had been built for Paul I. Some architects designed it after draft drawings by Paul I. None of the four facades repeats the other in architectural form, but at the same time they are united by the stone decoration. On the order of Paul I, who pressed on ending the construction, stone for its decoration was taken from the unfinished third Isaac's cathedral by A. Rinaldi and from the palace of Catherine II that was built at the farm Pella situated at a distance 40 km to the East from Petersburg, on the left bank of the Neva. A socle floor of the Mikhailovsky Castle along the entire perimeter is faced with huge blocks of dark-grey fine-grained Serdobol granite homogeneous in its texture. Rather thick light veins cutting the massive granite are observed in slabs of the socle of the eastern facade.

Flat obelisks with relief compositions of armour situated on both sides of the entrance to the courtyard of Michael's Castle are cut off pale-rosy Belogorsky marble. This entrance is adorned with a rich and massive inner colonnade made of rapakivi granite. Of rapakivi granite are high staircases leading up to four entrances within the courtyard having an octagonal form. A more modest and simple architectural style is characteristic of the facade facing the Summer Garden. Ten pairs of columns of Belogorsky rosy marble buttress the open terrace. The high attic is decorated with marble statuary and bas-reliefs. The stately staircase of Serdobol granite is embellished with the statues of Flora and Heracles. Nowadays they are replaced by bronze copies.

The lower part of the portico is faced with rusticated slabs of grey Ruskeala marble in which insertions of effective Juven marble with a distinct pattern of black-grey banding are put in. Ruskeala marble was used also to line niches of the portico where marble statues were standing earlier. Of the same marble, bases of the columns and pilasters and a cornice of the building are made. A balustrade of balconies was made of rosy Belogorsky marble. A tympanum of the fronton bears the bas-relief "The Glory of Russia is recorded by History in its tables of commandments" carved by the sculptor P. Stadgi of Pudost stone. A wide frieze with letters is of fine deep-crimson Shokhan porphyry (Shoksha quartzite). The Ionic Order columns and pilasters here are cut out of pale-rosy Belogorsky (Tivdiya) marble.

№ 56, 57 THE DWELLING HOUSES OF BARON VON BRESSEN AND VOYEYKOVA

These two dwelling houses represent exquisite models of the Northern Modern style. Light-grey talc–chlorite rock type, better known by the shortened name "talc–chlorite", or soapstone, was used for the design of the lower floors of the building. It is a fine-grained rock consisting of green talc and chlorite, yellow magnesite and a bare handful of white quartz. The rock is rather soft and therefore it was often used for carving. The stone slabs covering the walls of this building have either rocky or smooth surface finishes.

№ 56

THE MICHAEL'S CASTLE
1797-1800

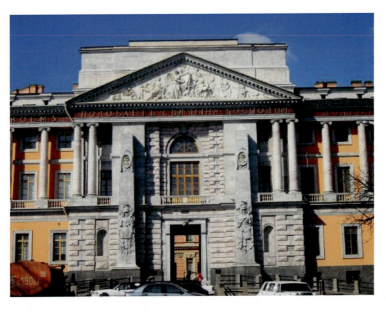

THE MICHAEL'S CASTLE
1797-1800

№ 56
THE MICHAEL'S CASTLE
1797-1800

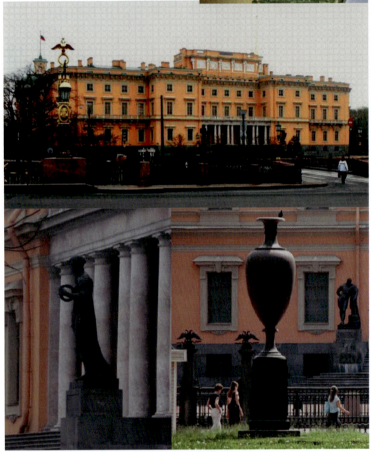

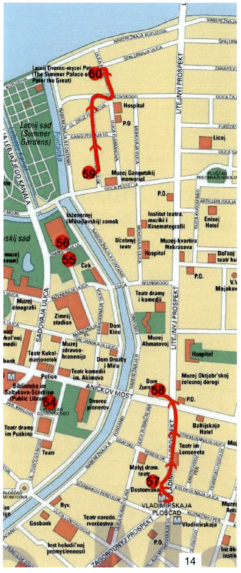

60 – The Bezborodko's Mansion

59 – The Stieglitz Museum

58 – The House of Voyeykova

57 – The House of Bressen

№ 57

A.-K.-V. Schulmann, 1904

19, VLADIMIRSKIY PROSPECT
The Dwelling House of Baron von Bressen

№ 58 THE STIEGLITZ MUSEUM

The Museum comprises a stately edifice built in the style of Italian palaces of the sixteenth century. The low socle is made of large blocks of dark-pink rapakivi granite, and the walls are faced with light-grey German (now Poland) sandstone. The ground floor is decorated with rusticated rocky slabs alternating ones smoothly finished. The doors and huge windows are provided with carved garlands of laurel leaves. The upper storey is clad with sandstone slabs having smooth surfaces, and the windows combined in pairs are adorned with three-quarter columns. The central risalita of the facade is topped with a triangular pediment the tympanum of which carries a high-relief depicting allegories of Painting, Sculpture, Architecture, (Decorative-) Applied Art and History of Art. The main figure of this composition is a Man-Creator. It bears the portrait similarities to M. E. Messmacher.

The pediment is crowned with the sculptural group "Glory" by A. G. Bauman. Standing in niches of the side risolites are statues of a woman with a book and a man holding a large hammer created by A. G. Chizov. The frieze of the museum is decorated with high-relief depictions of gryphons, and with roundels inside of which portraits of

great artists, sculptors and architects are carved, their names being inscribed on the figured slabs. They are written with gold against a blue mosaic background. Massive oaken doors finished with forged bronze lead to the vestibule of the museum. This magnificent room with polished columns made of patterned red rapakivi granite is embellished with polychromatic frescos. Halls of the museum reproduced styles of various epochs in the history of Art. There are Flemish Hall, Halls of Medici, Henry II, Lois XIV and others.

№ 58

72, NEVSKIY PROSPECT
Dwelling House of Voyeyekova
S.I. Minash 1909-1910

16

№ 59

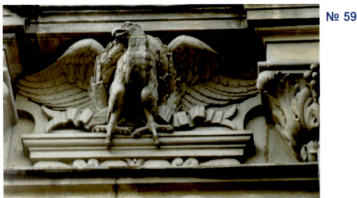

15, SOLYANOI PEREULOK
The Stieglitz Muzeum
M. E. Messmacher 1895-1995

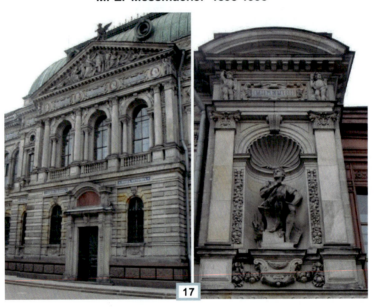

17

№ 60. N. A. KUSHELEV-BEZBORODKO MANSION (3, Gagarinskaya ul.)

Its face of an Italian palazzo in Renaissance style came into existence in 1857–1862 during the reconstruction by the architect E. Ya. Schmidt. The facade of the mansion is all over clad with smart Karelian marbles that are Ruskealsky of two kinds and Tivdian. The high socle is faced with rusticated slabs of the patterned grey-green Ruskeala marble. Another variety of this marble characterized by the more restful, soothing light-grey colouration was used for facing the first and second floors. Pilasters dividing the facade and the windows arranged in pairs are made of the delicate-rosy Tivdiya marble. The bases of the pilasters, cornices extending along the facade and balustrade of the terraces of the second floor are hewn from white marble.

№ 60

3, GAGARINSKAYA STR.
The Mansion of the Count
N. A. Kushelev-Bezborodko

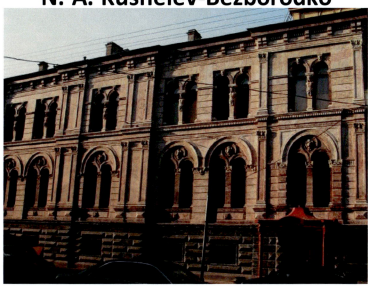

Start point: M "Gor'kovskaya"
Length of route: 0,4 km

61 – The Lidval's House
62 – The main Mosque
63 – The mansion of Kshesinskaya
64 – Two houses of Markov

№ 61 THE I. LIDVAL HOUSE (3, Kamenno-Ostrovskiy prospect)

It is the most prominent example of modern (jugend, art nouveau) style in St. Petersburg architecture. The plinth of the building throughout the perimeter was constructed of large smoothly finished granite slabs. The facing of the ground floor and a half of the first one, as well as architectural details, were hewn of soapstone. The combination of differently finished stone and raised plaster had given rise to the distinct, clear patterns of the facades.

Rich stone portals of doorways are decorated with numerous bas-reliefs depicting scenes of forest life. Here, we can see a wolf and hares, a falcon and long-eared eagle-owl, lizards and fungi—fly-agarics and morels. This animalistic and botanic decor carved of the soapstone is complemented with the ornament of excellently forged, figured balcony railings where sunflowers are in blossom and a gigantic spider stands rooted to the spot in its web.

3, KAMENNO-OSTROVSKIY PROSPECT
The Ida Lidal's House

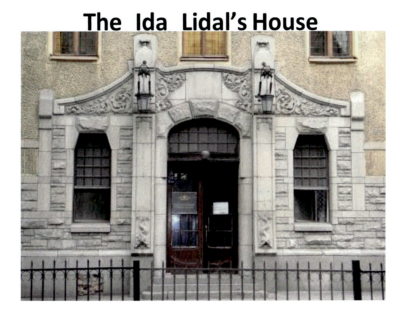

№ 62 THE MAIN MOSQUE

The main St. Petersburg Mosque was designed on the model of the Mausoleum of Tamerlane in Samarkand, but at the same time the architecture of the building bears features of Northern Modern as well. First and foremost, this impression is given by the austere stone facing made of grey Tiurula gneiss and Kovantsaari granite worked up in different techniques and, as a consequence, coloured various tints. Smooth surfaces of the granitic walls over windows are decorated with oriental scrolls. Minor angular arches are also cut in the granite, and two round medallions on the back facade are covered with sets of Arabic letters interwoven in one design resembling an ornament. In such a way, some sayings from the Koran are presented. Very impressive are the graceful tall minarets. They are faced with light-grey granite and entirely decorated with a carved ornament consisting of big rhombs. The splendid decoration of coloured majolica and China complements the austere grey stone.

7, KRONVERKSKIY PROSPECT
The Main Mosque
N. Vasilyev, N. Krichinsky, A. Gogen
1910 - 1914

№ 62

№ 63 THE KSHESINSKAYA`S MANSION

The mansion of the prima-dancer of the former Imperial Mariinsky Theatre M. F. Kshesinskaya is a remarkable sample of Modern style in architecture. Its facades are faced with granites of different colours and light facing bricks. Two kinds of red granite are used for the socle part of the mansion. The very bottom of it is clad with Finnish rapakivi granite. Above it, the out-of-the-common "frieze" more than one metre high runs along the facade. It is the original border, or selvedge made of large, angular, roughly broken blocks of Valaam granite (deposit Syyskuunsaari). The colour of these blocks is rich pink and red. They are carefully fitted together, the joints being blocked up with cement so well that the net of them may be taken for an ornament of a sort. From overhead, the border of the big block mosaic is traced with a strip, or belt of the same granite having a smooth surface. The wall facing the mansion up to the middle of the ground floor is executed of slabs of grey granite of two kinds: dark-grey Serdobolsky granite and light-grey one from Kovantsaari deposit. Predominating are the slabs of Serdobol granite—both polished and finished in such a manner that they have a "rocky" texture. The light-grey granite is used to a far less extent—for the window-sills, outside window frames and consoles of balconies.

1-3 , KRONVERKSKIY PROSPECT
The Mansion of Kshesinskaya
A. Gogen 1906

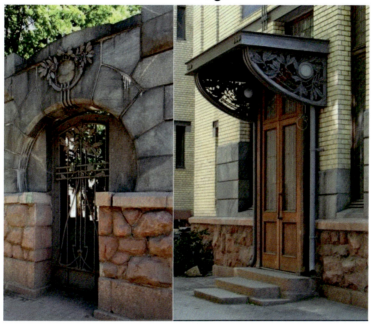

№ 64. TWO DWELLING HOUSES OF K. V. MARKOV

The dwelling houses of K. V. Markov (at 63 and 65, Kamenno-Ostrovsky Prospect) were put up after the design of V. A. Shchuko in 1910–1911 in the neo-Renaissance style. House N 63 is fully faced with dark-grey gneiss from the deposit Tiurula at Ladoga Lake. The rock contains large nodules of crimson-red almandine garnet. The reliefs had been cut by the sculptor V. V. Kuznetsov. At the bottom of the left risalita is a stone mask of a smiling Faun, from the mouth of which water streamed previously. The portal in the central part of the edifice is decorated with rusticated slabs and the pylon is faced with polished gneiss. The stone decoration of House N 65 is far more modest: the bottom of it is faced with a grey rock of Serdobol granite type, and the upper part is built of artificial stone.

65, KAMENNO-OSTROVSKIY PROSPEKT
The Markov's Dwelling House

**V. Shchuko
1910 - 1911**

№ 64

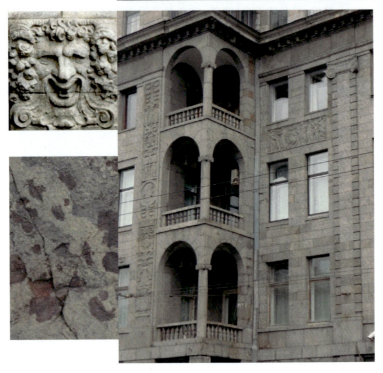

№ 65 THE BUDDHIST TEMPLE

Little known is an excellent temple—the Buddhist Temple and Datzan (religious School) are situated in Primorsky Prospekt, N 91, not far from Metro station "Staraya Derevnya". They were put up by G. V. Baranovsky in 1906–1915 in the style of old Tibetian architecture. Both forms of the temple and its stone decor are unusual for St. Petersburg. It appears as if it were constructed of massive blocks of red granites. The socle of the building, steps and a floor of the portico, pylons are made of rapakivi granite, while the walls are faced with Valaam granite. Blocks of black-grey coarse-grained stone of an uncertain nature frame the windows. It is the most unusual building through St. Petersburg.

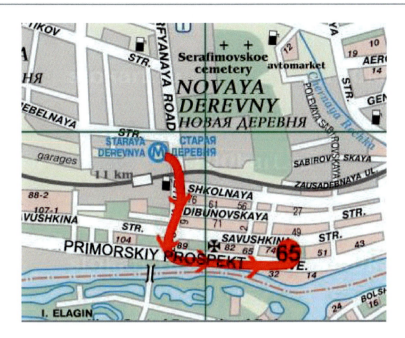

Start point: M "Staraya Derevnya"

Length of route: 0,8 km

65 – The Buddhist Temple

61, PRIMORSKIY PROSPEKT
THE BUDDHIST TEMPLE
G. Baranovsky 1906 - 1915

№ 65

25

The History of St. Petersburg Stones

St. Petersburg Decorative Stones

Andrey Bulakh and Elena Olhovaya

In accordance with the geological situation, igneous, metamorphic and sedimentary rocks used in the decoration of St. Petersburg.

1 Igneous Rocks

In the granites group are known: *Rapakivi granite, Gangut granite, Valaam granite, Antrea granite, Kovantsaari granite, Serdobol granite, Nystadt granite, Garberg granite* from Sweden. They have a different structure. Their color changes from gray to red.

Значительно реже использовались Gabbro, gabbro varieties—Labradorite and Diabases. The last one were valued for tombs and cemetery monuments. The diabase deposit is located on the shore of Lake Onega (Ropruchey near the village of Rybreka).

A unique coarse-grained Asby doleryte (diabase) from Dalarna, Sweden can be seen at the Admiralty Embankment. This dark stone was used for making the bodies of two giant croton vases.

Larvikite (laurvikite). This stone came to St Petersburg from Norway. Its black plates can be seen in the main facade of some building. A fine blue shining is typical for this stone.

Blyberg porphyry. The rock is named after its deposit at Blyberg village in Dalarna, Sweden. The pedestal of a giant pink granite vase in the Summer Gardens is carved of this stone.

2 Metamorphic Rocks

The *Karelian marbles (Ruskeala, Juvensky, Tivdiya)* and *Uralic marbles* were used in St. Petersburg decoration. Rocks have a striped structure and a variety of colors: from snowy-white to black, from light yellow-green to dark green, from pink to red-brown.

European marbles are rarely seen on the facades in St. Petersburg. The marble of the Cararra district and Sicilian marbles were used in building decoration, the interiors and as statuary. In interior decoration though, the color marbles Verde di Levanto, Rosso di Levanto and yellow Siena from Italy, serpentinite marble Verde antico from Greece, and Griotto from France and Belgium were abundantly used for floors, walls, columns, and pylons in mansions, palaces and churches.

Brusninsky and Shokshinsky Proterozoic quartzites were used in the decoration of St. Petersburg. The first were mined on the island of Brusna, near the southwestern shore of Lake Onega. Shokshinsky quartzite or Shokan porphyry was taken from a deposit near the village of Shoksha, located on the western shore of Lake Onega south of the city of Petrozavodsk.

Soapstone (pottery stone) is the talc–chlorite Proterozoic shale from the Nannanlahti deposit on Lake Pielinen in eastern Finland. The color of the stone varies from brownish-yellow to greenish-gray. This soft stone was one of the most popular stones used in the Art Nouveau architecture of St. Petersburg at the end of the nineteenth century. German greyish-lilac slate covers the roof of the Grand Ducal Burial Vault in the Peter and Paul Fortress.

A. Bulakh
Department of Mineralogy, Saint-Petersburg State University, Saint-Petersburg, Russian Federation
e-mail: a.bulakh@spbu.ru

E. Olhovaya (✉)
Scientific and Educational Department, The State Hermitage Museum, Saint-Petersburg, Russian Federation
e-mail: e.olhovaya@mail.ru

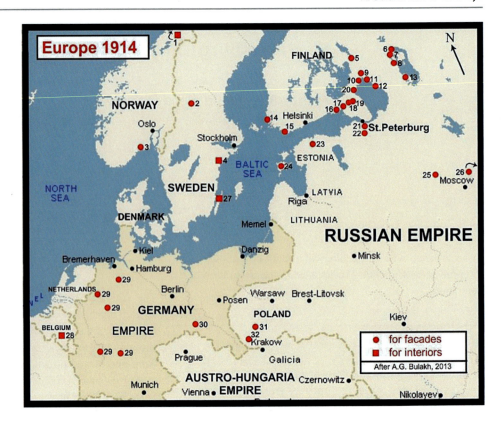

Fig. 1 Deposits of St. Petersburg ornamental stone

3 Sedimentary Rocks

During sedimentary carbonate rocks, the *Putilovo slab limestone* is the most famous. This Ordovician limestone is dolomitized and contains inclusions of green glauconite. Fossil molluscs, cephalopods and sea urchins, are commonly found in this rock. Clay partings lie between limestone bands.

Pudost yellowish limestone known as travertine or tuff. It came in two varieties. The first, a highly porous ornamental tuff found its main use in facing garden grottoes and making of artificial rocks and other park decorations. The second was a much more dense tuff such as the one used for facing the facades of Kazan Cathedral. The tuff quarries near the village of Pudost have long been disused. Dolomitic limestone was found in the nearby village of Paritsa. Contrary to many sources» that stone rather than the Pudost one, was used in the Gatchina Palace.

Kirna stone. The Ordovician light-grey limestone with lilac spots was brought to St Petersburg from the Estland province. Stone was mined near Revel (Tallinn), near the village of Kirna Grange.

Revel, Ezel and Wasalemma marbled limestones. These breeds were delivered to St. Petersburg from the Estonia. Their structure is similar to marble.

Sandstones were imported from Germany and Poland (Fig. 1). They were used for the exterior cladding of buildings (Fig. 2).

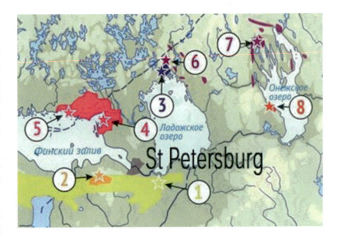

Fig. 2 Places of quarries near St. Petersburg (Popov 2012). 1–Putilovo slab limestone; 2–Pudost tufa stone; 3–Serdobol granite; 4, 5–Rapakivi granite; 6–Ruskeala marble; 7–Tivdia marble, Black schist; 8–Shoksha quartzite

Symbols:

1	Marble pink[a], Є-S	
2	Blyberg porphyry, PR	
2	Garberg granite, PR	
2	Åsby diabas (dolerite), PR	
3	Larvikite, P	
4	Marbles green and other[a], PR	
5	Soap stone, PR	
6, 7, 9, 11	Marble, PR	
8	Black schist, PR	
10, 19	Granite grey, PR	
13	Quartzite, PR	
14	Granite grey, PR	
12, 15–18, 19	Granite pink, AR-PR	
20	Almandine gneiss, PR	

(continued)

21	Platy limestone, O
22	Tufa, Q
23, 27	Limestone, Marbled limestone[a], O
25	Limestone, C
26, 28	Marble, Marble black[a], C
29–31	Colored sandstones, T–K
32	Marble, J
–	Marbles from France, Italy, Norway, Poland, Spain, Germany[a]

[a] Only in interiors

Reference

Bulakh AG (2014) Ornamental stone in the history of St. Petersburg architecture. Towards International recognition of building and ornamental stones. Geological Society Special Publication, London, p 2014

The Bronze Horseman and Thunder Stone: History and Nowadays

Georgy Popov, Mihail Ivanov, and Svetlana Janson

2022 marks the 350th anniversary of the birth of Emperor Peter the Great (1672–1725), the founder of St. Petersburg, who "opened a window to Europe". The first and most famous monument to Peter I was erected in 1782 in front of the Senate building in St. Petersburg in the Senate Square (Fig. 1).

Lots of books have been written about this statue. But there are some little-known facts about the history of the monument. The pedestal made of enormous glacial boulder known as the Thunder Stone deserves special attention.

Our contemporaries, speaking about the Bronze Horseman, emphasize that this monument is an outstanding achievement of Russian and world art, a vivid example of the triumph of educational ideas and impersonation of the transformations that completely changed the life of the Russian Empire.

1 History of the Equestrian Statue (The Bronze Horseman)

In 1762 Catherine II ascended the Russian throne. The Senate proposed to erect a monument to memorialize the empress. But the young empress decided that she would do wiser, immortalizing the memory not of herself, but of Peter I. She wanted to represent herself as Peter's rightful heiress.

G. Popov (✉)
Research Department, Pangea LLC, Saint Petersburg, Russia
e-mail: pangea@mail.ru

M. Ivanov
Department of Mineralogy, Crystallography and Petrography, Saint-Petersburg Mining University, Saint-Petersburg, Russian Federation
e-mail: Ivanov_MA@pers.spmi.ru

S. Janson
Research Center, Saint-Petersburg State University, Saint-Petersburg, Russian Federation
e-mail: s.janson@spbu.ru

In 1765, Catherine ordered the Russian ambassador in Paris to find an experienced and talented sculptor. Several French sculptors were considered as candidates for the role of the creator of the monument to Peter the Great. However, Catherine chose Falconet. In 1766 Falconet signed a contract for an "equestrian statue of colossal size" in St. Petersburg. Accompanied by his apprentice Marie-Anne Collot he set off from Paris to Petersburg.

Catherine's counselors recommended Falconet just to copy a composition of one of the equestrian monuments to a king or commander, installed by that time in European countries. There was a number of examples: the statue of the Roman emperor Marcus Aurelius in Rome; the statue of the Italian condottiere Bartolomeo Colleoni in Venice; the statue of the Elector of Brandenburg Friedrich Wilhelm in Berlin; the statue of the King of France Louis XIV in Paris and other outstanding works.

Members of the Russian Academy of Sciences advised to decorate the pedestal of the statue with bas-reliefs glorifying the great deeds of Peter I and to place the statues of vices that Peter had deposed (ignorance, superstition, laziness, deception) in the corners or to decorate the pedestal with the statues of heroic spirit, courage, victory and immortal glory.

As for the location of the monument there were several opinions: in the Palace Square in front of the Winter Palace, in front of the building of Kunstkamera or on the bank of the River Neva.

Falconet required unsurpassed courage and self-confidence in order to withdraw from the age-old traditions of depicting rulers in military armor sitting calmly in identical poses on hasteless walking horses surrounded by allegorical figures.

Falconet was supposed to make the monument as simple as possible, depicting not so much the emperor-commander, but the creator, legislator and benefactor of the country. The clothes of the future rider caused serious thoughts. He thought about the European costume, fashionable at that time, and the Roman toga, and military armor, and the

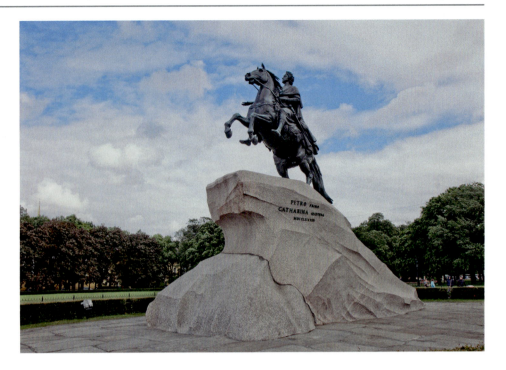

Fig. 1 Monument to Peter I (The Bronze Horseman). Sculptor Étienne Falconet. Photo by Georgy Popov, 2016

antique Russian attire. The sculptor decided to choose the classical heroic clothing.

The serpent as an important element of the composition appeared as a result of long cogitations. Falconet designed the serpent not only as a vivid artistic image, an allegory of envy, treachery and betrayal, which Peter overcame, but also as an element that improves the statue's balance.

Having conformed the composition of the future monument, Falconet began with its "small model" (Fig. 2). A year later it was finished and in 1768 a life-size "large model" of the bronze statue was started.

Falconet put all his soul into this work. He instructed to make a hill in the size of the future pedestal and forced a rider on horseback to jump on it. Having studied the movement of the horse, he turned to studying the details. He examined, sculpted and drew from all sides each part of the horse frozen for a moment in its movement in order to remember and repeat the shape of the muscles and ligaments. Unfortunately, the camera, which could help the sculptor in his work, was invented only 60 years later.

The sculptor chose the best stallions from the court stable —they were Brilliant and Caprice. Afanasy Telezhnikov was one of the horsemen. English ambassador Lord Cathcard being an expert on horses advised the sculptor.

It turned out to be a significant problem to mold the head of the emperor. Falconet entrusted this task to his apprentice Marie-Anne Collot, and she brilliantly coped with it.

In July 1769, a life-size clay model of the future monument was completed. Falconet invited the artists of the Academy of Arts to discuss possible shortcomings of the model, after that the model was exhibited for two weeks "for a national sight." At first there were many critical remarks, but later rapturous reviews predominated.

French diplomat Marie de Corberon wrote that this statue was the best of all in its kind, and it would make forget all the ridicule. One English traveler remarked that the monument perfectly expressed the character not only of the emperor, but also of the Russian nation. Falconet's teacher Jean-Baptiste Lemoyne wrote that what he saw had exceeded all his expectations. The philosopher and writer Denis Diderot enthusiastically declared that "… the beautiful Centaur composed of the hero and his horse is a fragment of a great epic poem." The Empress was pleased with the result of the work: "This horse gallops straight towards the posterity, who will appreciate its perfection better than contemporaries."

Technology for casting small bronze statuettes has been known since the 3rd millennium BC. First, a model of the future statuette (for example, from wood) was made. Then the model was covered with clay. After hardening, this clay shell was cut into two halves, carefully separated, the model was removed, and the halves were again connected and wrapped with wire. A hole was drilled from above in the thus obtained form and molten bronze was poured inside. All that remained was to wait until the bronze hardened, remove the mold and admire the resulting statuette.

In order to save expensive metal, craftsmen learned how to make hollow statuettes. Falconet acted according the same principle. The result was supposed to be an eight-ton five-meter colossus. The process of making the Bronze Horseman sculpture consisted of several stages.

Fig. 2 Drawing of the model of the monument to Peter I, made by Anton Losenko in the workshop of Falconet, 1770. Museum of Nancy (France)

(1) Falcone made a life-size model of the future sculpture.
(2) The model was covered with a thick layer of soft gypsum. Beforehand, the model was covered with fat on all sides so that the gypsum would not stick to it.
(3) After this the gypsum mold hardened, it was cut into pieces, the pieces were numbered and removed.
(4) A layer of soft wax was applied on the inner surface of each removed piece. Thickness of the wax layer was exactly the same as of the bronze layer that was planned in this place. Later, the wax was melted and bronze took its place. Falconet understood that in order to ensure the balance of the statue, its center of gravity should be made as low as possible. For this, the walls of the statue from below should be thick, heavy, and from above—very thin, no more than 7.5 mm. With this in mind, the wax of different thicknesses was applied to the mold.
(5) Pieces of the gypsum form, covered with wax from the inside, were reassembled and reinforced from the inside with a steel frame.
(6) The hollow was filled with gypsum and grated brick powder to fix the wax layer.
(7) Holes were drilled in the gypsum mold in the places where it was supposed to pour bronze and long wax pivots were attached. Later, having melted inside the clay mass, each wax pivot would turn into a tubule—a sprue. The sprues were combined from above into five large pipes. Special tubes were used to drain the molten wax and to release the air as the mold was filled with bronze. All of these numerous wax pivots (future tubules) resembled a branchy tree.
(8) The construction was carefully covered with a thick layer of soft clay and wrapped around with iron strips so that the bronze would not tear it apart with its weight.
(9) A huge fire was made around this "armored" mold, which had been burning for eight days, in the result all the wax (1640 kg) flowed out, making room for bronze. At the same time, the mold hardened and became even stronger. The wax pivots melted and turned into tubules.
(10) The hollows filled earlier with the wax were poured with the molten bronze through the formed tubules. During this complex procedure, an accident happened: the bronze partially leaked out onto the floor, and the workshop nearly burnt down.
(11) After the bronze had cooled down, all protective devices were dismantled. The former tubules, filled with bronze, were sawed off, and the places where they were attached to the statue were carefully polished.
(12) You remember that the bronze shell was filled with powder. A special hatchway was cut in the horse croup in order to remove this filler (gypsum and brick). Now it is invisible from the outside. The

hatchway is opened and supervisors get inside to monitor the condition of the steel frame and the bronze inner surface.

(13) The last step was to "heal" the cracks and cavities with bronze, polish the finished sculpture and cover with a protective layer of patina.

Upon completion of the work, in memory of these events, the sculptor left an inscription on the fold of Peter I's cloak: "Moulded and casted by Etienne Falconet, a Parisian of 1778" (Fig. 3).

The inscription on the pedestal also has its own history. Diderot offered a rather verbose version: "Catherine II dedicated the monument to Peter the Great. The resurrected valor brought this huge rock with colossal effort and threw it under the hero's feet." Falconet insisted on a shorter inscription: "Catherine II erected to Peter the First." And Catherine herself, removing the word "erected", gave the descendants a laconic motto with deep meaning: "Catherine the Second to Peter the First."

2 Thunder Stone

The pedestal of the Bronze Horseman is also a piece of art, the integral part of the monument to Peter the Great, like the sculpture of the emperor itself. Everything is essential in this stone: its size, proportions, shape, nature of processing, and, of course, its fascinating history.

Falconet, even while still in Paris, before leaving for St. Petersburg, had decided that a rock would be the pedestal of the monument to Peter—a symbol of the difficulties that he overcame.

Now the Thunder Stone under the Bronze Horseman seems absolutely natural—how could it be otherwise? But in those days, any pedestal, if it was not rectangular, looked like an innovation that contradicted established tastes. Doubtful was a possibility to find a large stone in the vicinity of St. Petersburg, and even if it could have been found, the possibility of its moving to St. Petersburg was rather problematic.

Catherine II, being a progressive-minded personality, liked the idea of a "wild rock". It was at the beginning of her reign that the magnificent baroque style changed to classicism. This meant a transition from decorative excesses to simple images and natural materials. She agreed that an exceptionally huge "wild stone!" should serve as the foundation for the monument to the Russian hero.

Initially, it was supposed to assemble the pedestal from several large stones. Falconet never dreamed of a whole pedestal: "The monolithic stone was far from my desires … I thought that this base would be built from well-fitted fragments." In one of his drawings he depicted twelve stones, fastened with iron or copper hooks.

An Instruction was drawn up for expeditions aimed at searching for suitable stones. Having found a stone of the required size, it was necessary to ensure its position, make measurements, clarify the distance from it to the road and to the waterways, take samples of the rock from its north and south sides and immediately submit all this to the Office of Buildings.

At the end of the summer of 1768, several stones were discovered that were close in size to what was required.

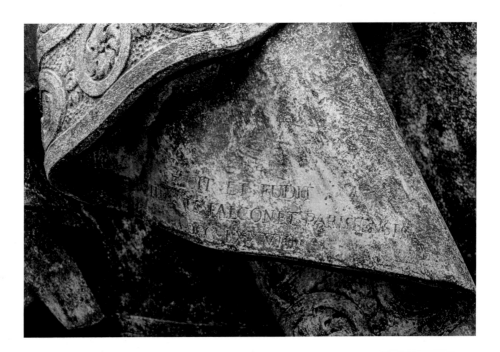

Fig. 3 Falcone's autograph on a pedestal. Photo by Georgy Popov, 2021

Blacksmith Sergei Vasiliev found five stones 7–9 m long on the Narva road. Andrey Pilyugin discovered 27 large stones on the coast of the Gulf of Finland and a few more near Gatchina and Oranienbaum (Fig. 4). The largest stone was found in Kronstadt (10 m).

Some of the found stones turned out to be fractured, other stones were of suitable texture, but completely different in shades and patterns, and would hardly look good together. And the "desired size" of the base, according to the project, should have been about 10 m in length, 4.6 m in width and 5 m in height.

In 1768, the peasant Semyon Vishnyakov reported about the "stone of a terrible size as if nature itself granted it as a ready-made pedestal" (Fig. 5).

The Thunder Stone made a strong impression on Falconet. He was enchanted by the granite monolith, imagining it as the pedestal. In front of him was the "wild rock" he had dreamed of. In a letter to the Duke d'Aiguillon Falconet described the finding as follows: "This is a boulder of beautiful and extremely hard granite, with very curious crystalline veins. They deserve a place in your natural history collection. This stone will give character to the monument and in this respect it can be called the exclusive one".

The order to dig the future pedestal from all sides was issued immediately.

The size of the boulder was amazing: "The length of the stone was 13.2 m, width 6.6 m, and height 8.1 m. It lay in the ground at a depth of 4.5 m. The upper and lower parts were almost flat and overgrown on all sides with moss two inches thick. Its weight was over 1600 tons. The very idea of transporting it to another place was terrifying (Fig. 6).

The Thunder Stone gained its name from a local legend that thunder had split the rock. Moreover, several gods of thunder are known in the Finno-Ugric pantheon and this stone was named in honor of one of them. Later legends say that Peter the Great himself loved to look around the surroundings from this "stone mountain".

The fate of the future pedestal was decided by Catherine's decree. She ordered to deliver the stone to Petersburg immediately. Anyone who came up with a mechanism for moving the giant block was promised 7000 rubles—a considerable reward at that time. While proposals were being received at the Office of Buildings, grandiose work started around the Stone: it was excavated from all sides, a future road was marked on the ground (bypassing swamps and hills), and barracks for 400 workers were built. Having made the necessary measurements, Falconet came to the conclusion that the stone should be turned on its side: in this position, it was more consistent with the clay model of the pedestal. The stonecutters began to flatten the side, and engineer Marinos Carburis ordered to prepare the levers and jacks.

The process of lifting such enormous stone was a very complicated technical procedure and it required special devices, such as a grating which consisted of four rows of logs laid crosswise. Also, levers were made to lift the stone. Each lever was made of three logs connected to each other. In total there were 12 of such levers. To add more power to the levers, four winches were installed to tighten the ropes (Fig. 7). The latter were threaded into iron rings poured into the stone with lead. The grating was covered with hay and moss so that the stone would not break from falling or split the logs.

Fig. 4 Glacial boulder near the village 4 Globitsy. Photo by Georgy Popov, 2022

Fig. 5 Thunder Stone found at Lakhta. Engraving by Jacob van der Schley after Yuri Felten's drawing, 1770. Source: gmgs.ru

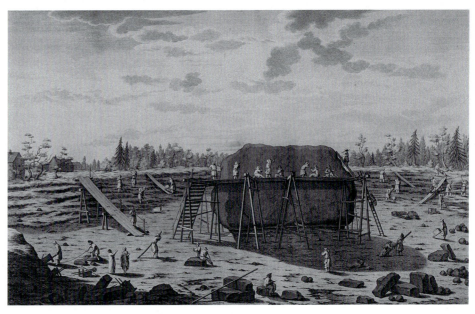

Fig. 6 Processing of the Thunder Stone. Engraving by Jacob van der Schley after Yuri Felten's drawing, 1770. Source: gmgs.ru

In March, the stone was placed on the grating. It stayed in place all summer, since the soft ground at this time of year did not allow continue the work. In the found stone there was a crack filled with earth. Five large birches grew from it. After the Thunder Stone was cleaned of the outer fractured parts and re-measured, its length was not enough to match the model of pedestal. According to rough estimates, the transported weight in total was about 1200 tons.

All parts of the stone were secured for transportation. This can be clearly seen in the paintings of Louis Blaramberg, who was invited by Catherine II specifically to make sketches of the transportation of the stone (Fig. 8).

Falconet wanted to shape the stone at the very site where it had been found, but Catherine II ordered all the processing of the stone to be done in the city in order to make "more fuss in Europe."

Due to insufficient size of the stone it was decided to enlarge the central block from the front and at back with two pieces cutting them with the help of a special curve (Fig. 9).

The Office of Buildings received many versions of the "machine" (on logs, iron rollers, etc.), but none of the proposed seemed worthy of attention.

All these proposals were thoroughly pondered and discussed. Carburis decided to transport the stone on hard balls

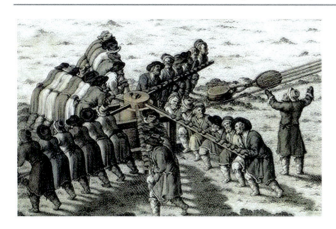

Fig. 7 Transportation of the Thunder Stone. Engraving by Jacob van der Schley after Yuri Felten's drawing, 1770. Fragment. Source: gmgs.ru

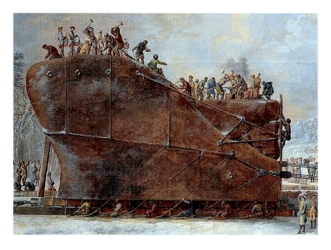

Fig. 8 Transportation of the Thunder Stone in winter. Louis Blaramberg, 1777. Fragment. Source: hermitagemuseum.org © The State Hermitage Museum, St. Petersburg, 2023

Fig. 9 The pedestal consists of several parts carefully connected together. Scheme by Georgy Popov, 2017

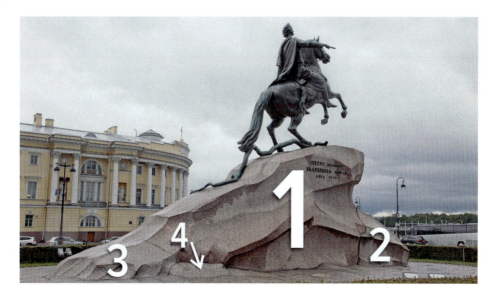

that touch a flat plane only at one point. For visual understanding, he created a model that could carry a tenth of the weight of the rock. After a successful test, the production of a much larger machine began.

The outer ring of the "ball machine" moved relatively to the inner one with minimal friction, contacting only the balls. The role of the rings was played by two huge logs laid on top of each other. In these logs the grooves were hollowed out and covered with copper. Copper balls rolled along the grooves between the logs. In the result it was a gigantic sleigh to move the stone on. When moving the upper logs had to remain stationary under the stone and the lower ones had to be taken out from behind and shifted forward (Fig. 10).

Seven small sledges followed the main one on each side to prevent the balls from stopping and touching the other. People on these sledges held the balls with iron poles. The track, along which the stone was dragged, skirted swamps, river floods, hillocks and other obstacles. The engineers built the track in the form of a broken line. This track was strengthened with piles, brushwood, silt, and rubble. When the stone was reaching the turn, the load was lifted with jacks, the rails were taken out and the rotation machine was put underneath. It consisted of two flat oak wheels lying one on top of the other with grooves and balls.

The progress of the first day of moving the stone was 42 m. 48 stonecutters continuously shaped this enormous rock. There was a smithy working at the top of the stone to provide the necessary iron parts. Other gadgets and a sentry were tied to the back of the sleigh. Thus, the stone was delivered to the coast of the Gulf of Finland.

The next step was to ship the stone. For this purpose a dam 366 m high and 15 m long was made near the coast. It

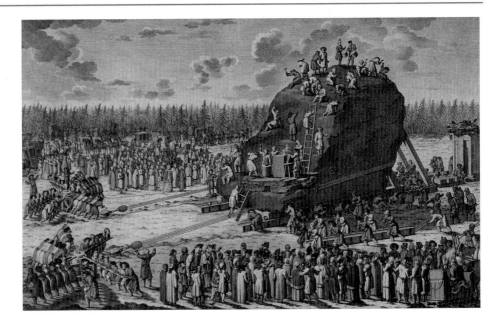

Fig. 10 Transportation of the Thunder Stone. Engraving by Jacob van der Schley after Yuri Felten's drawing, 1770. Source: gmgs.ru

consisted of many piles driven into the bottom of the gulf and reaching the water surface. The piles were intertwined with branches and connected with iron brackets. Transverse logs were attached to the piles and served as a path for the rock. The stone was placed on this dam before its shipping along the river Neva to Petersburg.

Supervision of the shipping the Thunder Stone was entrusted to Admiral S. Mordvinov. The experienced galley master G. Korchebnikov constructed a special barge. It was a vessel 55 m long, 18 m wide and 5 m high which consisted of two vessels with a solid deck installed in the middle. The cargo had to be placed so that the barge did not touch the bottom of the river, the depth of which at the mouth was only 2.4 m. In order not to shake the vessel and not drop the stone into the water during loading, the barge was flooded near the dam. One board was dismantled and, with the help of winches, the stone was dragged to the designated place. After that, the board was sealed and water pumped out. The stone and platform were attached with strong ropes to two vessels and transported by water to the Senate pier (Fig. 11).

The route of the Thunder Stone is shown in Fig. 12.

On September 22, the day of the coronation of the Empress, the rock arrived safely at the place of its destination. In the evening, a brilliant firework in honor of the successful transportation of the stone illuminated the city.

Unloading the stone caused a lot of trouble. The Neva River in this place is very deep and the vessel could not be lowered to the bottom. So, piles were driven in six rows along the shore so that the vessel, plunging into the water, could lean on them. Six sturdy trees were attached to one side of the vessel. The trees lay across and were tied to a nearby loaded ship. This maneuver made it possible to distribute the weight of the stone evenly. The unloading of the monolith took place in a solemn atmosphere in the presence of residents of St. Petersburg (Fig. 13).

Catherine the Great issued a medal (Fig. 14) to commemorate this event. Small fragments of the granite stone were inserted into rings, earrings and other jewelry in memory of this event. Some of these pieces survived up to nowadays.

Before the installation of the equestrian statue, the stone underwent significant shaping at its present place. The Thunder Stone was reduced to the size required by the model of the monument. Firstly, it concerned the height of the pedestal. Instead of the original 6.7 m, it was reduced to 5.2 m. Further, the stone was narrowed from 6.4 m to 3.4 m (Fig. 15). According to the model, the length turned out to be insufficient: 11 m instead of 15 m. Therefore, two additional blocks had to be attached to the monolith.

In this picture, one can see how much the sculpture would be lost against the background of a huge untreated pedestal. Bringing to one scale was carried out according the size of the human figures. The key idea of reducing the rock became the motto: do not make a statue for a pedestal, but make a pedestal for a statue.

But at this final stage of the work and to the casting of the sculpture, a misunderstanding between Falconet and the empress turned into a serious conflict and in September 1778 he was forced to leave Russia forever, without waiting for the opening of the monument. The completion of the work was entrusted to Yuri Felten, academician, chief architect of the Office of Her Imperial Majesty's buildings and gardens. It remained to finish the pedestal, install the sculpture on it, pave a platform around the monument and enclose it with a grating.

The opening of the monument was scheduled for August 7, 1782. This event took place a hundred years after Peter I

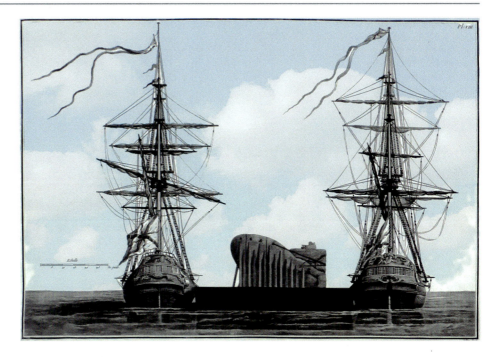

Fig. 11 Transportation of the Thunder Stone by water. Engraving from the book by Marin Karburi "Monument erected to the glory of Peter the Great …", 1777

Fig. 12 The route of the Thunder stone from Lakhta to the Senate square by water and land. Picture from the book by Georgy Ivanov "Thunder Stone", 1994

ascended the Russian throne. The monument was surrounded by a linen fence. Spectators filled the square. People watched from the windows and from the roofs of the surrounding houses.

The Inauguration was accompanied by a military parade. The number of troops engaged in the parade was about 15,000. Her Imperial Majesty arrived by boat and ascended onto the balcony of the Senate. After the signal, the canvas fell to the ground, and the monument in honor of the Great Monarch appeared to the audience. Drums sounded, the troops lowered the banners, volleys of cannons thundered from the fortress, the Admiralty, and the imperial yachts (Fig. 16). The audience expressed its admiration.

Envy and slander in relation to its creator subsided after the opening of the monument. Falconet was praised and his equestrian statue to Peter the Great gained worldwide fame. In the past and today, Falconet's immortal creation continues to inspire admiration. It was hardly clear to the first viewers that they were looking at one of the greatest sculptures of the eighteenth century. The crowd did not realize that in front of it was the most important, eternal, the most popular symbol of the city.

3 Modern Studies

In 2016, a team of St. Petersburg geologists carried out the first geological study of the Thunder Stone. In addition to observations, sketches, photography, measurements of radioactivity, smallest mineral samples were taken. There was enough material to carry out a number of microscopic and microanalytical studies. Subsequently, they examined the Thunder-stone and the Petrovsky pond (a pit formed after the excavation of the Thunder-stone) in Olgino.

A detailed visual examination of the Bronze Horseman pedestal showed that it is composed of light pink, coarse-grained, massive granite (Fig. 17). According to its textural and structural features, the Thunder Stone granite is not a typical rapakivi granite. The main minerals are pink microcline, plagioclase and quartz. Black hornblende, dark and light micas are present in small quantities. In total, 20 minerals have been identified.

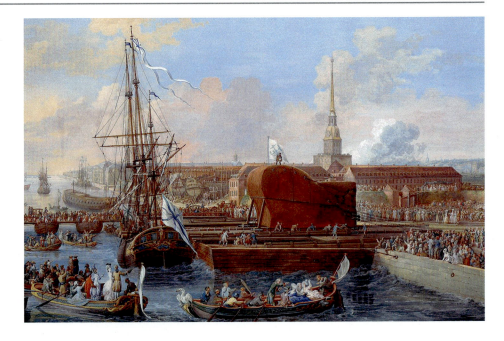

Fig. 13 Unloading the Thunder Stone at the Senate square in Saint-Petersburg. Louis Blaramberg, 1777. Fragment. Source: hermitagemuseum.org © The State Hermitage Museum, St. Petersburg, 2023

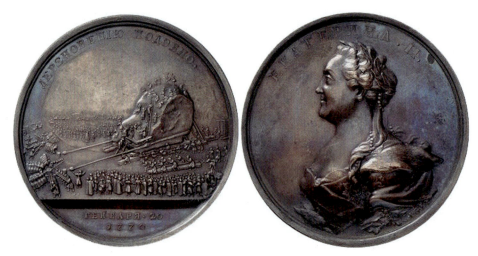

Fig. 14 Medal "Close to Daring" minted to commemorate the unique transportation of the Thunder Stone. Source: lahta-olgino.ru

Pegmatite veins and segregations were found in the Thunder Stone granite (Fig. 18). A veined pegmatite body 40–45 cm thick is located at the front of the central block of the pedestal. Pegmatites form an aggregate of large crystals of microcline and oligoclase up to 20 cm long, oriented perpendicular to the contacts with granite. They contain crystals of quartz, biotite and muscovite, topaz, zircon, monazite.

Topaz grains are translucent, fractured without crystallographic faces. The grain size is about 1.5 mm. The color of the grains is yellow, light green, less often colorless and bluish (Fig. 19).

Gamma activity of the Thunder stone and granite from the paving around the monument were measured. It turned out that the gamma activity of the pedestal fluctuates in the range of 46–63 μR/h, while the granite of paving is characterized by values in the range of 31–38 μR/h.

It has been established that the Bronze Horseman's pedestal consists of four different-sized fragments. Previously, they undoubtedly formed a single boulder (Thunder-stone). How much rock was cut off at Falconet's instructions from the original Thunder Stone? Basing on three-dimensional model of the pedestal its mass was calculated. The mass of the visible part of the pedestal is about five hundred tons. The mass of the original Thunder Stone was about one

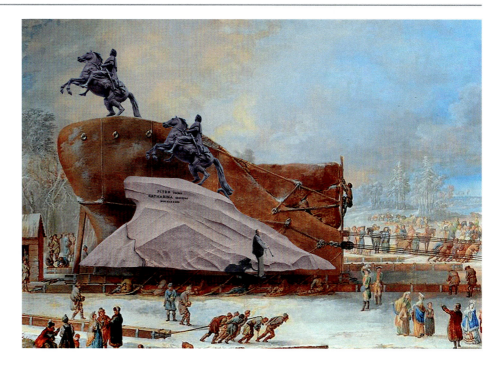

Fig. 15 Scheme by Georgy Popov. Using: Transportation of the Thunder Stone in winter. Louis Blaramberg, 1777. Source: hermitagemuseum.org © The State Hermitage Museum, St. Petersburg, 2023

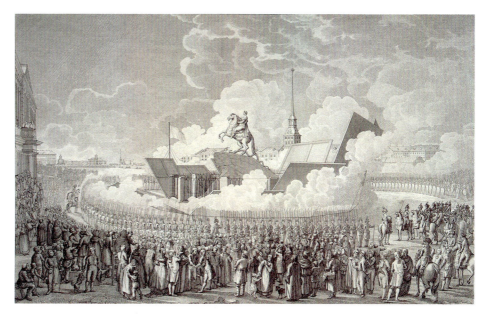

Fig. 16 Inauguration of the Monument to Peter the Great. Engraving by Alexander Melnikov of the drawing by Alexei Davydov, 1782. Source: hermitagemuseum.org © The State Hermitage Museum, St. Petersburg, 2023

Fig. 17 Thunder Stone granite. Size of a large crystal 1.3 sm. Photo by Georgy Popov, 2016

Fig. 19 Topaz in the Thunder Stone pegmatite. The long side is 2sm. Photo by Svetlana Janson, 2018

thousand seven hundred tons. Thus, 1200 tons of Thunder Stone were cut off in the course of processing.

References

Bakmeister IG (1783) Nachricht von der metallenen Bildsäule Peters des Grossen
Bulakh AG (2009) Stone decoration of Saint Petersburg. M. Tsentrpoligraph (in Russian)
Carburi M (1777) Monument élevé à la gloire de Pierre-Le-Grand. Paris
Correspondence of Empress Catherine II with Falconet. Introductory article by A. A. Polovtsov. St. Petersburg: Collection of the Imperial Russian Historical Society, volume 17, 1876 (in Russian)
Ivanov GI (1994) Thunder Stone. SPb. (in Russian)
Ivanovsky AD (1872) Conversations about Peter the Great and his associates. SPb (in Russian)
Kaganovich AL (1982) Bronze horseman. The history of the creation of the monument (in Russian)
Sobko NP (1896–1918) Russian biographical dictionary in 25 volumes. In: Polovtsov AA (ed) under the supervision of the chairman of the Imperial Russian Historical Society. The article about Falconet by Sobko NP, SPb: Publ. I. N. Skorokhodova. (in Russian)
Zembnitsky J (1834) On the use of Granite in St. Petersburg. SPb (in Russian)

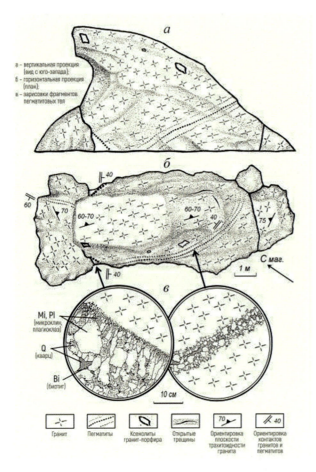

Fig. 18 Geological documentation of the Thunder Stone. Drawing by Mihail Ivanov, 2017

The Alexander Column—From Finnish Friedrichsham to Palace Square in St. Petersburg

Nikolay Filippov and Svetlana Tochanskaya

On August 30, 1834, in accordance with the project of the great architect Auguste Montferrand, in the very center of Palace Square, a column of pink coarse-grained rapakivi granite with a statue on its top 47.5 m high was installed—a monument to Alexander I who won the war of 1812–1814 with Napoleon. The monument consists of a pedestal (2.8 m) and a column scape (25.6 m).

Originally architect Montferrand considered as material a more durable gray serdobol fine-grained granite, mined in the area of Serdobyl (now Sortavala). He intended to make pedestal out of this granite, but, despite intensive searches, he did not find stone without cracks of the required dimensions.

Master Montferrand found the necessary monolith in the Pyuterlak quarry in the Vyborg province (modern Pyuterlahti village, Virolahti community, Finland) while extracting columns for St. Isaac's Cathedral. It was a block of rock without cracks, up to 35 m in length and up to 7 m thick. It was left untouched for any case, and when the issue about setting up the monument to Alexander I, architect Montferrand, having in mind this particular stone, drafted the monument in the form of a column from a single piece of granite— "a block of red granite, without flaws, capable of obtaining the best polish, not inferior in anything to the best granite of the East, is located in the Püterlax quarry, near Friedrichsgam, in the very place from which they were extracted 48 granite columns of St. Isaac's Cathedral" (Montferrand 1836). Pyuterlak granite, especially polished, is very beautiful, however, due to its coarse grain, it is easily destroyed under the influence of atmospheric influences.

1 Mining and Pre-treatment of Granite Monolith

Mining and pre-treatment in the Pyuterlax quarry were carried out in 1830–1832 (Fig. 1). These works were performed via the method of Mr. S. K. Sukhanov with supervision by masters Mr. S. V. Kolodkin and Mr. V. A. Yakovlev.

The method of extracting stones was approximately the same (Fig. 2). Previously, the rock was cleaned from the covering layer to make sure that there were no cracks in it, then the front part of the granite mass was leveled to the required height and cuts were made at the ends of the granite mass. They were made by drilling in a row of such numerous wells that they almost connected with each other. While one group of workers worked on slots in the ends of the massif, others were engaged in carving the stone below to prepare its fall. On the upper part of the array, a furrow 12 cm wide and 30 cm deep was punched in its entire length.

After that, from its bottom, wells were drilled manually through the entire of the massif at a distance of 25–30 cm from each other. Then, iron wedges 45 cm long were laid in the furrow along the entire length, and between them and the edge of the stone; these iron sheets are for better advancement of the wedges and to protect the edge of the stone from breakage.

The workers were set so that there were two–three wedges in front of each of them. With a signal all workers hit them at the same time, and soon cracks became visible at the ends of the massif, which gradually, slowly increasing, separated the stone from the general rock mass. These fractures did not deviate from the direction indicated by numerous wells.

The stone was finally split off and overturned by levers and capstans onto a prepared bed of branches thrown over an inclined log grillage with a layer of 3.6 m. Capstan (from the French cabestan) is a mechanism for moving cargo, consisting of a vertically mounted shaft, on which, during rotation, a chain or rope is wound, attached at the other end

N. Filippov
Research Department, Russian Geological Research Institute (VSEGEI), Saint Petersburg, Russian Federation
e-mail: nikolay.philippov@vsegei.ru

S. Tochanskaya (✉)
Research Department, St. Petersburg State Geological Unitary Enterprise "Mineral", Saint Petersburg, Russian Federation
e-mail: svetlana@helcom.ru

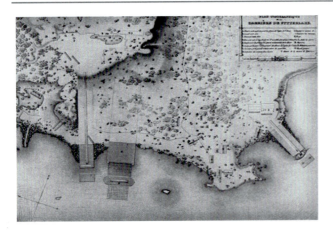

Fig. 1 Plan of a quarry in Pyuterlaks. Engraving by Schreiber after a drawing by Montferrand (1836)

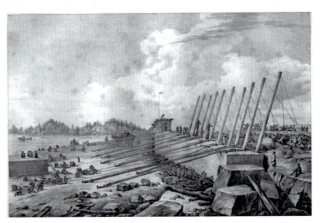

Fig. 3 Overturning the array for the column bar in a quarry (Montferrand 1836)

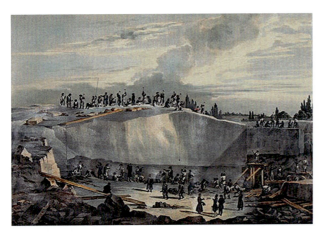

Fig. 2 Type of work in the quarry. Lithograph by Bichebois and Watteau after a drawing by Montferrand (1836)

to the transported cargo, such as an anchor. The capstan is a vertical gate and is a type of winch with a drum mounted on a vertical shaft. The total weight of the stone was about 4000 tons. In total, 10 birch levers with a length of 10.5 m and 2 iron (shorter ones were installed) ropes were fixed at their ends, which the workers pulled. In addition, 9 capstans with chain hoists were installed, the blocks of which were firmly fixed to iron pins embedded in the upper surface of the array (Fig. 3). The stone was turned over in 7 min, while the work on its extraction and preparation for separation from the general rock mass lasted almost two years.

After separating off the raw part, from the same rock big sized stones were carved for the basement of the monument, the largest of which weighed about 410 tons.

The next and one of the most important stage of work was the trimming of the granite block. In February 1832, the contracted executor Mr. V.A. Yakovlev started lining, rounding and turning the stone mass into a column. Initially, after preliminary preparations, the excess part of the longitudinal composition of this huge body (along about 30 m) was separated from the blank-block.

Then and there it was followed by cutting off across the mass, actually intended for the column, about 4 extra meters from the same 30 m length. Splitting or proper separation took place as follows. Along the mass there was by nature a small crack, a groove about 30 cm deep was cut down along it, in which holes were drilled through about 15–20 cm to half the depth of the block. Huge wedges were fixed vertically in the holes and with sledgehammers weighing 16–25 kg they separated in a single piece the excess longitudinal part of the stone that was about 4 m long, which was thrown aside with the help of a wooden wag. From the broken off parts, three whole steps were made for the facade of the monument, and the fourth step was broken out of the mountain separately.

The next step was the rounding of the column directly in the quarry by rough cut. After completion of work in the upper part, the rounded mass was turned down by means of capstans. The other side was rounded in the same way.

At the end of the rough dressing of stone, the rod from the base to the capital (top) for finishing was completely divided into 12 equal parts, each part had a size of 2.13 m (one sazhen—Russian measure of length equal to 2.13 m). Each of these parts across had its own template made of wood, upholstered in iron, in half a circle, the diameter of which corresponded to the thickness of the column at each of the points. From the side of the base, 6.4 m higher and at the capital, a corresponding row of rings, the so-called lighthouses, were installed across the entire mass, 26.6 cm (6 inches) high from the surface of the mass. The length in the direction of the column, at the base and the middle lighthouse was approximately 1 m (1.5 arshins—Russian unit of length equal to 28 inches), and at the capital—0.2 m (1 arshin and 11 vershoks. Vershok—measure of length equivalent to 1.75 inches). The end beacons were left for the

scale of the column, the middle beacon was hewn for a while, for the most convenient raising of the column to the pedestal. After the installation of the column in place, the middle lighthouse was destroyed, and the outer ones were hewn out according to their belongings.

In process of stone dressing 125 of the most excellent and most experienced stonemasons were involved, placed on the sides of the column in five rows, 25 people each: on both sides of it, below, in the middle and above.

2 Transportation of the Row Piece to St. Petersburg

The almost finished Alexander Column was ready for transportation to St. Petersburg. It was decided to do it with water ways. Transportation was handled by ship engineer Colonel K. A. Glazyrin, who designed and built a special boat-barge for the delivery of the column (https://yura-falyosa.livejournal.com/1552879.html), which received the name "Saint Nicholas" (Fig. 4) 45 m long, 12 m wide, 4 m high and with a cargo capacity of up to 65 thousand pounds (~1100 tons).

For loading works a slip and a pier were built (50 × 40 m). The loading of the column onto the boat was carried out from a platform constructed from wood at the end of the pier whose height was the same as the height of the boat (Nikitin 1939). At the same time, a pier was being built in the northern capital, ready to receive an unusual ship and its cargo. The architect's plans were immediately after unloading the column over a special wooden bridge to the square.

Foremost a stone for the pedestal weighing about 400 tons (24,960 pounds) was delivered. In addition to it, several more stones were loaded onto the ship, and the total weight of the entire load was about 670 tons (40,181 pounds).

Fig. 5 Delivery of blocks for the pedestal of the Alexander Column (Montferrand 1836)

Under this weight, the ship bent somewhat, then it was decided to install it between two steamers and tow it to its destination despite the stormy autumn weather (Fig. 5). It arrived safely in St. Petersburg on November 3, 1831. Two hours later, the stone was already unloaded ashore with the help of 10 capstans, of which 9 were installed on the embankment, and the tenth was fixed on the stone itself and worked through a reverse block, fixed on the embankment.

The stone for the pedestal was placed in 75 m from the foundations of the column, covered with a canopy, and until January 1832, 40 stone cutters cut it from five sides (Figs. 6, 7).

At the beginning of summer in 1832, loading and delivery of the column monolith began. Loading onto a barge this monolith, which had a huge weight (670 tons), was a more difficult operation than loading a stone for a pedestal.

The ship arrived at the Pitterlax quarry at the beginning of June 1832, and the contractor Yakovlev, with 400 workers, began loading the stone. At the shore of the quarry, a pier 32 m long and 24 m wide was made in advance on piles

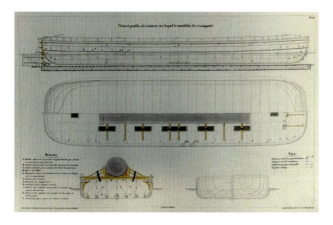

Fig. 4 The project of the bot "Saint Nicholas" (https://yura-falyosa.livejournal.com/1552879.html)

Fig. 6 Movement of the block for the pedestal of the Alexander Column from the embankment (Montferrand 1836)

Fig. 7 Future pedestal under a canopy (Montferrand 1836)

Fig. 8 Loading a column rod onto a barge (Montferrand 1836)

from log cabins filled with stone, and in front of it in the sea a wooden avanmol of the same length and design as the pier. A passage (port) 13 m wide was formed between the pier and the pier. The road from the place of breaking stone to the pier was cleared, and protruding parts of the rock were blown up, then logs were laid close to each other along the entire length (about 90 m). The movement of the column was carried out by eight capstans, of which 6 dragged the stone forward, and 2 located behind, held the column during its movement due to difference in diameters of its extremities. To align the direction of movement of the column, iron wedges were placed at a distance of 3.6 m from the lower base.

In 15 days of work, the column was delivered to the pier. From the pier, 28 logs, 10.5 m long and 60 cm thick, were laid on the ship. It was necessary to drag the column onto the ship along with ten capstans located on the avanmol. In addition to the workers on the capstans, an additional 60 people were placed in front and behind the columns to monitor the ropes going to the capstans, and those with which the ship was strengthened to the pier. On June 19, at 4 am, master Montferrand gave the signal for loading.

The column moved easily along the beds and was almost already submerged, when an incident occurred that almost caused a catastrophe (Fig. 8). Due to the slight inclination of the side closest to the pier, all 28 logs rose and immediately broke under the weight of the stone, the ship tilted, but did not capsize, as it rested on the bottom of the port and the wall of the pier. The stone slid down to the lowered side, but lingered against the wall of the pier.

People managed to run away, so they managed to avoid casualties. Contractor Yakovlev quickly got his bearings and immediately organized the straightening of the vessel and the lifting of the stone. A military team of 600 people was called to help the workers. Soldiers arrived at the quarry after 4 h that covered the distance of 38 km.

Fig. 9 Arrival of the column on the Dvortsovaya Embankment (Montferrand 1836)

After 48 h of continuous work without rest and sleep, the ship was straightened, the monolith was firmly strengthened on it, and by July 1, 2 steamers delivered it to the Dvortsovaya Embankment (Fig. 9).

In order to avoid the failure that occurred during the loading of the stone, Montferrand paid special attention to arrangement of devices for unloading. The bottom of the river was cleared of the piles that remained from the cofferdam after construction of the embankment wall, and inclined granite wall was leveled to a vertical plane using a very strong wooden structure so that the vessel with the column could approach the embankment quite close, without any gap. Connection of the cargo barge with the embankment was made of 35 thick logs that laid close to each other, 11 of them passed under the column and leaned on the deck of another heavily loaded vessel located on the river side of the barge and served as a counterweight. In addition, at the ends of barge, 6 more thicker logs were laid and

strengthened, the ends of which on one side were firmly connected to the auxiliary vessel, and opposite ones extended 2 m to the embankment. With the help of 12 ropes covering it, the barge was firmly pulled to the embankment. To lower the monolith ashore, 20 capstans worked, of which 14 pulled the stone, and 6 held the barge. The descent was successful and took only 10 min.

For moving and raising of the monolith, wooden sub-bridges were arranged. They consisted of an inclined plane, flyover going to it at right angles and a vast platform. The design occupied almost the entire area surrounding the installation site and towering 10.5 m above its level.

In the center of the platform, on the stone mass of the sandstone, scaffolding was built, 47 m high, consisting of 30 four block posts, reinforced with 28 struts and horizontal braces. 10 central pillars were higher than others and at the top, in pairs, connected by trusses, on which lay 5 double oak beams, with pulley blocks suspended from them. Montferrand made a 1/12 life-size model of the scaffold and subjected it to the examination of the most knowledgeable people. This model greatly facilitated the work of carpenters. The lifting of the monolith on an inclined plane was carried out in the same way as moving it in a quarry, along completely laid beams with capstans.

After 12 days, leading by Mr. V. Yakovlev the monolith was unloaded ashore. Then it was hewn by masons and, according to a specially constructed structure, on a wagon placed on cast rollers, it was delivered to the place of lifting (Figs. 10, 11).

While a granite block was being mined in Finland, in St. Petersburg, work was underway to prepare the foundation for pedestal and column itself. For this, geological exploration was carried out on the Palace Square. She identified deposits of sandstone, where it was planned to start digging a pit. It is interesting, but visually it seems to all tourists that the Alexander Column is located exactly in the middle of the square. However, in reality this is not the case. The column is set a little closer to the Winter Palace than to the General Staff.

While working on the foundation pit, the workers stumbled upon the already installed piles. As it turned out, they were dug into the ground at the behest of Mr. Bartolomeo Rastrelli, who half a century earlier planned to set a monument to Peter I here. It is surprising that seventy years later the architect managed to choose the same place.

1250 pine piles were installed at the bottom of the pit, hammered from a mark 5.1 m below the level of the area and to a depth of 11.4 m. On each square meter, 2 piles were driven, they were driven with a mechanical pile driver, made according to the project of the famous engineer A. A. Betancourt. Copra weighed 5/6 tons (50 pounds) and was lifted by a horses (horse-drawn sweep).

The heads of all the piles were cut to the same level, which was determined by the fact that before it the water was pumped out of the pit and marks were immediately made on all the piles. Between the tops of the piles exposed by 60 cm, a layer of gravel was laid and compacted. And on the site leveled in this way, a foundation was erected with a height of 5 m from 16 rows of granite stones. The much simpler task was to set the upper parts of the pedestal—despite the fact that the lifting height was higher, the next stairs consisted of stones much smaller than the previous ones, besides, the workers gradually gained experience. The remaining parts of the pedestal (hewn granite blocks) were installed on the base on the mortar and fastened with steel brackets.

A monolith weighing 400 tons was placed on the basement, which became the basis of the pedestal (Figs. 12, 13).

To install the monolith on the basement, a platform was built, on which it was rolled with the help of rollers on an inclined plane. The stone was placed on a pile of sand, which was previously poured nearby the platform. "At the same time, the earth trembled so much that eyewitnesses—passers-by who were on the square at that moment, felt, as it were, an underground shock."

After the counterforts were placed under the monolith, the sand was removed and rollers were placed. The props were cut, and the block sank onto the rollers. The stone was rolled onto the foundation and accurately installed. The ropes that were thrown over the blocks were stretched with nine capstans and the stone was lifted to a height of about one meter. They took out the rollers and poured a slippery layer of a peculiar composition, on which a monolith was installed.

The monolith was connected to the foundation with a special solution. O. Montferrand described it this way: "Since the work was carried out in winter, I ordered to mix cement with vodka and soap (0, 1 part). Due to the fact that the stone was originally installed incorrectly, we had to be move it several times with the help of two capstans and with

Fig. 10 Moving the finished column from the embankment to the overpass (Montferrand 1836)

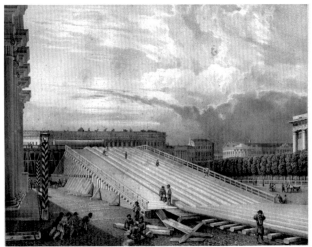
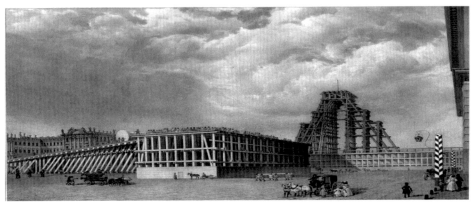

Fig. 11 Moving the finished column along the overpass (Montferrand 1836). **a** at the beginning of the flyover bridge, **b** at the flyover bridge, **c** at the end of the flyover bridge

special ease, of course, thanks to the soap that I ordered to mix into the mortar".

A plaque and a commemorative casket with coins, minted in honor of the War of 1812, were mounted in the center of the foundation.

Of interest are the measures taken by the builders to trim the surface of the sixth lower face of the stone and install it on the prepared foundation. In order to turn the stone over with the lower unhewn face up, they arranged a long inclined wooden plane, the end of which, forming a vertical ledge, rose 4 m above the ground level. Under it, on the ground, a layer of sand was poured, on which the stone was supposed to lie when it fell from the end of the inclined plane. On February 3, 1832, the stone was pulled by nine capstans to the end of the inclined plane, and here, after a few seconds of hesitation in balance, it fell with one edge onto the sand, after which it was easily turned over.

After trimming the sixth face, the stone had to be laid on rollers and pulled onto the foundation, and then the rollers were removed. To do this, 24 posts, about 60 cm high, were brought under the stone, then sand was removed from under it, after which 24 carpenters, working in a very coordinated manner, simultaneously hewed the posts to a small height at the lowest surface of the stone, gradually thinning them. When the thickness of the posts reached about 1/4 of the normal thickness, then a strong crack began, and the carpenters stepped aside. The remaining part of racks that was not cut down broke under the weight of the stone, and it fell a few centimeters. This operation was repeated several times until the stone finally sat on the rollers. To install the stone on the foundation, a wooden inclined plane was again arranged, along which it was raised with nine capstans to a height of 90 cm, first lifting it with eight large levers (vags) and pulling the rollers out from under it. The space formed under it made it possible to lay a layer of mortar.

The builders faced different tasks and the most difficult one was to install the column. On the basis of the developments of Lieutenant General A. A. Betancourt on the installation of the columns of St. Isaac's Cathedral in December 1830, an original lifting system was designed (Architectural and artistic monuments of Leningrad, 1982). It included: scaffolding 22 sajen (47 m) high, 60 capstans

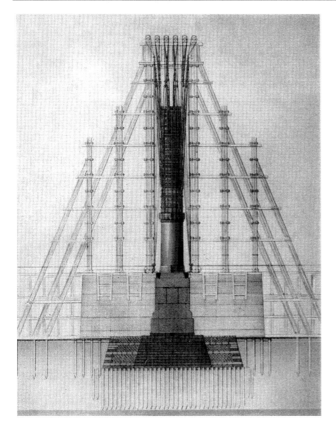

Fig. 12 Construction of granite pedestal and scaffolding with stone base for column installation. Roux lithograph based on a drawing by Montferrand (1836)

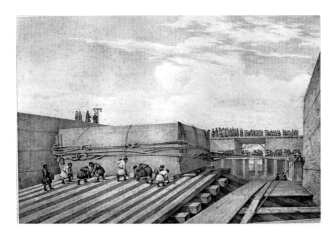

Fig. 13 Installing the pedestal on the foundation (Montferrand 1836)

only in that the bushes collected from racks (Nikitin 1939) were of different heights and larger sections (maximum— 45 × 45 cm).

First, the column was rolled up on an inclined plane to a special platform, which was located at the foot of the scaffolding, and wrapped around it with ropes, to which special blocks were attached. Another block system was located at the top of the scaffolding. The ropes that encircled the stone went around the upper and lower blocks, and the free ends were wound on capstans placed on the square.

After all the preparations, the day of the solemn ascent was appointed. On August 30, 1832, a lot of people gathered to watch this event—the entire square, the roof and windows of the General Staff Building were filled. The emperor himself and entire imperial family came to honor the raising.

To bring the column to an upright position on Palace Square, it was attracted with a force of 2000 soldiers and 400 workers, who installed the monolith in 1 h and 45 min.

The stone block was lifted obliquely, then it slowly separated from the ground and was placed in a position above the pedestal. At the command, the ropes were released, and the column smoothly sank into its place (Figs. 14, 15). The people yelled "Hurrah!" loudly. The sovereign himself was very pleased with the successful completion of the case.

Nicholas the First was so impressed by the solemn rise that he exclaimed: "Montferrand, you immortalized yourself!" After the direct installation of the column, it was sanded, polished and decorated during two years. The

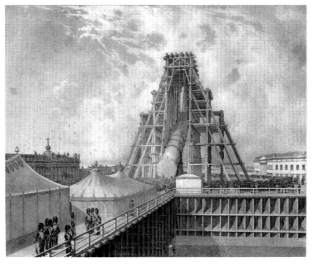

Fig. 14 Start of column lifting (Montferrand 1836)

and a system of blocks. At the finished pedestal of bricks, a temporary array was laid out to the mark of the base of the column (10 m from ground level) for the installation of scaffolding. The scaffolding system differed from St. Isaac's

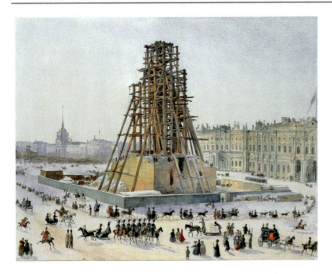

Fig. 15 Denisov Alexander Gavrilovich. Rise of the Alexander Column. 1832 (State Russian Museum, collection, rusmuseum.ru)

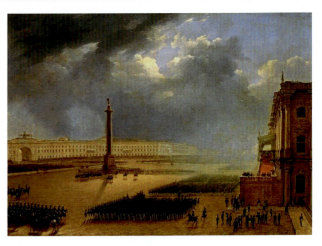

Fig. 16 Bichebois, L. P., A. Baio A. J.-B. Grand opening of the Alexander column (August 30, 1834)

solemn opening ceremony of the monument took place on September 11, 1834 (Fig. 16).

3 Brief Info

Alexander Column (dimensions and weight):

The total height is 47.5 m.
The height of the monolithic part is 25.6 m.
Pedestal height—2.85 m.
The height of the angel figure is 4.26 m.
The height of the cross is 6.4 m.
The lower diameter of the column—3.5 m.
Upper column diameter—3.15 m.
Pedestal size—6.3 × 6.3 m.
Fence dimensions—16.5 × 16.5 m.

The total weight of the structure is 704 tons.
Monolith weight about 600 tons.
The total weight of the angel with the base at the top of the column is about 37 tons.

References

Architectural and artistic monuments of Leningrad, Art, L., 1982.
http://www.hellopiter.ru/Alexandria_pillar_pic.html
https://rusmuseum.ru
https://vk.com/album-9313481_182655468
https://yura-falyosa.livejournal.com/1552879.html
Montferrand A (1836) Plans et détailes du monument consacré à la mémoire de l'empereur Alexandre. Thierry frères, Paris
Nikitin N. P. Auguste Montferrand, Design and construction of St. Isaac's Cathedral and the Alexander Column. L., 1939.

The Alexander Column: Life After Installation

Mihail Ivanov and Georgy Popov

The Alexander Column is made of rapakivi granite. It was erected in 1834. A few years after unveiling of the monument, small, thin vertical cracks appeared. Attentive observers began to notice that some cracks elongated over time and new ones appeared. Attempts were taken to remedy them with cement, granite inserts, synthetic resins, layers of wax and special mastic (Lyubin and Makeeva 2018). Understanding the reasons of this phenomenon is a serious problem for the preservation of this greatest historical and artistic monument.

It is believed that the preservation of the Column is complicated by the tendency of the rapakivi granite ("rotten stone" in Finnish) to destruction due to the peculiarities of the structure of this rock (Lyubin and Makeeva 2018; Härmä 2018). Traditionally fracturing of the Column has been associated with the Column vibration and temperature fluctuations due to unstable weather conditions. At the same time, the Column itself was considered as a physical body that experienced deformation not only at the moment of its separation from the granite massif, but also during primary processing and its transportation.

The granite block from which the Alexander Column was made at the Pyterlakhti quarry was part of the Vybog rapakivi granite massif. So the Column can be considered as a geological object. It turned out that from this point of view, the understanding of the origin and development of cracks is connected with the study of the jointing of the parent massif. Is it possible that cracks in the Column are inherited features?

M. Ivanov
Department of Mineralogy, Crystallography and Petrography, Saint-Petersburg Mining University, Saint-Petersburg, Russian Federation
e-mail: Ivanov_MA@pers.spmi.ru

G. Popov (✉)
2Research Department, Pangea LLC, Saint Petersburg, Russian Federation
e-mail: pangea@mail.ru

1 Jointing at the Rapakivi Granite Massif (The Provenance Site of the Alexander Column)

The Pyterlakhti rapakivi granite refers to the second phase of granitoid magmatism of the Vyborg granite massif. It is known (Larin 2011; Härmä 2018), that this large multiphase batholith occurs in a predominantly layered form. The massif is of Precambrian age, about 1500–1650 Ma. It outcrops in the northwestern part of the Karelian Isthmus and in southern Finland, where quarrying enterprises are currently operating to extract monolithic blocks for building purposes (Fig. 1).

The Vozrozhdeniye quarry (the old Finnish name Kavantsaari) is located at 18 km northeast of Vyborg (Fig. 2). Unlike the Pyterlakhti quarry, it does not show "classical" rapakivi (the so-called "pyterlites"), but rapakivi-like granite rocks belonging to the third age group of the Vyborg massif. The sites of both quarries are characterized by a flat relief, glacial smoothness, shining polish and traces in the direction of the glacier movement.

Both quarries have similarities in terms of rock jointing. Especially, if we compare the historical images of the places where the granite block of the Alexander Column was taken with modern photographs of the old and new Pyterlakhti quarry, what will we see?

First, the granites of these quarries are cut by horizontal cracks. This makes the massif look like a layer cake. According to the drawings of Auguste Montferrand, the thickness of granite layers at the Pyterlakhti quarry reached 7–8 m (Fig. 3). Thickness of the layers at the current operating enterprise does not exceed 2–3 m. At the Vozrozhdeniye quarry, the height of the monolithic layers in the upper ledge of the quarry was 7 m, and the length along the strike reached 40 m.

Secondly, horizontal cracks are repeated at different intervals at both sites. There are horizontal cracks of two orders: 1st order—extended cracks (10–50 m and more);

Fig. 1 General view of the modern pit of the Pyuterlakh granite deposit rapakivi (Finland). The arrows on the enlarged fragment indicate open cracks separately of different order. *Photo* by A. A. Zolotarev (2017)

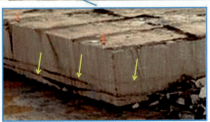

Fig. 2 The northern flank of the rapakivividny granite deposit "Vozrozhdenie" and geological sections as of the development of this quarry in 1992 (according to Ivanov (2015)): 1—open horizontal cracks separately of different order; 2—tectonic cracks accompanied by quartz-albite zones-muscovite mineralization; 3—cracks of the north-eastern strike

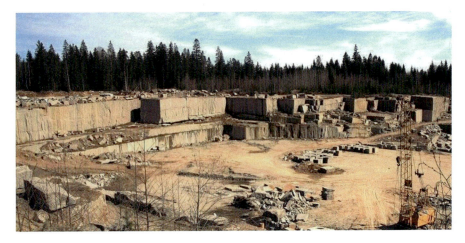

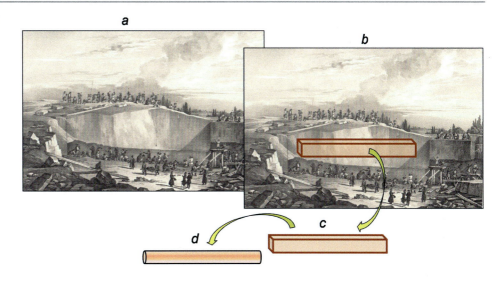

Fig. 3 General view of the site of the Pyuterlakh quarry according to the drawing of Montfferand (**a**); the estimated location of the rapakivi granite block, which served as a blank for the Alexander column (**b**); the shape of the granite block (**c**) and the column itself (**d**)

2nd order—non-extended (1–2 m) and short cracks (up to 10–20 cm). Moreover, a series of second-order cracks can be seen inside individual, at first glance, monolithic layers. Extended cracks of the 1st order are usually open. Sometimes the crack walls are 10 mm apart so that the free space between them is filled with loose detrital or plant material. The walls of cracks of the 2nd order look different. They can be tightly compressed and not visible during routine examination of rocks and are detected only in the course of splitting the granite.

Thirdly, at both locations, horizontal cracks are combined with vertical cracks of northwest and northeast strike. NW-trending cracks are grouped into extended zones of jointing. They are accompanied by displacements of rock blocks and are filled with quartz-albite-muscovite mineral aggregate. Another group of vertical NE-trending cracks is developed locally and their location is limited by horizontal and vertical NW-trending cracks (Ivanov 2015).

What are the causes of age-related cracks in the rapakivi granite? According to the geological characteristics, the rapakivi granites of the Vyborg massif experienced deformations at three stages of their history: (1) at the early stage—cooling of igneous masses and compression of rocks; (2) during the period of manifestations of fissure tectonics and low-temperature quartz-albite-muscovite metasomatism; (3) at the late stage—when rising to the surface and increasing the volume of rocks.

2 Features of the Behavior of Cracks of Prototectonic Jointing

Prototectonic jointing in rocks looks like a system of regularly oriented cracks. Monolithic-looking blocks of rocks are split along a certain system of planes. The reason for this phenomenon is the reduced strength between the grains and the appearance of microcracks in the rock-forming minerals with a decrease in the rock volume during its cooling (Morakhovsky 2000). Sheet-like intrusive bodies are characterized by sheet jointing oriented parallel to the flow surfaces of the magmatic melt and horizontally oriented contacts with host rocks. At the same time, the jointing is expressed by hidden micro defects within the rock.

Geologists know that a rock in deep underground workings looks completely monolithic. Closer to the surface or in natural outcrops, the same rock becomes jointy. Obviously, jointing cracks in such cases are the result of physical unloading in the rock of latent jointing (Fig. 4). Prototectonic jointing of the rapakivi granite massif is visible and

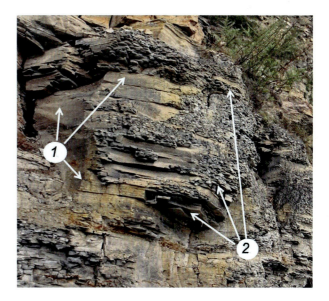

Fig. 4 Exposure of sedimentary rock with developed separateness: 1—sections on which separateness is expressed by latent fracturing; 2—areas where separateness is expressed by open cracks (photos from open sources)

divides it into layers. In addition, it manifests itself in the finest usually invisible defects within the layers. The question arises: when will these defects "wake up"?

3 What Are the Cracks in the Alexander Column?

Observations and interpretation of photographs show (Fig. 5, 6) that visible open cracks are oriented mainly along the Column. At the same time, they are parallel and sloped at an acute angle to the vertical axis of the monument. The strike of the cracks is meridional, the azimuth of the dip line is east at an angle of 75–85° (Fig. 7).

Analysis of the results of geological documentation concludes that the cracks in the Column are grouped into three jointing zones—I, II, III, and divide it into four blocks respectively—A, B, C, D (Fig. 7) (Ivanov and Popov 2021).

Consequently, the nature of the jointing of the Alexander column lies in the coincidence of the shape and orientation of its cracks with the horizontal cracks of jointing in the rapakivi granite of the Vyborg massif. Indeed, the Column is made of a block enclosed between horizontal cracks, that is, from rocks with a developed horizontally oriented jointing. Quarries of the old Pyterlakhti quarry that have survived to this day obviously prove this conclusion (Fig. 8).

Fig. 6 The methodology for documenting cracks in the granite of the Alexander column: a general view of cracks in the column photo (**a**) and their image in the fracturing diagram (**b**)

It is not surprising that when choosing a monolithic block, no microcracks of jointing had been noticed in it. Geological experience confirms that defects of this type can be practically invisible in the bedrock. Thus, the cracks in the granite of the Alexander Column are most likely to be the microcracks of the sheet jointing inherited from the rocks of the parent massif.

Why do microcracks lengthen with time and their number increases? When the Column was installed in a vertical position, the conditions of compression of "sleeping" and hidden cracks of jointing changed to conditions of tension (Fig. 9). The Column in a state of elastic deformation "settles" under its own weight. The "sleeping" jointing may continue to unfold, while the hidden one may prepare to awaken. In addition, the opening of cracks in a granite column is facilitated by temperature weathering (especially frosty) associated with periodic changes in weather conditions.

The logic of the analysis is based on the consideration of the Alexander Column as a part of the Vyborg rapakivi granite massif. From this point of view, the monument is a block of rock, separated from the seemingly monolithic, but from the part of the granite massif, which was affected by hidden cracks. The Column inherited the textural heterogeneity of the massif in the form of sheet jointing. Cracks of jointing are characterized by a genetically determined ability to open during the physical unloading of rocks near the earth's surface. Individual microcracks often remain in a "sleeping" state. The conditions for the opening of individual cracks arose during the installation of the monument: in the original (horizontal) position in the parent massif, the hidden microcracks of jointing were under compression, but after bringing the Column to a vertical position the

Fig. 5 The scheme of photographing the Alexander Column from different sides of the world to document the fracturing developed in it (composition by Ivanov (2021))

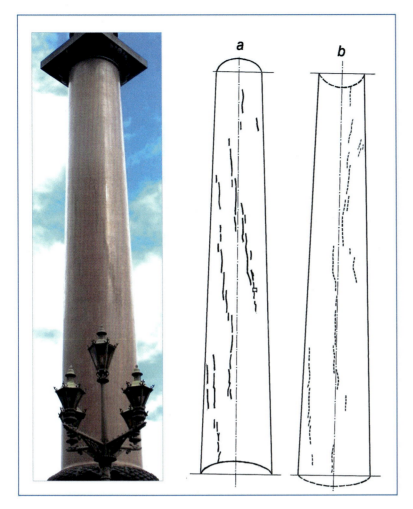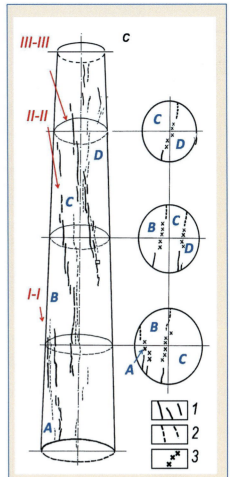

Fig. 7 The fracturing scheme of the granite of the Alexander column in the form of projections on the vertical plane of the latitudinal strike **a**—cracks visible on the southern side of the column (1); **b**—cracks on the northern side of the column (2); **c**—combined projection a and b. The cross-sections indicate the alleged latent cracks separately (3) (Ivanov 2015)

compression conditions changed to conditions of tension. "Sleeping" microcracks that found themselves in such conditions began to wake up over time and turn into extended open cracks and form zones. Layered heterogeneity, i.e., jointing, embedded in the rapakivi granite of the Vyborg massif, can be further developed and, therefore, should be considered as a potential threat to the preservation of the great monument (Fig. 10). In general, the condition of the Column does not currently cause much concern. Restorers assess the condition of this monument as satisfactory.

The presented "geological" approach to the analysis of the nature of jointing in the Column will help specialists in the field of engineering geology, geophysics and mining, together with experienced restorers, to assess correctly the state of the monument in the future and to make the right decision to preserve this truly great work of art.

Fig. 8 Higher-order individual cracks, observed in the Rapakivi granite of the Alexander column (**a**) and in the ledges of the old pit of the Pyuterlakh quarry (**b**). *Photo* by G. N. Popov and A. A. Zolotarev

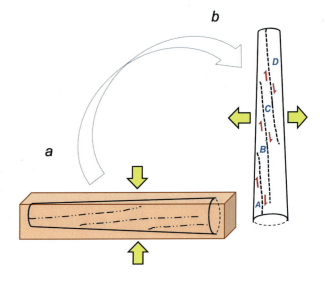

Fig. 9 The layout of the crack concentration zones separately in the granite block that served as a blank for the Alexander Column (**a**), and in the column itself after its installation on the pedestal (**b**)

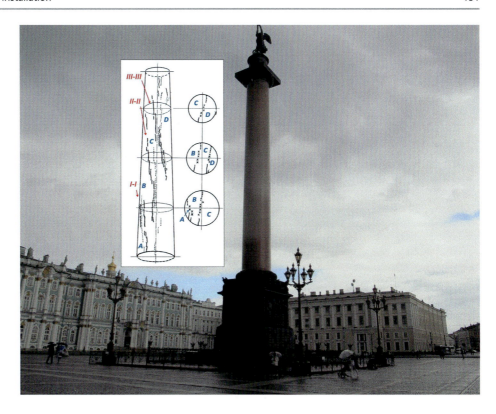

Fig. 10 The Alexander column on the Palace Square of St. Petersburg in comparison with the scheme of its fracturing. *Photo* by Ivanov (2021)

References

Härmä P (2018) Natural stone production in the Wiborg rapakivi granite batholith in southeast. Härmä P, Selonen O (eds) Finland Geotechnical report 10/2018. The Finnish Natural Stone Association, Helsinki, p 34

Ivanov MA (2015) Mineralogical features and patterns of spatial distribution of jointing of different ages in granites and pegmatites of the Vozrozhdenie (Kavantsaari) quarry, Vyborg massif. Notes of the Mining Institute, National Mineral and Raw Materials University, "Gorny". SPb, vol 212, pp 21–29

Ivanov MA, Popov GN (2021) Nature of the jointing of the granite of the Alexander Column in St. Petersburg—a geological aspect. Museum under the open sky. Problems of preservation of monuments in the urban environment. Proceedings of the V scientific-practical conference "Museum under the open sky". Medna Comfort, St. Petersburg, pp 23–25

Larin AM (2011) Rapakivi granites and associated rocks. Nauka, SPb, p 356

Lyubin DV, Makeeva EI (2018) The Alexander Column. History of restoration. Preventive Care. Open Air Museum. Strategy for the preservation of sculpture in the urban environment. "ZNAK", SPb, pp 66–72

Morakhovsky VN (2000) Non-kinematic tectonics and its ore-forming significance. St. Petersburg Mining Institute, SPb, p 117

Rapakivi Granite—Symbol of St. Petersburg

Andrey Bulakh and Elena Panova

Rapakivi granite is widely used in the architectural decoration of St. Petersburg (Bulakh 2013; Bulakh et al. 2020; Ziskind 1989). The famous Alexander Column on Palace Square, consists of 114 columns of St. Isaac's Cathedral that are made of this stone. They are lined with podiums of the St. Petersburg Academy of Sciences, Admiralty, Senate and Synod, stone embankments of the Neva.

Since the 1760s, rapakivi from the Vyborg massif has played an increasing role among decorative stones in the architecture of St Petersburg. It was mined in several quarries near Vyborg and Friedrichsgam (Hamina) and in rocks along the coast of the Gulf of Finland. Therefore, this stone was called the "Finnish pink sea granite". Currently, the term "Finnish rapakivi granite" is applicable. The most famous granite breaks are in Peterlaks and Himmekula (Hämeenkylä). During 1809–1917 quarries were located in the Vyborg province of the Grand Duchy of Finland (the Great Principality of Finland) of the Russian Empire, and then until 1940—within the Republic of Finland.

The Vyborg massif is a giant multiphase intrusion and is exposed on the daytime surface on an area of about 18,000 km^2. Most of the batholith is located on the territory of Finland, the smaller one is in Russia. The structure of the Vyborg massif is dominated by pink rapakivi (Larin 2011; Rämö et al. 2005).

Until the 1960s, among the granites in the architecture of St. Petersburg, mainly pink rapakivi was used. It is represented by two varieties—Vyborgites (for example, columns inside the Kazan Cathedral) (Fig. 1) and Peterlites (for example, the Alexander Column and its pedestal, porticos and colonnades of St. Isaac's Cathedral) (Fig. 2).

Examples of early use of pink rapakivi are the facing of the Hermitage Bridge (1763–1766) and the creation of the granite Palace embankment (1763–1767). In rare cases, gray rapakivi arrived in St. Petersburg. Here are the examples: (a) the facing of the plinth of the front facade of the Academy of Arts (1764–1768); (b) the portal of the mansion of the Chancellor of the Russian Empire A. A. Bezborodko on Pochtamtskaya Street, 7 (1783–1795); (c) the bases of the Rostral columns, the two upper rows of granite blocks in the lining of the podium of the Stock Exchange (1804–1810) (Fig. 3); (d) facing of the basement of the General Staff Building (1819–1829) to the right of the arch; (e) slabs of the sidewalk of the University Embankment, 1–5) (1804–1810).

After the 1960s, gray and pinkish-gray porphyritic granite rapakivi from quarries in the Leningrad region (near the city of Vozrozhdenie) began to be used in Leningrad-Petersburg. He composes the Gubanov intrusion. Examples of this granite use include: obelisk on Vosstaniya Square in front of the Moscow Railway Station (1982); monument "2000 years from the Birth of Christ" (2001) in the Alexander Nevsky Lavra; memorial stele on the site of the former Vvedensky Cathedral on Zagorodny Ave. (2001); stele at St. Andrew's Cathedral on lines 6–7 (2001) (Tutakova 2014). In paving slabs, stone can be seen everywhere —in new sidewalks, building plinths, steps and floors. It is traditionally called rapakivi, but it is sharply distinguished from the famous "old" stone by the color and texture of the rock. In the sidewalks of streets, in the floors and in the

A. Bulakh
Department of Mineralogy, Saint-Petersburg State University, Saint-Petersburg, Russian Federation
e-mail: a.bulakh@spbu.ru

E. Panova (✉)
Department of Geochemistry, Saint-Petersburg State University, Saint-Petersburg, Russian Federation
e-mail: e.panova@spbu.ru

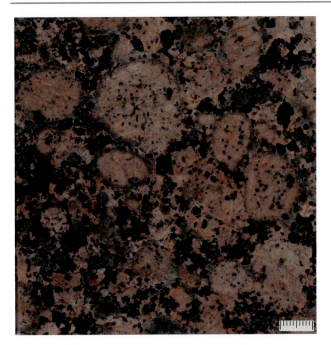

Fig. 1 Vyborgite

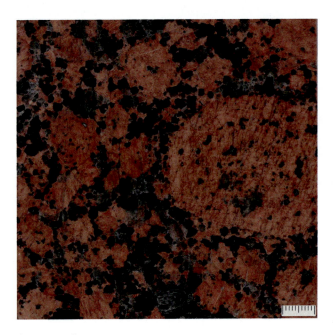

Fig. 2 Peterlite

lining of the walls of houses, in the subway, you can observe the heterogeneity of the structure of these granites. There are rounded remnants of coarse-grained ovoidal granite (Fig. 4). Veins of different composition are distinguished in the slabs of sidewalks and in the floors of the subway (Fig. 5). They are diverse in their mineral composition and structure.

Since the 1990s, rapakivi granite from Finland began to arrive in St Petersburg again. It differs in shades of color and texture features from Vyborgite and Peterlite in ancient St. Petersburg architectural objects (Tutakova 2014) (Fig. 6). On the territory of the Vyborg massif, from Lappeenranta to Hamina and Kotka, granites of the Baltic Brown (Vyborgite), Eagle Red and Carmen Red (Peterlite) varieties are mined. In addition, rapakivi granite of the Balmoral Red variety comes from a small Wehmaa intrusion near the Gulf of Bothnia.

The texture of the Baltic Brown granite in the sidewalk near the metro station "Ploshchad Vosstaniya" is different. Ovoids of the breed are arranged in the form of chains. Plagioclase borders are rare. The Piterlites from the places of modern mining ("Carmen red" and "Karelia red") have their own characteristics in relation to the Piterlites in the architectural objects of "old" Petersburg. Granite of the Eagle Red and Balmoral Red varieties from the Wehmaa intrusion is characterized by a seasoned medium-grained structure. Examples of the use of new varieties of stone are given in Table 1.

A wide range of variations in the color and structure of rapakivi granites has been established in the Vyborg massif. Currently, there are restoration tasks of searching for rocks to replace individual blocks of historical buildings. It is important to mutually agree on the old and new names of commercial varieties of stone mined in Finland, the Leningrad Region and Karelia. Now the simple use of the term "rapakivi granite" is not enough for the customer and the buyer—a sculptor, architect, engineer when choosing a stone.

Fig. 3 Gray and pink rapakivi in the basement of the exchange

Fig. 4 Xenolith in the granite of the Gubanov intrusion

Fig. 5 Heterogeneity of granites of the Gubanov intrusion

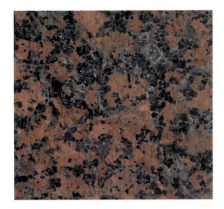 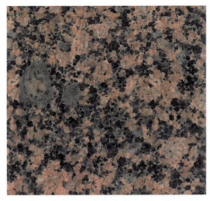 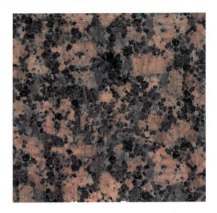

Fig. 6 Rapakivi granite from modern quarries **a**—Eagle red; **b**—Balmoral red; **c**—Karelia red

Table 1 Examples of the use of rapakivi granite in St. Petersburg

Stone	Object. Address	Year
"Old" vyborgit	Columns inside the Kazan Cathedral	1805
"Old" gray rapakivi	Pedestals of rostral columns	1805
"Old" peterlit	Alexander column	1833
Gray granite from the Vozrozhdenie quarry	Concert hall "Oktyabrsky"	1967
	Monument to the 40th anniversary of Victory. Pl. Vosstaniya	1985
Pink granite from the Ala-Noskua deposit	The pedestal of the monument to Alexander Nevsky	2002
Baltic brown	Sidewalk around the metro pavilion "Ploshchad Vosstaniya"	2008
Eagle red	Sidewalks of the embankment from the Trinity Bridge to the Winter Palace	2006
Karelia red	McDonald's. Sredny Ave. V. O., 29 a	1996
Balmoral red	Nevsky Prospekt sidewalk from Moika to Fontanka	2009

References

Bulakh AG (2013) Building and ornamental stone in the history of St Petersburg architecture//Global Heritage Stone: towards international recognition of building and ornamental stones. In: Pereira et al (eds) Geological society vol 407. Special Publications, London, pp 243–252, Ziskind MS (1989) Decorative and facing stones. L.: Nedra 255 p. (in Russian)

Bulakh A, Harma P, Panova E, Selonen O (2020) Rapakivi granite in the architecture of St Petersburg: a potential Global Heritage Stone from Finland and Russia/Global Heritage Stone: Worldwide examples of Heritage Stones. Hannibal JT, Kramar S, Cooper BJ (eds) Geological society, vol 486. Special Publications, London. https://doi.org/10.1144/SP486-2018-5 http://www.geolsoc.org.uk/pub_ethics

Larin AM (2011) Granit rapakivi I assotciiruushii porodi [Granite rapakivi and the associating rocks]. SPb.: Nauka. 356 p. (in Russian)

Rämö OT, Haapala I (2005) Rapakivi granites. Precambrian geology of Finland—key to the evolution of the Fennoscandinavian shield. In: Lehtinen V, Nurmi P, Rämö O (eds) Elsevier, Amsterdam, pp 533–562

Tutakova AYa (2014) A natural stone of the Karelian Isthmus in architecture of St. Petersburg. SPb.: Russian collection. 88 p. (in Russian)

Ziskind MS (1989) Decorative and facing stones. L.: Nedra. 255 p. (in Russian)

Valaam Monastery Granite

Elena Panova and Vladimir Gavrilenko

Everyone who is interested in the history and architecture of St. Petersburg is familiar with the term "Valaam granite". This stone looks especially impressive in the decor of churches and buildings in St. Petersburg.

In 1909–1915, the Tibetan Dalai Lama Tubdan-Chzhamtso and the Buryat lama Aghvan Lobsan Dorzhiev initiated the building of a large Buddhist temple in Saint Petersburg (architect G. V. Baranovsky) (Fig. 1). The forms of the temple are borrowed from Tibetan architecture, and the face of the building is cladded with local stone. The walls of the datsan, laid out of roughly processed "Valaam granite" and rapakivi granite, resemble an impregnable mountain fortress and a temple in Lhasa. Bright ornaments, a sacred circle of endless life and fanciful gilded capitals which decorate massive pylons, make a visitor think of sacred.

Another cathedral in St. Petersburg faced with "Valaam granite" is the church of the French Embassy, consecrated in the name of the Mother of God of Lourdes (architects L. N. Benois and M. M. Peretyatkovich) (Fig. 2). It is situated in Kovensky lane near Vosstaniya Square and was built in 1908–1909 and possesses the appearance of a medieval castle. Almost the entire facade of the temple is cladded with red "Valaam" granite, the deliberately rough processing of which gives the building a severe ascetic look.

"Valaam granite" is often found in the decor of St. Petersburg. In Nevsky Prospect, beautiful weakly banded red granite attracts attention, the well-polished slabs of which decorate the house No. 46. The facade of the building is cladded with this stone to the height of the two lower floors. The house was built in 1901–1902 by the project of L. N. Benois for the branch of the Moscow Merchant Bank.

At the beginning of the twentieth century, the monument to Emperor Alexander III was set in the square near Nikolaevsky, now the Moscow railway station. The pedestal of the monument was made of "Valaam granite". The history of this monolith is described in the book by A. G. Bulakh and N. B. Abakumova "Stone decoration of the main streets of Leningrad" (1993) and in the book by A. G. Bulakh "Stone decoration of St. Petersburg. Essays on different things" (1999). After the figure of the emperor was transferred to the courtyard of the Russian Museum in 1937, the unique stone pedestal was cut into pieces for monuments of F. Lassalle, Rimsky-Korsakov, N. Glinka.

"Valaam granite" is used for decoration of the Petrogradskaya side and house no. 40 in Malaya Morskaya street. This granite can be seen in the facing of the royal pavilion of the Vitebsk railway station and the royal pier in Kronstadt. They lined the walls of the Moscow Merchant Bank (1901–1902, L. N. Benois), the basement of the first Russian Insurance Company (1889–1901, L. N. Benois) and the frieze of the mansion of M. F. Kshesinskaya (1904–1906, A. I. Gauguin). It was used for the cladding of the basement of the Cathedral of Christ the Savior in 1818–1883 in Moscow (architect K. A. Ton). When the cathedral was blown up in 1934, the "Valaam granite" was removed and later used in the decoration of "Moscow" Hotel, the USSR Ministry of Defense and the buildings of the Supreme Soviet. In the 1970s and 1980s, granite from the island of Syuskuyansaari was used to decorate the stations of the Moscow metro. Whether for its noble color, or because it was a favorite stone of the Russian Emperors, this rock was called the royal.

On the Valaam archipelago islands there is the monastery, which was founded in the IX century. Many of his buildings are made of this granite. Two columns of the covered porch, steps of the porch and soles, window sills and floors of the Transfiguration Cathedral (1887–1896, A. Silin, G. I. Karpov, N. D. Prokofiev) are made of red granite of St. Herman's Island. Columns, the lower part of the kiosk and part of the floor of the Chapel of All the Sorrowful Joy (1896),

E. Panova (✉)
Department of Geochemistry, Saint-Petersburg State University, Saint-Petersburg, Russian Federation
e-mail: e.panova@spbu.ru

V. Gavrilenko
Department of Environmental Geology, Saint-Petersburg Pedagogical University, Saint-Petersburg, Russian Federation

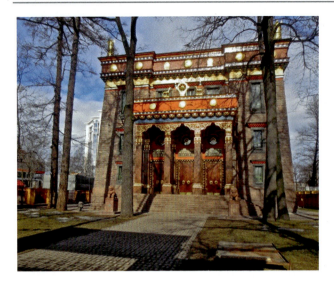

Fig. 1 Buddhist temple in St. Petersburg

Fig. 2 The church of the French Embassy in St. Petersburg

The main buildings of the monastery are located on the shore of the long Monastyrskaya Bay. At the very shore there is a small golden-domed chapel in the name of the icon of the Mother of God "Joy of All Who Sorrow" (Fig. 3.). The graceful columns of the chapel are carved from red "Valaam" granite, their capitals and bases are from black amphibolite.

On a hillock overlooking the bay, the blue-white building of the Valaam Monastery of the Transfiguration of the Savior sets above the everlasting rest. Its founders were the Monks Sergius and Herman. The main monastery building of the ensemble is the Transfiguration Cathedral was built between the 1887 and 1890 (architects G. I. Karpov, A. N. Silin, N. D. Prokofiev). The columns at the entrance are carved from red "Valaam" granite (Fig. 4). They rest on a gray "monastery" granite socle.

The five-domed cathedral of forty-three meters height with a 72 m bell tower is built of brick. The bricks were produced here, on Valaam. The monks painted the walls and icons, and cast most of the bells. The floor in the church is paved with platy "Putilov" limestone, and the windowsills are carved from red "Valaam" granite and black amphibolite. The steps to the shrine with the relics of the founders of the monastery, the Monks Sergius and Herman are made of "Valaam" granite and black amphibolite.

The most active stone construction on Valaam took place in the nineteenth century during the reign of the Father Superior Damaskin (1839–1881). Father Damaskin was not only a confessor, but also a gifted proprietor and builder. In 1866, he acquired for the monastery several islands with forest, hay mows and stone quarries in 40 km from Valaam, where he built chapels. Quarries of red granite later called

staircase and porch of the Chapel of the Sufferings of the Cross of the Lord (1880s, K. Brandt), window sills of the Church of the Resurrection of Christ (1901–1906, V. I. Barankeev), pedestals and crosses at the Hegumen cemetery are of this granite.

The best way to Valaam Island from St. Petersburg is by ship. The ship slowly sails past the majestic cliffs overgrown with pine forest into Nikonovskaya Bay. According to a legend, St. Andrew the First-Called, landed in this particular bay and erected a stone cross here. Now on this place there is a skete in the name of the Resurrection of Christ called the brick church, built in 1901–1906 (architect V. I. Barankeev). The iconostasis is made of Juven marble and "Valaam" granite. The base is made of gray "monastery" granite.

Fig. 3 The Chapel in the name of the icon of the Mother of God "Joy of All Who Sorrow" (Valaam Island)

Fig. 4 The columns at the entrance of the Transfiguration Cathedral (Valaam Island)

Fig. 5 The Church of St. Prince Alexander Nevsky (Syuskuyansaari Island)

"Valaam" were on the island of St. Herman (now the island of Syuskyuyansaari). Pink-gray "monastic" granite was quarried on the island of St. Sergius (now the island of Putsaari). The very Valaam island is composed mainly of dense crystalline rock—brown gabbro-diabase. "Valaam" granite was shipped to St. Petersburg, Moscow and other cities.

The Herman Skete of the Valaam Monastery was founded on the island of St. Herman. In 1904, the Church of St. Prince Alexander Nevsky was built according to the project of architect V. I. Barankeev (Fig. 5). Currently, the church has been destroyed. The basement and stairs are laid out of blocks of red "Valaam" granite, mined nearby. The monks began the extraction of fine-medium-grained red granite in the second half of the XVIII century (Fig. 6). Stone processing was carried out in workshops, stone-cutting, stone-cutting and stone-grinding workshops worked. After the Revolution of 1917 quarries of "Valaam" granites were practically not developed.

Since 1972, the Syuskuyansaari granite deposit develops for blocks (Fig. 7). Granite of this deposit was used in Novorossiysk (monument "Malaya Zemlya"), in Kursk (monument "40th anniversary of Victory"), in Chelyabinsk (monument "Kulikov Battle"), in Petrozavodsk (memorial in the Sands and city embankment), in Kondopoga (Victory

Fig. 6 The old quarry (Syuskuyansaari Island)

monument). In Tynda railway station decorated by this granite. The facades of buildings in Bratsk, Bryansk, Kazan, Kuibyshev, Novosibirsk, Omsk, Saranka are lined with Valaam granite. In Mongolia, it is lined with the airport

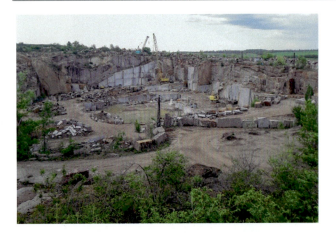

Fig. 7 Modern granite quarry (Syuskuyansaari Island)

Fig. 9 Church of Saints Sergius and Herman (Novo-Valaam Monastery, Finland)

Fig. 8 The memorable Stella in the modern quarry (Syuskuyansaari Island)

building in Ulaanbaatar, in Prague—the Moskovskaya metro station. Currently, the deposit is operated for the extraction of blocks, and paving stones and crushed stone are produced from substandard waste (Figs. 7 and 8).

After Finland gained independence in 1918, the Valaam monastery turned out to be the only holy place of Russia outside the USSR. The New Valaam Monastery was established in Heinävesi (Finland), between the towns of Kuopio and Joensuu. Hegumen Chariton decided to transfer the Valaam shrines there. Now the New Valaam Monastery near Heinävesi is one of the centers of Orthodoxy in Finland (Fig. 9).

Atlantes Hold Sky on Stone Shoulders

Igor Borisov

One of the symbolic places in St. Petersburg is the gallery in front of the main entrance to the New Hermitage. Its portico is decorated with 10 figures of Atlantes by the sculptor A. I. Terebenev, made of gray Serdobol granite, standing on pedestals made of rapakivi granite (Fig. 1).

"Serdobol granite" is a name for dark and light gray, crystalline rocks that were quarried in the 1770s–1930s on the islands and the coast of the northern part of Lake Ladoga and in the vicinity of the city of Serdobol (Sortavala) (Alopeus 1787; Zembitsky 1834; Serdobol granite quarries 1885; Archive 1768; Ryleev 1984). The term "Serdobol granites" combines igneous rocks of the Lower Proterozoic age (1.86–1.87 Ga) with similar properties, represented by fine- and medium-grained diorites, quartz diorites, granodiorites, tonalites and plagiogranites which compose intrusive bodies ranging in size from 200 m^2 to 5 km^2, which have a sheet-like shape and occur among metamorphic rocks. They are composed of feldspar (30–55%), quartz (20–45%) and mafic minerals (5–20%), with a small amount of accessory minerals. These granites are distinguished from other intrusive rocks by their mechanical strength and artistic expressiveness. From these granites, Russian and Finnish stonecutters made base stones, steps of stairs, pedestals of monuments, bowls of fountains, graceful columns and sculptures that decorate St. Petersburg, Peterhof, Sortavala and other cities. Many architects used this stone in their works, among them are A. Rinaldi, V. Brenna, A. N. Voronikhin, N. E. Efimov, V. P. Stasov, A. I. Terebenev, A. I. Stackenschneider, A. P. Bryullov, O. R. Montferrand, M. Mikeshin, M. Chizhov, P. K. Klodt, A. I. Hohen, M. M. Peretyatkovich, A. A. Grechashnikov, V. Hartman, I. Schroeter, I. A. Monighetti, I. S. Bogomolov, A. M. Opekushin, E. Saarinen, W. V. Ullberg, E. Huttunen, J. Ahrenberg, V. Sjöström, etc.

I. Borisov (✉)
Republic of Karelia, The Regional Museum of the Northern Ladoga Region, Sortavala, Russia
e-mail: aldoga@bk.ru

The New Hermitage, the first special museum building in Russia, was being built in the capital from 1839 to 1852. Serdobol granites which were used for interior and façade decoration demonstrated their remarkable qualities as columnar and sculptural stone. To see this, you need to visit the Twelve-column and Twenty-column halls of this museum, which amazes with the beauty of powerful polished columns. The colonnade that decorates the Main Staircase of the New Hermitage makes a huge impression (Figs. 2, 3, 4).

At the Museum main entrance from Millionnaya Street for 150 years, the timeless Atlantes "have been holding the sky". According to the project of the architect von Klenze, the side facade of the building was to be decorated with figures of Atlantes supporting a massive portico. Giant (up to 8 m high) sculptures of Atlantes in the temple of Olympian Zeus on the island of Sicily (480 BC) were taken as an example.

The winner of the competition was a young sculptor Alexander Ivanovich Terebenev—a purposeful, selfless, talented artist. Terebenev recruited more than a hundred assistants from stonecutters and taught them for more than a year to work with Serdobol granite. Each craftsman did a certain job: someone trimmed the hands, someone torso, someone legs. Terebenev finished the face of each sculpture himself.

When all ten the statues were polished, they were installed on low pedestals made of red rapakivi granite from the Pyterlahti quarries. The memoirs of contemporaries and articles of that time are full of enthusiastic reviews about the Atlantes. The newspapers wrote: "The mythological Atlantes are presented in the form of majestic giants, holding a huge weight on their mighty shoulders. The proud heads of giants, crowned with wreaths of ears of corn, are tilted down. Strong arms are bent at the elbows, thrown behind the head … The muscles of naked athletic figures are full of great strength. Bear skins wrap around their thighs. Everything strikes with grandeur, rigor and simplicity. Calmness is external and emphasizes internal tension …" (Samoilov 1954).

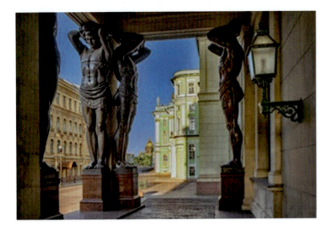

Fig. 1 Atlantes of the hermitage

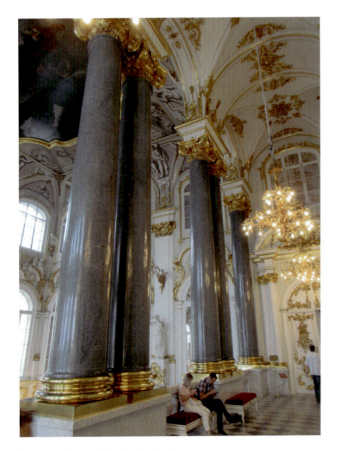

Fig. 2 Columns of the Jordan Staircase

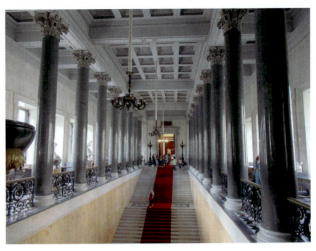

Fig. 3 The Grand Staircase. The New Hermitage

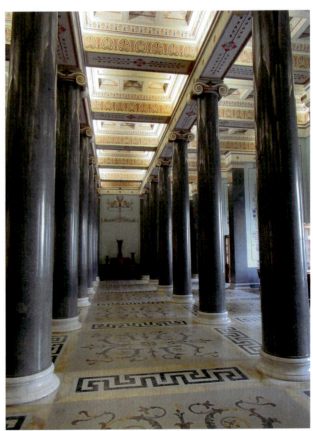

Fig. 4 The twenty-column hall. The New Hermitage

The Secretary of the Academy of Arts, V. I. Grigorovich, described Terebenev's work as follows: "Nowhere in Europe there is a single sculptor who uses granite, as the ancient Egyptians and Greeks had done. Now, thanks to Terebenev, this Egyptian art has become Russian" (Samoilov 1954).

A. I. Terebenev loved to work with Serdobol granite and proved this by making beautiful sculptures that decorated the buildings of Peterhof, built under the direction of A. I. Stackenschneider. The Belvedere built on the Babigon Hills (1852–1856) has survived to this day. This tall building resembles an ancient Greek temple. Along its entire perimeter on the second floor there is a terrace, decorated with twenty-eight polished columns made of Serdobol granite (Fig. 5). A wide stone staircase leads from Meadow

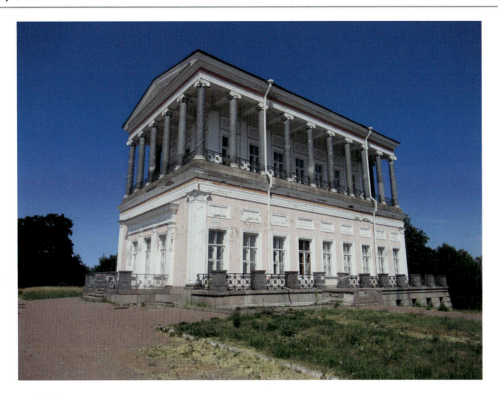

Fig. 5 Belvedere. Peterhoff

Park to a massive portico with four beautiful caryatids. The caryatids of the Belvedere resemble the famous marble sculptures of the Erechtheion temple in the Acropolis, Athens (Fig. 6).

In the 18th—early twentieth centuries Serdobol granites were used for decoration of many buildings in St. Petersburg, such as: the Marble Palace (walls, window frames, cornices, columns); Nevsky Gates of the Peter and Paul Fortress, Mikhailovsky Castle (stairs and basement); pedestals of monuments to Peter I, Nicholas I, Catherine II and I. A. Krylov; obelisk "Rumyantsev Victories" (stele, pedestal); Kazan Cathedral (basement); columns of Glory and columns of the Jordan Stairs of the Winter Palace; columns of the Nicholas Palace; supports of the Nikolaevsky bridge; bowls of fountains in the gardens near the Admiralty and the Winter Palace; mansion of A. F. Kshesinskaya; Wawelberg house; building of the Oktyabrskaya Railway Administration, etc.

Serdobol granites decorate various buildings of Peterhof —the Lion Cascade (1853–1857, columns) (Fig. 7); Rose Pavilion (1845–1848, herms). Serdobol granites were used for graceful pedestals of the monuments "The Millennium of Russia" in Velikiy Novgorod (1862), to Peter I in Petrozavodsk (1873), A. S. Pushkin in Moscow (1880), as well as for the main staircase and the base of the Museum of Fine Arts named after A. S. Pushkin in Moscow.

Serdobol granites were widely used in the 1870s–1930s in the construction and decoration of the Finnish town of

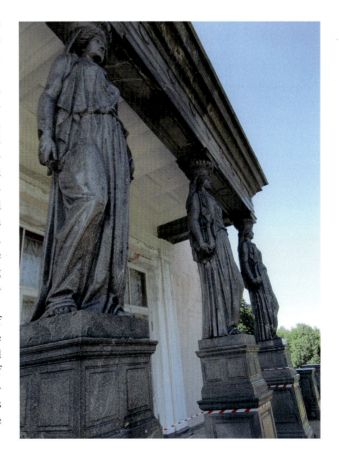

Fig. 6 Belvedere caryatids. Peterhoff

Fig. 7 Lion cascade. Peterhoff

Serdobol (Sortavala), for example: People's Bank (1905, base, stairs); United Bank of the Nordic Countries (1913, base, columns); Bank of Finland (1915, facade cladding) (Fig. 8); hotel "Seurahuone" (1939, base, stairs), Women's Gymnasium (1911, base, stairs); Lyceum (1901), City Hall (1885, base, stairs), Karelsky Bridge (1932, supports) and some others.

Several dozens of historical quarries of Serdobol granites are known over the territory of the Northern Ladoga. The main historical quarries are located on the islands of the Sortavala archipelago Riekkalansaari, Vannisensaari and Tulolansaari and on Cape Impiniemi. Until now art historians discuss where the monoliths for the Atlantes of the Hermitage had been quarried. All sculptures are outwardly identical, but are made of several varieties of Serdobol granite. Atlantes of the "front row" are made of light gray plagiogranite. The granite of the two last Atlantes and from the "back row" is dark gray with black schlieren of biotite. The rock contains light quartz-feldspar veinlets resembling human veins.

Tulolansaari Island is located at 7 km southeast of the town of Sortavala. In the eighteenth century the inhabitants of the Tulolansaari Island began to master the mining craft. The name of Mount Ruotsenkallio—Swedish rock, or quarry —suggests that in the seventeenth century the Swedes quarried granite on this island.

To visit the island associated with the world-famous Atlantes of St. Petersburg, we will go by boat along Lake Ladoga to its eastern shore. Having ascended Mount Ruotsenkallio and then descended into a hollow we will stop near a long thin stone slab. It is a monument to miners of the nineteenth century. The surface of the plate resembles a washboard (Fig. 9). It is covered with evenly spaced grooves —traces of holes that are drilled in the rock during the extraction of stone blocks. A barely noticeable path leads to a small lake. This is the Main Quarry, flooded with groundwater. Monoliths for the columns and Atlantes of the Hermitage were quarried there in the nineteenth century.

The largest extraction of granite was carried out from 1770 to the 1860s. Favorable natural fracturing made it possible to obtain blocks of the correct shape up to 12 m^3 in size. Blocks in ledge outcrops are 3–6 m long with a cross-section from 1.5 to 3 m (Figs. 10 and 11). Along the western edge of Mount Ruotsenkallio, for 400 m, there is a discontinuous chain of small quarries with a total volume of production of about 7 thousand m^3. On the eastern slope of Mount Rutsenkallio the working has a length of 80 m, a depth of up to 3 m and a width of up to 26 m, with a production volume of up to 2 thousand m^3. Complex natural fracturing of the rock at the site causes the irregular shape and small sizes of the obtaining blocks. In the process of quarrying a lot of small fragments came out and littered the quarry site (6).

Nowadays, there are about fifteen quarries and many small workings on the island of Tulolansaari abandoned 60–150 years ago. Many workings are hidden in the forest under a thick layer of moss. But as soon as you remove the moss from the ledge, the pictures of the past come to life before your eyes.

Fig. 8 The Finnish Bank. Sortavala

On the surface of the rock cleared of plants and earth, a craftsman chooses a site where the stone is homogeneous, dense and without cracks and marks the contours of the future block. He makes grooves 7–10 cm deep and 4–5 cm wide along the perimeter of the stone piece with a hammer and a chisel. In these grooves the workers manually drill holes with a diameter of 15–30 mm at a distance of 5–17 cm from each other. If there are no horizontal cracks, the master drills horizontal holes. Next, the separation of the block from the rock begins. To do this, the drill holes are charged with gunpowder and undermined. Often, blocks were separated by driving wedges into cracks and holes. In winter time the extraction of stone was carried out using water.

After the granite blocks had been separated from the rock, the stonecutters got to work. They used traditional mining tools: a chisel, bush hammer, mallet, sledgehammer, etc. Extra pieces of rock were removed from the surface of the stone giving the piece the desired shape. Rough processed blocks were dragged to the pier to be loaded onto sailing ships. If the quarry was near the shore, then blocks weighing up to 8 tons were lowered to the pier along an inclined plane of two or three parallel bars with under laying rollers and thick ropes. Delivery of monoliths from remote quarries was more complicated. It included the strong drag sledges driven by a dozen harnessed horses. A good road was built from the distant quarries to the loading point on the shore, along which stones weighing up to 30 tons had been transported for decades.

At the pier, the granite was loaded onto sailing deck vessels (soims, boats). One vessel could load in the hold up to 35 blocks with a volume of up to 1 m^3 or 10–15 blocks with a volume of up to 2.5 m^3. Large blocks weighing more than 16 tons were loaded onto the deck.

Vannisensaari Island is located at 6 km to the east of the town of Sortavala. It is composed of light gray, sometimes with a pink tint, fine-medium-grained, weakly banded Serdobol granites. On the island there are three heritage quarries which produced block stone for St. Petersburg (Figs. 12 and 13).

Large blocks up to 2.6 m long and 1.5 × 1.6 m in cross-section were obtained in the northern and southern parts of the island. The output of large blocks was insignificant due to complex fracturing. A lot of small fragments were left in the course of stone extraction and littered the site.

The largest quarry is on the southeast cape of the island. It is a group of trenches made on the slopes and top of a low mountain range. The length of the largest working is 70 m, the width is 10–20 m, the depth is 1.5–3 m, and the volume is more than 2000 m^3. Traces of drill holes with a diameter of 20 mm, drilled "in line" at a distance of 6–10 cm, as well as traces of stone processing were left on the ledges and prepared blocks. The blocks were extracted in one or two ledges. The site of the quarry is significantly littered with the small stone fragments and defective blocks 0.6–3 m long, 0.5–1.5 m wide and 0.5–1 m high.

Fig. 9 Monument to the ore miners, Tulonsaari Island

Serdobol granite from the island of Riekkalansaari was widely used in the architecture of the town of Sortavala until 1939 as a base and curb stone, to manufacture stairs of buildings and bridge supports, in cladding the walls of buildings and interior decoration. Also, the stone was used to make tombstones at cemeteries. A small part of this granite was sent to St. Petersburg in the nineteenth century.

Finnish stonecutters processed the surface of granite products in different textures, such as "rock" (the surface looks like natural rock), "dotted" or "forged" (surface with evenly spaced rounded sockets), "hewn" (smooth surface processed with a chisel) and "grooved", "hilly" and "hilly-grooved" (surface with unevenly spaced grooves and rounded sockets).

In total, in the period from 1870 to 1930 at Nukuttalahti quarries about 4000 m^3 of rock was quarried, including about 600 m^3 of regular shaped blocks with an average volume of 0.5–0.6 m^3 and monoliths 3–4.5 m long, 0.7–0.8 m wide and 0.5–0.6 m thick.

Quarries in the vicinity of the village Nukuttalahti are made in the coastal ledges of rocks in the form of trenches with a width from 5 to 20 m and depth of 1.5–4 m. They are easily accessible and well preserved, only overgrown with forest. In the ledges and in separate blocks there are traces of vertical holes with a diameter of 17, 24 and 30 mm, drilled "in a line" at a distance of 10–20 cm from each other. Many substandard blocks are left in the quarry.

The *Impiniemi* granite quarry is located on the cape of the same name. The rocks of the intrusive massif are represented by plagioclase medium- and fine-grained granites of gray color with various shades (dark, light, bluish, pinkish) with massive and gneissic texture. They are characterized by high physical and mechanical properties, decorative effect and are well polished. Natural cracks break granites into rectangular and bevel blocks of 0.5–2.5 m3, up to a maximum of 6 m^3.

Impiniemi granites were used for floors, stairs, curbs and decoration of buildings and constructions. In the nineteenth century, these granites were used in the construction and decoration of St. Petersburg buildings and architectural monuments. The stone was quarried by drill-wedging method, and shipped to St. Petersburg along Lake Ladoga.

There are 19 small heritage quarries at Cape Impiniemi. The workings have the shape of trenches up to 2.5 m deep and up to 25 m long. Unprocessed blocks of 4–5.5 m in length still lie in some quarries. Traces of boreholes 20–22 mm in diameter, drilled "in a line" at a distance of 10–15 cm from each other can be found on the surface of ledges and blocks. In the 1970s, an experimental quarry 12 m long, 2–4 m wide and 1–2 m deep was tested in the southern part of the deposit.

Prospecting research was carried out at Vannisensaari Island in 1955. Granite reserves amounted to 4.7 million m^3. This quarry deserves further study, and the stone can be used for restoration work in St. Petersburg.

The quarries of the *Riekkalansaari island* are located on the northwestern coast, in 4 km from the town of Sortavala, near the village Nukuttalahti (Fig. 14). The rocks are represented by medium-grained plagioclase granites of light gray, dark gray and pink-gray color often with quartz and pegmatoid veins. These granites are well suitable for processing and of highly decorative qualities, but they contain scattered dissemination of pyrite. Over time brown smudges appear on the stone as the result of pyrite oxidation. The rocks at the quarry have favorable fracturing. Distance between vertical cracks is 0.5–3 m.

Nowadays the quarries of Tulolansaari, Vannisensaari, Riekkalansaari and Impiniemi have significant reserves of

Fig.10 Quarry "Ruotsenkallio-2", Tulolansaari Island

Fig. 11 Granite block in the quarry "Ruotsenkallio-2", Tulolansaari Island

stone that can be used for restoration purposes. These places are often visited by tourists, students and schoolchildren. The most famous are the quarries of Tulolansaari Island, which officially have the status of a monument of historical and cultural heritage of Karelia and are located on the territory of the Ladoga Skerries National Park. There are plans to create a mountain-historical park here with excursion trails and mountain-landscape expositions.

Fig. 12 Quarry "Vannisensaari"

Fig. 13 Quarry "Vannisensaari"

Fig. 14 "Nukuttalahti" quarry, Riekkalansaari Island

References

Alopeus S (1787) A brief description of marble and other stone quarries, mountains and rocks of Russian Karelia. St.Petersburg, 1787. (in Russian)

Archive, 1310, No 1, ph 50, pp 18–19, 1768. On the manufacture of marble and wild stone for the construction of St. Isaac's Church in the Keksgolmsky district of graveyards Serdobolsky and Ruskeala with the installation of grinding mills there

Ryleev AV (1984) Study of mineral resources of stone building materials in Karelia. Institute of Geology, Karelian Research Centre, Russian Academy of Sciences, Petrozavodsk

Samoilov AN (1954) Alexander Ivanovich Terebenev (1815–1859). In: Russian Art. Moscow: Art

Serdobol granite quarries//Eng J 6(7) (1885)

Zembitsky Ya (1834) On the use of granite in St. Petersburg//Mining Magazine, SPb.

Old Stories of Ruskeala

Igor Borisov

St. Isaac's Cathedral is one of the main architectural landmarks of St. Petersburg. It is one of the most grandiose and majestic cathedrals of Russia. The outside walls of the cathedral are cladded with light gray marble slabs. The color of this stone reminds the light of northern white nights (Fig. 1). This stone is from Ruskeala on the northwestern shore of Lake Ladoga.

The first mention of the village of Ruskeala dates to the tax books of 1500 (Alopeus 1787; Mining road 2014). Initially, Ruskeala was a site between the Ruskolka River and a mountain made up by marble. First, a chapel (1632) and later a church subordinate to the parish in Kitei were built on this mountain.

At the end of the seventeenth century, nearby Ruskeala, the Swedes organized the first marble quarries. The Swedes used this marble for foundations and walls of buildings and to produce building lime (Leningrad regional archive of Vyborg (n.d.); Leningrad regional archive of Vyborg (n.d.); Russian State Historical Archive 1787; Russian State Historical Archive 1768).

After 1721, the Swedish marble quarries were forgotten for many decades. When Catherine II ascended the Russian throne, St. Petersburg demanded its own domestic marble. In the 1760s, deposits of beautiful marbles in the Vyborg province (formerly North Karelia) came out of oblivion. Industrial quarrying of Ruskeala marble started after 1768. A small ordinary village was transformed in a few years. Marble carvers from Yekaterinburg, Italian and Russian stone masters, foreign technicians, mining engineers and architects from St. Petersburg come here. Catherine II approved the idea of reconstruction of St. Isaac's Cathedral, associated with the name of Peter the Great, entrusting the design and construction of the church to a young architect from Italy, Antonio Rinaldi. It had to be the third St. Isaac's Cathedral.

I. Borisov (✉)
Republic of Karelia, The Regional Museum of the Northern Ladoga Region, Sortavala, Russia
e-mail: aldoga@bk.ru

The first wooden St. Isaac's Church was built in 1710. The second brick and stone St. Isaac's Church was founded in 1717. Due to an unsuccessfully chosen place on the unfortified bank of the Neva River, the walls of the church cracked and the building was dismantled. Antonio Rinaldi began the construction of the third St. Isaac's Church in 1768. However, later, by decree of Tsar Paul I, the finishing marble was removed to decorate the Mikhailovsky Castle. In 1816, the dilapidated St. Isaac's Church was closed and it was decided to build a new church in its site. The construction of the fourth cathedral was entrusted to a French architect Auguste de Montferrand. Construction began in 1818 and completed in 1858.

By this time about seven hundred people worked at the Ruskeala quarries and several sawing and polishing machines were in operation. Several quarries functioned on White Mountain, the largest of which reached a depth of thirty meters and had an area of several thousand square meters. The marble quarried at this site was homogeneous of light gray, bluish-gray color with thin white and black stripes and acquired the name "Belogorsky" marble.

Most of this marble was used to decorate the third and fourth St. Isaac's Cathedrals, a smaller part was used for window trims of the Marble Palace (1768–1785), for facing the southern facade of the Mikhailovsky Castle (1797–1800) (Fig. 2), to make window sills and floor boards of the Winter Palace (1760s), the construction of the obelisk "Rumyantsev's victories" (1799), the pedestal of the monument to Peter I (1800) in front of the Mikhailovsky Castle and other buildings of St. Petersburg.

Marble from the White Mountain was used in various edifices: the Orlov (or Gatchina) Gate (1772), the Chesme Column (1777–1779), the Catherine Palace (1782–1785) in Tsarskoye Selo, the columns of the Gatchina Palace (1766–1770), the pedestal of the "Roman fountains" (1798–1800) in Peterhof, the milestones of the Tsarskoye Selo (1772–1775) and Peterhof (1777–1787) roads (Fig. 3). At the beginning of the XIX century a quarry at the Green Mountain nearby White Mountain came into operation. Marble

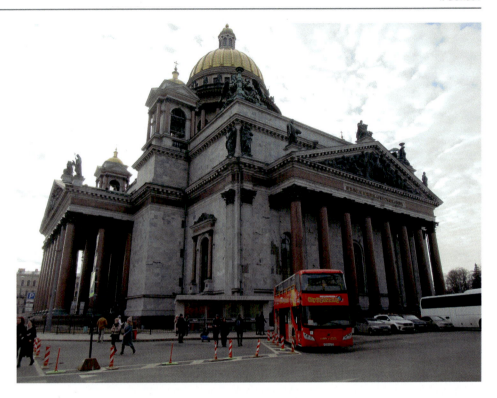

Fig. 1 St. Isaac's Cathedral lined with Ruskeala marble

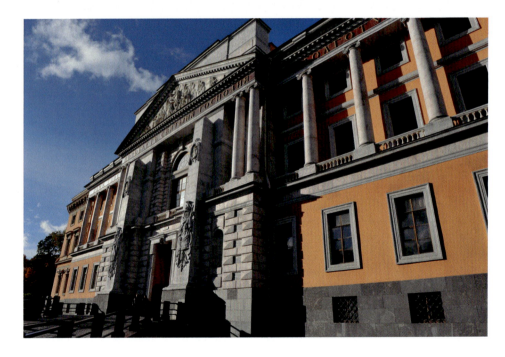

Fig. 2 Mikhailovsky Castle (Ruskeala marble is in the mail portal)

quarried at this new quarry was of grey color with green streaks and it got the name "Zelenogorsky". It was used in the interior decoration of the Kazan Cathedral (1801–1811) as well as for small paraphernalia items such as candlesticks, snuffboxes, and inkwells.

Other varieties of marble distinguished at the Ruskeala deposit are white with gray stripes, white with bluish stripes, pure white sugar-like and black marbles.

Marble at the Ruskeala was quarried as follows. First, the workers made a horizontal ditch 1.5–1.8 m wide and 4–6 m deep along the bottom of the ledge. Simultaneously, two grooves of the same size were made around the marked block. For this purpose, boreholes of 3.8 cm in diameter and 30–50 cm deep were drilled along a certain network. The boreholes were loaded with gunpowder, stamped with clay and blown up. From the top of the ledge in the direction of

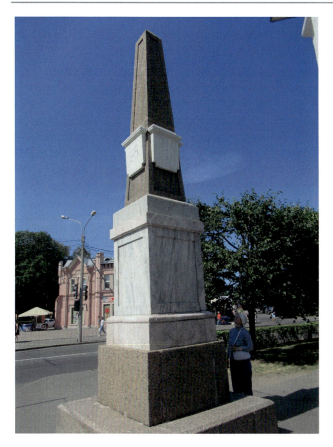

Fig. 3 The milestone of the Peterhoff road

the separation line at a distance of 2–6 m from each other, boreholes with a diameter of 7.6 cm and a depth of 5.7–9.5 m were drilled. They were filled with gunpowder and blown up.

Dihedral and tetrahedral drills from 1.5 to 9.8 m long were used for drilling. During one shift, two workers drilled 0.5–4 m of the rock. The process of drilling was manual and carried out in the following way: one worker hit the drill with a hammer, and the second held the drill and turned it after the blow.

In this way marble blocks weighing up to five tons were quarried in Ruskeala. Then, with the help of gunpowder, they were divided into smaller blocks, and those, in turn, were trimmed to obtain blocks of the correct shape. The transportation of marble blocks from Ruskeala to St. Petersburg was carried out in two stages: in winter, by a sleigh from the quarries to the river pier in the village of Helyulya. With the start of navigation the blocks were shipped on heliots along the Helyulya River, Lake Ladoga and the Neva to St. Petersburg.

In the period from 1769 to 1830 more than 200,000 tons of marble were quarried at the "Main" marble quarry of Ruskeala. Most of this stone in the form of blocks and slabs was sent to St. Petersburg, Tsarskoye Selo and Gatchina. A smaller part in the form of boulders and rubble was stored in dumps.

Ruskeala marble, due to the peculiarities of its composition and structure, turned out to be short-lived in the humid climate of St. Petersburg. Therefore, already in the 1870s, the first restoration of the walls of St. Isaac's Cathedral was carried out. Ruskeala marble was not enough for the restoration of the cathedral. Some of the broken slabs have been replaced with pale gray Italian "Bardiglio" marble inserts.

In 1840, quarrying of the Ruskeala marbles for St. Petersburg gradually faded and with the completion of the construction of St. Isaac's Cathedral came to an end. Without government orders, the Ruskeala quarries were completely neglected. But after a few years they revived. It was decided to continue marble quarrying in Ruskeala, but not for decorative and construction purposes, but for building and technological lime.

Most of the calcite marble was used for lime production, and a smaller part of the calcite-dolomite composition was used to produce building rubble, decorative chips and blocks. Lime was employed at pulp and paper mills for bleaching paper and in the construction industry, crushed stone was used to cover roads. But only calcite marbles were suitable for production lime of high quality and these rocks made up separate thin horizons and nests. It took a lot of effort and time to remove the dolomite marbles to get to the suitable rocks from the surface. The underground way is turned out to be the most economical and productive way of extracting raw materials in such conditions. It was used in combination with open pits. In the last third of the XIX century—the first third of the XX century the Ruskeala site was exploited at seven horizons, three of which were underground.

According to the mine surveying plan of 1945, the first (upper) underground horizon was located at around 71–74 m above the sea level. A transport drift with a cross section of five by three meters (in the widest parts up to 20 m wide and up to 10 m high) branched off a vertical shaft of the Main Mine. After 150 m it connected with the second shaft and a mining drift 150 m long. This drift was of a complex configuration with a width from 15 to 50 m and height of arches from 3 to 4 m. Pillars of rock were left along the axis of the drift to prevent the collapse of the roof. 15,000–20,000 m^3 of marble was mined in this shaft. The second (middle) underground horizon was 13 m below the first one and occupied an area in the center of the deposit 320 m long and 35 to 95 m wide. It was connected with the surface through the main shaft. Typical of the second horizon was the unusually large size of the workings, separated by giant pillars of rock. The width of the underground tunnels reached 30 m with the roof height of 3–6 m. 60,000–70,000 m^3 of marble were mined on the second underground horizon. The third (lower) underground horizon was at about

44 m. Its workings were not large, since the mining of marble was soon suspended.

Marble extraction from the underground and open horizons was carried out by the traditional drilling and blasting method. This method consisted of drilling a certain network of holes with a diameter of 30–50 mm and a depth of 1–3 m. The drill holes were charged with gunpowder and in the result of massive explosion the rock completely fell apart into pieces. In the 1930s, manual drilling was replaced by machine drilling with perforators. The rock mass was loaded into trolleys manually. Often there were large boulders which were broken with hammers into smaller ones. The workers pushed the trolleys loaded with stone along the rails from the faces to the mechanical lifts at the shafts. Initially, the lifting was powered by horse traction, and later, by a steam engine. The trolleys with marble raised to the surface were brought to the kilns. In 1896 at the Ruskeala plant operated three kilns with a capacity of 17–20 tons of lime per day, and in 1937, six kilns that produced 30–50 tons of lime per day (Fig. 4).

At the beginning of the nineteenth century the Finns began to deepen and widen the Main Quarry and reached the second underground horizon. In the first third of the twentieth century, the Ruskeala quarry and lime plant were called "Loukhios". In the first third of the twentieth century, Ruskeala marbles were used to decorate the Finnish cities. It was used in cladding the walls of the Savings Bank (1903) in Helsinki, and the floors of the city hospital (1910s) and the restaurant (1938) in Sortavala.

Ruskeala marbles produced good decorative white and gray chips for plastering walls and concreting floors and stairs of stone buildings in cities and towns of the Southeast Finland. From 1873 until the 1930s Ruskeala marble was also widely used as a memorial stone. On the outskirts of the village of Ruskeala an old cemetery has been preserved, where you can see skillfully carved marble tombstones.

After World War II, the Ruskeala plant again started to produce lime. But the Main Quarry was flooded, so the new workings were located nearby. From 1951–1952 the plant began to produce, in addition to lime, marble chips, and from 1960 it produced decorative crushed stone and lime flour for fertilizers.

In 1973–1985, decorative cladding marble was quarried at Ruskeala using Italian cable sawing machines. Slabs and blocks of marble were delivered to various parts of the Soviet Union. In St. Petersburg, grayish-green and light gray Ruskeala marbles decorate the underground halls of the Primorskaya and Ladozhskaya metro stations (Fig. 5). However, the production of block stone was suspended, because the practice of using massive explosions at the deposit caused the network of cracks. After the closure of the block quarry the Ruskeala plant continued to produce crushed stone and building lime for various regions of the country.

Now the old Ruskeala quarries have turned into beautiful mountain lakes; they are like giant marble bowls filled with the purest bluish-green water (Figs. 6 and 7). Old deserted mines and drifts look now like mysterious caves (Fig. 8). The dumps around the quarries resemble bizarre hills overlooking onto natural and technogenic landscapes. Nowadays, the Ruskeala Main Quarry with the remains of drifts and shafts is a mining monument of the late 18th - early twentieth centuries. The quarry is 450 m long, 60–100 m

Fig. 4 Ruskeala lime plant, 1930s

Fig. 5 Primorskaya metro station, St. Petersburg

Fig. 6 The main quarry of the Ruskeala deposit (Marble Canyon)

wide, 30–50 m deep, flooded to the level of the upper underground horizon. The old underground tunnels and grottoes are well visible. An old mine more than 50 m deep, which once connected all three underground horizons, has been well preserved. It can be reached by short adits cut in the rock. At the foot of the Belaya Mountain, dilapidated kilns, which were in operation from the beginning of the twentieth century till the 1980s, and a small crooked house of marble blocks which once was the factory management office (1899) have survived.

Every year, hundreds of tourists and stone lovers come to Ruskeala to wander along the labyrinths of quarries and dungeons, touch their cold marble walls with their hands, to look at the world around them with surprise and joy.

Fig. 7 The main quarry of the Ruskeala deposit (Marble Canyon)

Fig. 8 The tunnel of Ruskeala deposit (Marble Canyon)

References

Alopeus S (1787) A brief description of marble and other stone quarries, mountains and rocks of Russian Karelia. St.Petersburg (in Russian)

Leningrad regional archive of Vyborg, f. 1, No 212 (in Russian)

Leningrad regional archive of Vyborg, f. 1, No 13 (in Russian)

Mining road (2014) Institute of Geology, Karelian Research Centre, Russian Academy of Sciences, p 115–166 (in Russian)

Russian State Historical Archive (1768) f. 1310, op. 1, p 50, sh. 18, 19 (in Russian)

Russian State Historical Archive (1787) f. 789, op. 15, No 84, sh. 4 (in Russian)

Putilovo Limestone—First in St Petersburg

Leonid Hariuzov and Anton Savchenok

Starting from 1710, one of the main building materials of the city, along with brick, became layered carbonate rocks, which occur in the southern environs of St. Petersburg. Quarrying began near the village of Putilovo, after which this stone is named "Putilovo stone" or "Putilovo limestone". Limestone was quarried within the ledge of the Baltic–Ladoga glint (Fig. 1). In winter, the stone was delivered by sleigh to the shores of Lake Ladoga, and then shipped to St. Petersburg.

This stone was used in the early periods for construction of fortresses, fortifications, and churches on the territory of the Novgorod Republic (Staraya Ladoga, Oreshek (Shlisselburg) fortress, Koporye fortress, etc. Besides, it was used as (1) backfill material to form the foundations of buildings; (2) waterproofing material at the base of cellars; (3) masonry material at the foundation–brick wall border; (4) cladding material for the basement parts of the facade walls; (5) structural material in the brickwork (under-cornice slabs, plinths, bases, and beam ceilings of openings; (6) architectural and decorative design of facades - consoles, decorative inserts in the facing brickwork; (7) manufacturing material for flights of stairs, blind area of landings, corridors, and lobbies, pedestrian sidewalks and platforms, in the design of various types of porches and terraces, parapets, various kinds of fences, gate pylons, columns, etc.; and (8) cladding material for some embankments, and bridges (Figs. 2, 3, 4, 5, 6, 7, 8, 9 and 10).

Amount of the stone quarried and used in the construction of the city is practically incalculable. During the eighteenth and nineteenth centuries, the volume of production on average constituted 70,000 m^3/year. After World War II, the size of production did not exceed 7–8 thousand m^3/year. Maximum production was in 1996 when the volume of the rock mass amounted to 44,000 m^3/year. At present, the production is at the level of the post-war years. The stone is quarried at the Putilovo and Babino Seltso quarries (Fig. 11).

What is this stone and what are the features of its composition and structure that affect the architectural attractiveness and stability in the operation of buildings and constructions?

Limestones of the Leningrad region belong to the Volkhovian horizons of the Arenigian Stage of the Lower Ordovician (the absolute age is about 470 million years). The deposits are distributed along the ledge of the glint which stretches from the Leningrad region through Estonia to Sweden. For a long time, the limestone packet has been called "wild" due to the usage of the stone in an unprocessed wild form or because of its uneven variegated color. The "wild" packet consists of layers, each of which has its own name. Each layer has special decorative and physical properties and composition. Therefore, each of them was suitable mainly for certain types of building products (Table 1). The stone for cladding the basements of the old St. Petersburg buildings was taken from the "Butok" and "Bratenik" layers. The limestone of "Staritsky" layer was used for window sills. Other limestone layers were employed for less important purposes (for example, back stairs steps). It is noteworthy that the most catchy and eminent in color limestones were not used, because they are extremely fragile. As a result, in the course of quarries exploitation, a large amount of the extracted stone went to waste. Part of the stone from the wastes was used for the production of building lime.

The total thickness of the "wild" packet reaches 2.2 m. They form steep slopes, walls, cornices, and waterfalls along the banks of the Volkhov and Tosno rivers (Fig. 12). Thick-platy limestones are divided along the bedding planes, to which clay interlayers are confined, into slabs of different thicknesses with slightly wavy surfaces. The color of

L. Hariuzov
Research Department, St. Petersburg "Special Project Restoration", Saint-Petersburg, Russian Federation
e-mail: hariuzov66@yandex.ru

A. Savchenok (✉)
Research Department, Committee for the State Inspection and Protection of Historic and Cultural Monuments, Saint-Petersburg, Russian Federation
e-mail: savanton@mail.ru

Fig. 1 Staraya Ladoga Fortress on the Volkhov River

Fig. 2 Facing of the basement part of the facade

limestone can be uniform or spotted. The main colors are gray-beige, greenish-gray, red-violet, and yellow.

Limestones are characterized by the presence of fossilized remains of marine organisms, such as trilobites, gastropods, bryozoans, etc., united under the general term—detritus. Some layers are characterized by traces of vital activity of drilling organisms in the form of uneven cylindrical passages. The abundance of fossilized organic remains determines the structure of the rock as organogenic-clastic.

Fig. 3 Facing of the basement part of the facade, the base of the column

By chemical composition, limestone is a carbonate rock with CaO content of 38.3–50.6 wt. % and CO_2 from 34.7 to 40.6 wt. %. The following oxides MgO (1.1–5.5), Al_2O_3 (1.7–4.0), SiO_2 (3.6–9.0), and Fe_2O_3 (1.3–3.0) are present in minor quantities (wt. %). These oxides are typical for clay minerals and determine the color of the stone.

Mineralogical composition of limestone is not complicated. The main mineral, calcite, makes up the fine-grained matrix. Calcite replaces organic detritus and forms crystals and druse-like intergrowths in voids. Dolomite (calcium and magnesium carbonate) is less common and occurs in the form of rhombohedral crystals. Dolomite content in the rock can reach 10 vol. %.

Glauconite (a complex alkali–iron–magnesium silicate) is a typical mineral of limestone and occurs in the form of impregnated grains of dark green color. Besides the mentioned minerals, limestone contains quartz grains, mica flakes, pyrite, and iron hydroxides. The latter have uneven distribution in some layers and provide red, brown, and purple tonality of the rock.

Clay component is conventional for the Putilov limestone although it makes a small amount (about 1 vol. %). It has a greenish-gray, yellow, and brown color. The clay substance fills the interlayers separating rock layers from each other. The negative effect of the clay substance on the quality of the Putilov stone is determined by some properties of clays, such as their reduced mechanical strength, the ability to swelling under wet conditions and ability to cracking under dry conditions. Thus, the technical properties of limestone depend on the quantity and nature of the clay substance distribution within the rock volume.

The slabstone was quarried along the layers with the help of special long crowbars, picks, less often using mine powder. The slabs were well separated along the bedding, due to the presence of clay interlayers between them and the system of steeply dipping joints of the northeast and northwest strike made it possible to obtain slabs up to 1.5 m^2 or more in size. The quarried slabs were stored in "warehouse" on the banks of the rivers. At modern quarries, the slabs are stored near the stone processing factories (Fig. 13). The main

Fig. 4 Decorative elements—pilaster capitals

Fig. 5 Column on the base with a plinth

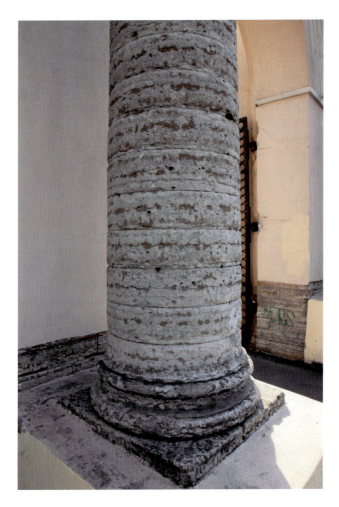

Fig. 6 Porch country cottages. Petrodvorets

Fig. 7 Entrance group pylons

Fig. 8 Spiral staircase in the interior

Fig. 9 Lining of the retaining wall (Griboyedov Canal at the Kazan Cathedral)

Fig. 10 Lining of trusses and abutments of the Ioannovsky Bridge

Fig. 11 General view of the modern quarry (Putilovsky)

work on cutting the slabs was carried out at a quarry or in warehouses, from where the finished products were transported along the rivers and the Ladoga Canal to Petersburg. The processing of the slabs was carried out using mechanical saws with a free abrasive (quartz sand) across the layering in accordance with the specified size. Further processing was carried out by a hand tool using the method of cutting and peeling by rough grinding with a free abrasive. The lower bearing surface of some building products was not processed and retained its natural wavy uneven shape. In the process of grinding with an abrasive, the wavy uneven surface of the stone was flattened to dense limestone. In order to avoid the

Table 1 Scheme of limestone "Putilovskaya plate"

No. layer	Name	Size, cm	Using
1	Butok	22	Facing plates, steps (Solyanoi lane, 13)
2	Bratenik	13–19	Plinths, steps, paving slabs, cornices (Solyaniy Lane,13, Liteyny ave., 19, Mokhovaya str., 30, 36)
3	Pereplet	25	Plinths, steps, paving slabs
4	Konopljanistiy	7–12	Facing plates, cornices
5	Mjagonkiy	9–9,5	Plinths, steps
6	Nadjoltiy	13–20	Plinths, steps
7	Yellow	18	Steps (Mokhovaya str., 30, Konyushennaya, 4, Mendeleevskaya line, 1)
8	Butina	2–7	Rubble stones
9	Red	24	Plinths
10	Staritskiy	11	Facing of plinths, window sills, ritual stone
11	Green	9	Facing plates (Nevsky Ave., 26-28, Mendeleevskaya line, 1)
12	Beloglaz	20	Facing plates, (Mokhovaya str., 30, Konyushennaya str., 6), rubble
13	Krasnenkiy	8–8.5	Rubble stones
14	Melkocvet	10	Rubble stones
15	Velvet	10	Rubble stones

Fig. 12 Waterfall on the Tosna river

Fig. 13 Storage of limestone slabs at the (Putilovsky) deposit

stone destruction along layering it was necessary to arrange the products with natural layering parallel to the ground. Installation of the plates vertically led to their rapid splitting.

Before the Revolution of 1917, at the Putilovsky quarry, seven layers of "wild" limestone out of fifteen went to waste due to their extremely low resistance under ambient conditions. The most valued layer was the "Bratenik" layer, which was used to make floor slabs and steps of the front stairs. The "Butok", "Staritsky", and "Bratenik" layers were highly valued. Rocks from "Nadjoltiy", "Yellow", and "Beloglaz" layers were destroyed faster, and therefore they were used less frequently, in particular for the back stairs.

"Putilov" limestone as a building and decorative cladding material has been tested in St. Petersburg by time. When following quarrying, processing, and maintenance technologies, it is strong and reliable material.

Such Different Sandstones

Anton Savchenok

Sandstone occupies a special position in stone decoration of many cities all over the world. It is easily processed by a chisel, and thus preserves the shape of different complexity in architectural details and sculpture. It is resistant to weathering. This type of decorative facing stone is typical for buildings of the eclectic and Art Nouveau periods erected in the 1850s–1910s in St. Petersburg. At this time, interest in domestic natural stone gradually faded and fashion turned to imported foreign stones. Techniques for using sandstone came to Russia from Western countries, where this material is traditional. The most prominent examples are the Reichstag (Bundestag) building, the Brandenburg Gate, and the Dome in Berlin, cathedrals, churches, the Royal Palace, and the railway station in Dresden.

Nowadays, among the architectural monuments of St. Petersburg, there are more than 35 buildings and other architectural constructions decorated or cladded to a greater or lesser extent with various types of sandstones. Most of them are cultural heritage sites located in the historical center of our city. If you take a walk in the center of St. Petersburg: along Bolshaya Morskaya Street, Nevsky Prospect, Stremyannaya Street and Grafsky Lane, Palace and Angliyskaya Embankments, along the streets located between the Summer and Tavrichesky Gardens, you can see buildings decorated with sandstone.

According to historical data, the first building in St. Petersburg where sandstone was used is the house in Liteiny Prospekt, 42. This is the former mansion of Princess Z.I. Yusupova, erected in 1852–1858 by the architect Ludwig Bohnstedt. For the front facade, he chose the so-called "Bremen stone"—light gray sandstone from Germany. This is a strong dense fine-grained rock made of quartz grains cemented with silica. This stone was used for facing slabs, columns, and sculptural and carved decorations. The construction of the building began in 1852, but later the supply of stone was interrupted by the outbreak of the Crimean War and the naval blockade of St. Petersburg. This forced L. Bohnstedt in 1856 to withdraw and terminate the contract. The contract for the completion of the construction was signed with Augustine Triscorni. He delivered from Germany the previously paid, but not shipped "Bremen Stone". However, the volume of delivered sandstone was insufficient. The contractor purchased other types of natural stone, indicated in the historical data as "Gatchina stone" and "Revel sandstone". "Gatchina stone" presents the dolomite quarried in the neighborhood of Gatchina. "Revel sandstone" is an organogenic-detrital limestone quarried near the city of Tallinn. As a result, at present, in the facing of the front facade, one can see color heterogeneity and spot due to the use of various rocks. The gray areas are parts made of "Bremen sandstone", and the yellowish ones are made of Gatchina dolomite and organogenic-detrital limestone (Fig. 1).

Another building situates in Solyanoi Lane next to the St. Panteleimon Church. This is the building of the Museum of the Central School of Technical Drawing of Baron A. von Stieglitz. It was built by the project of the architect M. Messmacher in 1895–1896. Façade of the building is designed in the forms of Italian Renaissance (Fig. 2). The building stands on a high base made of Pyterlahti granite and has a central and two side risalits. Above the base, most of the architectural elements of the façade are made of sandstone. There are two color varieties in the facing sandstone blocks: gray and yellow. All smooth walls, sculpture, semi-columns, and their bases are made of gray sandstone, while the window holes at the level of the ground floor and the panes under the windows of the first floor are made of yellow. The album of the German company "Zeidler&Wimmel" (1976, 2001) tells that the sandstone quarried at the Rakowice Male quarry in Lower Silesia, 12 km south of Bolesławiec (Bunzlau). The company completed all preparatory technical, stone-cutting, and sculptural work with sandstone at the quarring site, and then mounted it on

A. Savchenok (✉)
Committee for the State Inspection
and Protection of Historic and Cultural Monuments,
Saint-Petersburg, Russian Federation
e-mail: savanton@mail.ru

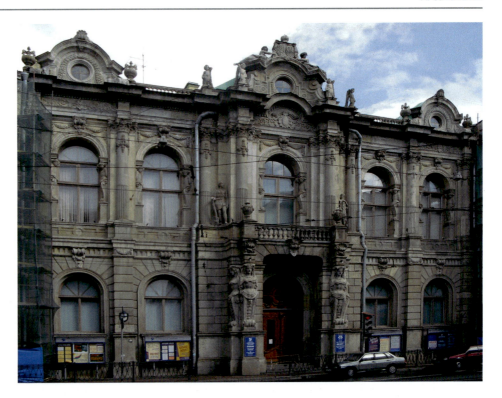

Fig. 1 General view of the front facade of building No. 42 on Liteyny Avenue

the walls of the building. For this work, the company was awarded the medal of the Ministry of Finance of Russia "For Diligence and Art".

The former building of the Russian Bank for Foreign Trade (Bolshaya Morskaya Street, 32) was built in the eclectic style by V.A. Schroeter in 1887–1888. The entire height of the building is cladded with three color varieties of "Württemberg" sandstones: red-brown, green, and yellow, quarried in Germany. Red-brown sandstone was used in the cladding of the basement and door portals; green—in the cladding of the first floor; yellow—in wall cladding and architectural elements above the second floor inclusive (Fig. 3). In the course of restoration in 2005–2006, some of the sandstone parts replaced. On the basement floor, made of red-brown sandstone, the stone remained intact with traces of weathering. The cladding and architectural details of the higher floors underwent restoration. Inserts and badly damaged or missing parts replaced. Polish sandstone from the Szmilów quarry (Bulakh et al. 2011) differs from the historical sandstone not only in color but also in structural and textural features (Fig. 4) used to replace the lost details and parts of the yellow and green sandstone blocks.

"Württemberg" sandstones were used in the cladding of the building of the former palace of Grand Duke Mikhail Mikhailovich in Admiralty Embankment, 8. The building was designed by the architect M. Messmacher in 1885–1891 in the style of Italian Renaissance. Two color varieties of sandstone were used in the architecture of the building: red-brown and yellow. Red-brown sandstone was used in the cladding of the basement and first floors, and yellow sandstone was used in the cladding of the second and third floors (Fig. 5). An interesting feature of this building is that the architect used natural stone only for the facade overlooking the Admiralty Embankment. All the other exterior parts of the building are made using two-layer plaster with sandstone-colored upper decorative layer.

Two buildings located relatively close to each other are cladded with sandstone. These are the building on Bolshaya Morskaya Street, 22, and the building on Gorokhovaya Street, 4. The first building was completely rebuilt in 1905 by the architect Carl Baldi for the Central Telephone Station. Two color varieties of sandstone were used in the cladding of the building: red-brown and gray. Gray sandstone was used for cladding at the level of 1–3 floors and red-brown for the first floor and carved decor at the level of the third floor (Fig. 6).

The apartment building in Gorokhovaya Street, 4, constructed in 1908–1909 by the project of the architect Marian Peretyatkovich in neoclassical style with elements of Art Nouveau for the Salamander Insurance Company. Several types of natural stone—red Gangut granite, red "Radom" sandstone, and white marble—were used in the decoration of the building. The sandstone was used not only for the cladding of the bay windows and railing of the balcony and cornice but also for numerous carved elements. A salamander carved from a sandstone block above the main entrance (Fig. 7). In some publications, the stone of these two buildings is referred to as "Radom" sandstones.

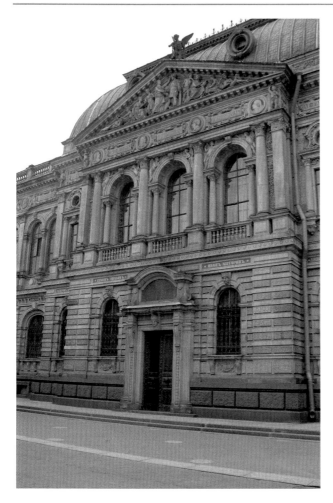

Fig. 2 General view of the front facade of building No. 15 on Solyanoy Lane

Another interesting building is on Socialists street, 14. It was built according to the project of the architect B. Girshovich in 1905–1906 with the front facade designed in the Art Nouveau style. The front facade of this building outstands with a rich variety of finishing materials. The walls are cladded with brown and green glazed bricks at the level of the third, fourth, and fifth floors. Sandstone was used in the design of the walls at the level of the 1–2 floors, belts in the lower and upper parts of the fifth floor, and the wall of the attic above the cornice of the central part. Sandstone details are decorated with various stone carvings (Fig. 8). This sandstone is unique for the architecture of our city and is not found elsewhere. It is remarkably rich in green color, strikingly different from the light green sandstone found in the cladding of the building in Bolshaya Morskaya Street, 32. The provenance of this sandstone remains unknown.

Summarizing the information on sandstones, it should be noted that, according to color and physical and mechanical properties, the most probable sources of these rocks are located in Central Europe within the modern territories of Germany and Poland. Historical references on the architecture of St. Petersburg name these sandstones as follows: "Stuttgart", "Bremen", "Württemberg", "Radom", "Kunovsky", "Shydlovetsky", etc. These names have obvious German and Polish roots, but sandstones with such names are not known either in Germany or in Poland and are trademarks of the stone. They are given roughly according to the place where the stone was brought from but do not indicate the exact places of quarring the stone which is important when planning restoration work.

Four large regions can be distinguished based on the published information on the history of the sandstone supply to St. Petersburg and the geography of their quarrying. On the modern political map of Europe, they are located within the territories of Germany and Poland (Fig. 9, Table): a—100 km south of Bremen, the Weser Mountains and the Teutoburg Forest (modern territory of Germany); b—the region of Baden-Württemberg and northwestern Bavaria (modern territory of Germany); c—the region of Lower Silesia (modern southwestern Poland); d—Swietokrzyskie mountains (modern Central Poland).

Sandstones were delivered to St. Petersburg from these regions both by sea and by railway. Historical quarries are located near major rivers: the Oder, Elbe, Weser, and Main, so it was convenient to deliver the stone to the coast of the Baltic Sea to Stettin, Hamburg, Bremen, and Rotterdam, and then ship to the cities of Europe and St. Petersburg.

In the second half of the nineteenth century, railways, as new transport arteries, significantly expanded the geography of supplies of natural stone from Europe to Russia. In the 40s of the nineteenth century, many European countries started railways construction. In 1845, the railway from Warsaw to Vienna was opened. It passed the town of Szydłowiec and other places in present-day Poland, where sandstone was traditionally quarried. The railway from Warsaw to St. Petersburg was built a bit later in 1852–1862. Apparently, Lower Silesia and the Swietokrzyskie mountains were the main regions for sandstone supply by railway.

The term "Radom" may indicate the closeness of quarries to the town of Radom (Central Poland). But in reality, there are no sandstone quarries near this town. Stone from this region was delivered to St. Petersburg by railway and the town Radom was mentioned in the bills as the site of departure.

A similar situation happened with the "Bremen" sandstone shipped to our city. There are no sandstone outcrops near the city of Bremen. They are located approximately 100 km south in the river Weser valley. The city of Bremen, being a port city, was only the place of the final shipment of the stone on its way to St. Petersburg and other European cities.

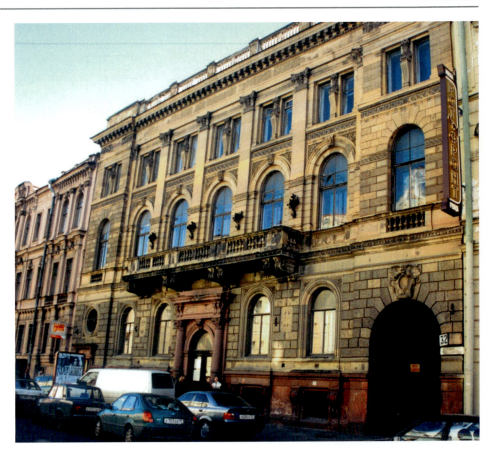

Fig. 3 General view of the front facade of building No. 32 on Bolshaya Morskaya Street. Photo 2004

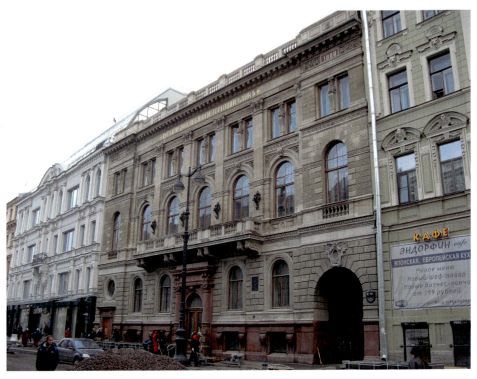

Fig. 4 General view of the front facade of building No. 32 on Bolshaya Morskaya Street. Photo 2008

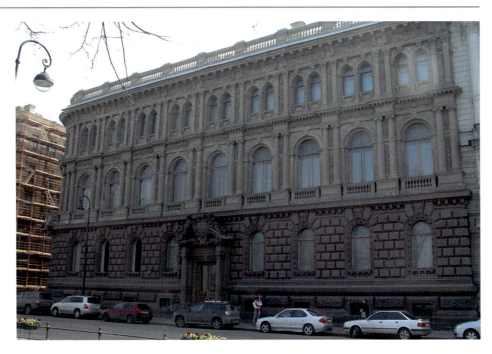

Fig. 5 General view of the front facade of building No. 8 on Admiralteiskaya nab. Photo 2005

Fig. 6 Details of the facade design of building No. 22 on Bolshaya Morskaya Street

Thus, the names of sandstone cited in literature and other available sources in most cases indicate not the place where the stone was quarried, but the geographical site of its purchase or shipment.

While working with archival documents and historical literature, special attention should be paid to the history of the territories with sandstone outcrops (quarries). The political map of Western and Eastern Europe from the beginning of the nineteenth to the middle of the twentieth centuries underwent significant changes. In the period from 1815 to 1915, part of the territory of modern Poland (the Kingdom of Poland) belonged to the Russian Empire. The territory of the Świętokrzyskie Mountains belonged to the Kingdom of Poland, but the territory of Lower Silesia, currently belonging to Poland, belonged to the German Empire. This territory will come under the jurisdiction of Poland only after 1945.

Most sandstones in Poland are of Triassic, Jurassic, and Cretaceous ages. The outcrops are located in three major regions of the country: Lower Silesia, the Świętokrzyskie

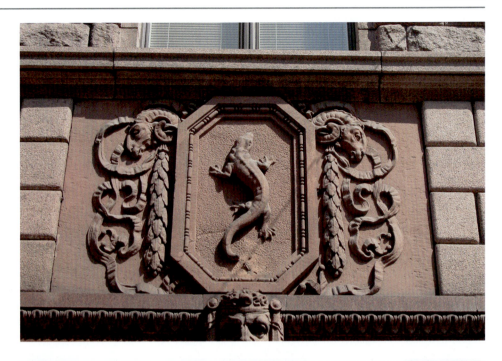

Fig. 7 Details of the facade design of building No. 4 on Gorokhovaya Street

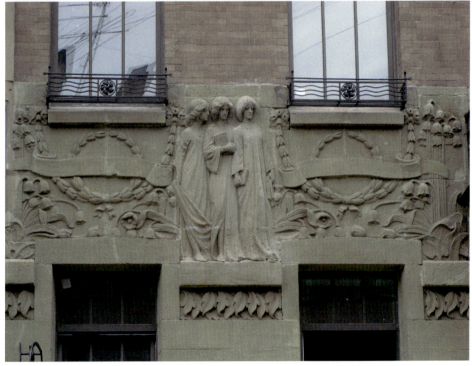

Fig. 8 Details of the facade design of building No. 14 on Socialist Street

Mountains, and the Carpathians (Natkaniec-Nowak and Heflik 2000). Sandstone from the first two regions was employed in the architecture of St. Petersburg.

Lower Silesia has always played and still plays an important role in the Polish map of building and road materials. Upper Cretaceous sandstones from the North Sudet trough, as well as Permian and Upper Cretaceous sandstones from the Inner Sudet trough, are economically important in this region.

In the North Sudet trough, sandstones outcrop between the settlements of Zlotoryya, Boleslavets, and Lvuvek-Slyonsky. These are light-colored quartz sandstones with clayey or clayey-siliceous cement. The difference between sandstones of different layers is in their structural and textural features. The most famous quarries are Żerkowice, Mala Rakovitsa, Zhelisof (Żeliszów), Nowa Wies Grodziska (NowaWieśGrodziska), and the now deserted quarry near the village of Czaple.

Fig. 9 Areas of the main sandstone deposits (state borders are given for the period 1871–1918) (Table)

Number on the map	Places
I	Bentheim, Gildehaus
II	Oberkirchen
III	Velpke
IV	Baumberg
V	Ruthen
VI	Arholzen, Karlshafen
VII	Niederwaim
VIII	Udelfang, Kylltal, Vogesen
IX	Schweinstaler, Pfalz
X	Neckartaler Sandstein
XI	Wustenzel, Miltenberg, Ebenheid, Eichenbuhl
XII	Coburg, Schonbach, Sand am Main, Neubrunn, Schonbrunn
XIII	Żerkowice, Rakowiczki, Czaple, Nowa Wieś Grodziska, Żeliszów
XIV	Szczytna, Radków, Słupiec
XV	Tumlin, Kopulak, Baranów, Wąchock, Szydłowiec, Śmiłów

In the Inner Sudet trough, sandstones occur at various levels, but Permian "Red Silesian sandstones" are economically important. They are distinguished from other rocks by their light red to brown color and distinct parallel bedding. Near the village of Nowa Ruda, there is a small Słupiec I outcrop where this sandstone is currently being quarried. Upper Cretaceous blocky sandstones are quarried in this region at two outcrops: Radków and Szczytna-Zamek. This sandstone is light yellow to pink-brown, medium-grained, and composed of quartz.

In the Świętokrzyskie Mountains (Małopolska Upland) Lower Triassic sandstones occur in the south, and Lower Jurassic sandstones occur in the north. Lower Triassic sandstones can be found in several exploited and deserted deposits. The dark cherry variety from the Kopulak quarry near Suchedniów is similar to the Lower Triassic sandstone which was quarried near the village of Wąchock. In terms of structural and textural features and composition, it is uneven-grained sandstone with ferruginous-siliceous-argillaceous cement.

Sandstone from the village of Wonhotsk near the town of Szydlowiec is remarkable for being used as a building stone for a 12th-century basilica in Poland. The walls of the basilica are faced with slabs of dark cherry Lower Triassic sandstone and yellow Lower Jurassic sandstone from nearby quarries (Kamieńskiey and Skalmowskiey 1957).

Lower Jurassic sandstones outcrop in the north of the Świętokrzyskie region. These are white and light yellow fine-grained sandstones with clay bands. Sandstones were quarried near small towns (Nietulisko, Kunów, Szydlovec). Today, there are several small quarries in the region and one large quarry near the town of Smiłow. They produce white and light yellow fine- and medium-grained sandstone with siliceous cement.

Sandstones in Germany make up single mountains and uplands. The rocks outcrop in the central and southwestern parts of the country with mountainous and plateau relief. Triassic and Cretaceous sandstones are widely used in architecture. Intensive export to St. Petersburg took place from central (northern part of Bavaria and Baden-Württemberg and southern part of Rhineland-Palatinate) and northern (North Rhine-Westflia and Lower Saxony) Germany. Sandstones of central Germany are of Lower Triassic and Upper Triassic ages.

Lower Triassic sandstones are motley rocks with spotted color. The most interesting and significant from the point of view of possible export to St. Petersburg are the following quarries. The Schweinstaler sandstone (Schweinstalersandstein) quarry is located east of the city of Saarbrücken in the southern part of the Rhineland-Palatinate. This sandstone is medium-coarse-grained light red, red, and rarely white. The sandstone is composed of quartz and clayey cement. This sandstone is very durable and withstands the influence of water and acids.

A well-known group of Lower Triassic sandstone quarries in central Germany are the quarries of red Main fine-grained sandstones (Roter Mainsandstein) located along the Main River and its inflows. Two large quarries are

Fig. 10 Collection of sandstones used in the decoration of St. Petersburg

known near the village of Wustenzel (Wustenzellersandstein) and near the town of Miltenberg (Miltenberger Sandstein). In central Germany, Coburgersandstein, Schonbachersandstein, and Sandersandstein quarries are located near Hasfurt. The sandstones of the first two deposits are fine-grained of yellowish-gray color. The Sandersandstein sandstone show fine-even-grained texture and has a greenish-gray color.

In the northern and central parts of Germany, heritage quarries are made up of Triassic and Cretaceous sandstones. Lower Triassic sandstones form the Weser Mountains. The most famous is the red sandstone quarry near the village of Arholsen (Roter Wesersandstein Arholzen) and the red and gray sandstone quarry near the town of Bad Karlshafen (Roter und Grauer Wesersandstein Karlshafen). The sandstone is medium-grained, composed of quartz with clay cement. In the old days, stone from these quarries was shipped along the Weser River to the sea via the city of Bremen.

Lower Cretaceous sandstones outcrop in the southern part of Lower Saxony. The most famous are the quarries of Wealden (WealdenSandstein), Bentheim (Bentheimersandstein), Gildehaus (Gildehausersandstein) sandstones and sandstones of the Teutoburg Forest (Teutoburger WaldSandstein).

Wealden sandstone (WealdenSandstein) occurs to the east of the towns of Süntel and Nesselber and forms the Deister uplands, Stemper and Reburg mountains. The sandstone is light yellow, fine-grained, and composed of well-rounded quartz grains with clayey cement. Bentheim and Gildehaus sandstones were quarried near the small towns of Bentheim and Gildehaus close to the border with the Netherlands. The sandstone is fine-grained, coarse-grained, white, and yellow in color, resistant to weathering. Sandstones of the Teutoburg Forest (Teutoburger WaldSandstein) occur from the Diemel River to Bevergern. The sandstone is medium-grained of a light yellow to brown color, composed of quartz.

Upper Cretaceous sandstones occur in the central and northern parts of the North Rhine-Vestaflia. Historically important sites are the Baumberg group of quarries (Baumberger Sandstein) and the quarry of Rüthen sandstone (Rüthener Sandsteine) near the city of Dortmund. Baumberg sandstone (Baumberger Sandstein) is medium-grained and yellow in color with calcite cement. Rüchen sandstone (Ruthner Sandstein) is medium-coarse-grained of bright green in color.

According to the descriptions of architectural objects and descriptions of sandstones from various quarries in Poland and Germany, it can be seen that the most important macroscopic feature of the rock is its color. The following color varieties are distinguished: (1) red-brown; (2) gray and light yellow; (3) light green; and (4) green (Fig. 10a–d).

Comparison of the structural and chemical characteristics of sandstones from the architectural monuments of St. Petersburg and the quarries of Poland and Germany made it possible to identify specific places where the stone was quarried for the architectural objects of St. Petersburg. Most often, the sandstones of the first two color varieties are used in the cladding of buildings in St. Petersburg.

References

Bulakh AG, Marugin VM, Zolotarev AA, Savchenok AI (2011) Restoration of two mansions faced with german sandstone in St. Petersburg. Qualimetrical estimation of results. Bausubstanz 1:56–60

Kamieńskiey M, Skalmowskiey W (red) (1957) Kamieniebudowlane I drogowe., Warszawa

Natkaniec-Nowak L, Heflik W (2000) Kamienie Szlachetneiozdobne Polski. Krakow

Zeidler&Wimmel (1976) Reisner J., Zeidler-und-Wimmel-Steinbruch- und Steinmetzbetriebe (Berlin, West; Kirchheim, Würzburg), Bauen in Naturstein: 200 Jahre; Steinbrüche, Steinmetzbetriebe, Steinindustrie, Bruckmann

Zeidler&Wimmel (2001) 225 Jahre Architekturmit Naturstein

Soapstone (Talc-Chlorite Schist)

Anton Savchenok and Leonid Hariuzov

Talc-chlorite schist in geological, architectural, and local history literature is called "pot stone" or "soapstone". It is a metamorphic rock consisting of talc, magnesite, and chlorite. Traditionally, this stone was used in everyday life due to its special physical and mechanical properties, such as high heat capacity and low coefficient of thermal expansion. The peasants carved stove pots and other kitchen utensils out of it, for which the stone is called "potted". Dishes made of this stone retained heat for a long time, due to its high heat capacity. It is also used in the manufacture of stoves and fireplaces. The presence of talc in the rock gives it a greasy shine. For this, the stone is named "soapstone".

The appearance of potted stone in the architecture of St. Petersburg is inextricably linked with the history of the development of the architectural style "modern" in the late nineteenth–early twentieth centuries. In St. Petersburg, the leading variety of Art Nouveau has become the "Northern Art Nouveau" style. This style required a qualitatively new stone, different in properties from granites, marbles, sandstones, quartzites, and other rocks. This place is occupied by a potted stone. It is durable and resistant to urban environments (repels moisture and is relatively slow to pollute). The stone is quite soft and malleable to the sculptor's chisel. This made it possible to use it as facing slabs with various processing textures and decorate the facades of buildings with bas-reliefs, high reliefs, and sculptures. Having entered the construction practice together with the "Northern Art Nouveau", potted stone remained in the architecture, cladding, and decoration of buildings built in the style of "neoclassicism" in the second decade of the twentieth century.

Houses built during the period of Northern Art Nouveau and neoclassicism are characterized by a bright and expressive appearance. In St. Petersburg, these periods are inextricably linked with the names of famous architects (F.I. Lidval, S.I. Minash, N.V. Vasiliev, A.F. Bubyr, A. Shulman, V.S. Karpovich, M.H. Dubinsky, I.A. Pretro, V.A. Kosyakov, architects of the Benois family, etc.). To date, there are many buildings and structures decorated with this type of stone in the architecture of St. Petersburg.

Sculpture and bas-reliefs located on the sides of door portals, window frames, and inter-window spaces have become one of the special areas of use of potted stone in architecture. As a rule, these are fabulous and mythical creatures that are combined with the asymmetry of the forms of the building itself. Along with the sculpture in the decoration of the building, slabs of this stone are used with different textures of the processing of the front surface—rocky, smooth polished, hewn, and treated with buchard.

One of the famous examples of Northern Art Nouveau in our city is the building located at the address Kamennoostrovsky Prospekt (house 1–3) (Fig. 1). This apartment building was erected by F.I. Lidval in 1899–1904. The main part of the building consists of three buildings. Various finishing materials are used in the decoration of facades: light brown rough plaster, granite blocks, and slabs of potted stone, made in smooth and rocky textures. The most attention is attracted by the carving of potted stone at the entrance to each building. In the center of the decoration of the central portal is a cartouche with the date of construction of this part of the building—1902. To the right of the date, there is a pine branch with cones, a forest bird resembling a magpie is sitting on it; it tries to peck a hare sitting next to it. Behind him, another hare is seen running out of the thicket. To the left of the date is the head of a lynx with an open mouth. Nearby, on a thick branch, sits an owl with open wings. Above you can see a large relief owl. She tilts her round head down and stares at passers-by with unseeing eyes. On the wall of the left front door, you can see images of fantastic big-headed fish, and above the right front door there are lion

A. Savchenok (✉)
Committee for the State Inspection and Protection of Historic and Cultural Monuments, Saint-Petersburg, Russian Federation
e-mail: savanton@mail.ru

L. Hariuzov
Research Department, St. Petersburg "Special Project Restoration", Saint-Petersburg, Russian Federation

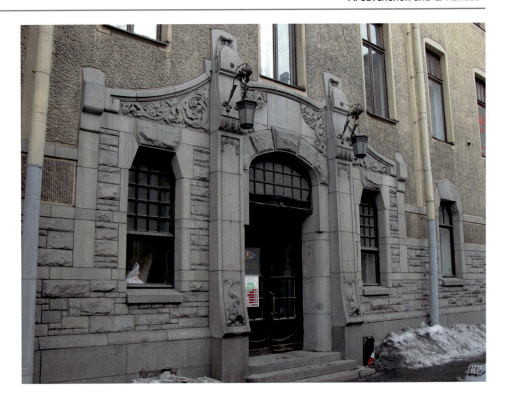

Fig. 1 Registration of the entrance to the northern volume of building 1–3 on Kamennoostrovsky Avenue from the kurdoner side

masks of various sizes. No less interesting is another house built by F.I. Lidval in St. Petersburg. This is the apartment house of M.N. and N.A. Meltserov. It is located at the intersection of Bolshaya Konyushennaya Street and Volynsky Lane (1904–1905) (Fig. 2). In 1907, at the first facade competition, the building was awarded a medal. The expressiveness of the facade of this building is emphasized by window openings of various shapes, sizes, and solutions: rectangular and oval, narrow and wide, and double and single. In the design of the facade, the architect used a combination of smooth and rough plaster finishes, carved rosettes, ovals, wreaths, cartouches, garlands, and two types of stone surface treatment. In terms of decoration with natural stone, the main role is given to potted stone, the use of which in the decoration is uneven across the floors. To the height of the first two floors, with the exception of the granite basement, the building is lined with potted stone. Already starting from the third floor, the architect gives a big role in the decoration to the plaster technique. Potted stone in the third floor is used for facing semicircular and trapezoidal bay windows. Throughout the third, fourth, and fifth floors, there are inserts into the walls of decorative details from the pot, shaped like bricks. A more massive, solid facing with this stone begins only at the level of the upper part of the windows of the fifth floor and the upper floor of the bay window along Volynsky Lane. Potted stone is used in the cladding of the building in details with different textures of surface treatment from smooth and hewn, to details made in the texture of the rock, or carved elements. The technical side of the cladding was carried out by the "Finnish Joint-Stock Company for the development of potted stone in the city of Vilmanstrand". Currently, this city is called Lappeenranta (Kirikov 2006).

Another landmark and important architectural object from the point of view of the use of materials in the decoration and decoration of facades is House No. 26–28 on Kamennostrovsky Avenue (Fig. 3). This house built in 1911–1913 by order of the first Russian Insurance Company (architects L.N. Benois, A.N. Benois, and Yu.Yu. Benois). The main volumes of the building, forming wings in the plan and facing Kamennostrovsky Avenue, are separated from each other by a large courtyard (kurdoner) oriented in line with Rentegna Street and separated from the avenue by a portal in the form of a transition on granite columns. The building is five-storeyed with a high ground floor. At the first cursory glance, anyone passing by will have the impression that this building is lined with natural stone to its full height. This is not the case. Two stones were used in the cladding and decoration of the walls of the building. Pink granite was for the decoration of a high ground floor and potted stone for wall cladding at the level of the first and second floors and only on the section of the front facades and facades of the passage to the kurdoner to the portal with columns. All finishing above the intermediate cornice (at the level of third–fifth floors) on the front facades and all the finishing from the granite base at the facades in kurdoner is made with decorative plaster. The master plasterers of the beginning of the twentieth century skillfully selected the plaster recipe,

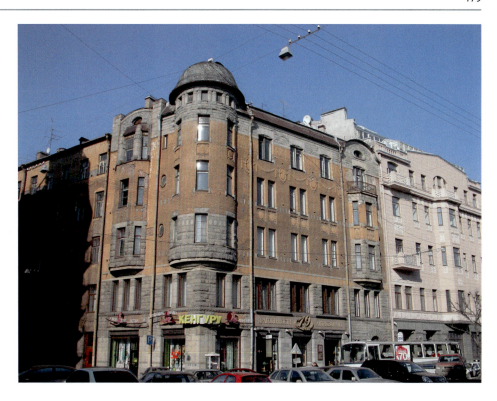

Fig. 2 General view of the former apartment building of M.N. and N.A. Meltserov. (Bolshaya Konyushennaya str., 19). Photo 2006

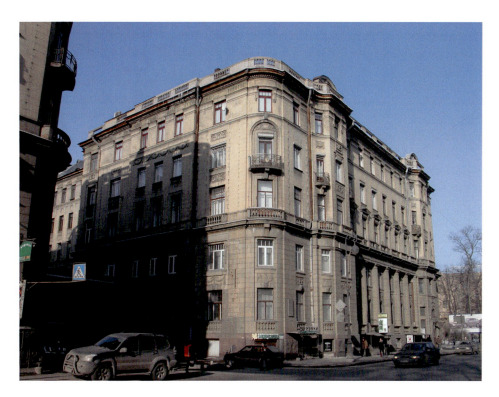

Fig. 3 General view of the left wing of House No. 26–28 on Kamennoostrovsky Avenue

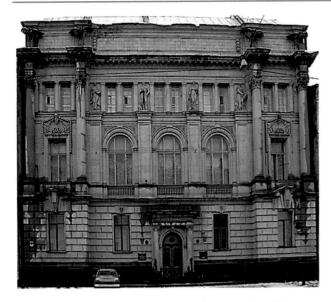

Fig. 4 General view of the building of the former Naval Academy (11th line V.O., 8)

Fig. 5 Fragments of the carved decoration of the facade of the building of the former Naval Academy (11th line V.O., D. 8)

which allowed them to visually "deceive" the viewer, giving the front facades of the building the appearance of a palazzo, lined with natural stone to the full height. This effect was achieved both through the use of plaster at high altitude, and through the use of finely ground and sifted potted stone, which was used for lining the walls of the lower floors of the building, as a filler in decorative plaster.

An example of an artful combination of natural stone and plaster finishing is a building located on Vasilievsky Island. This is House No. 8 on the 11th line (Fig. 4). The monumental building was built in 1905–1907 by architect M. H. Dubinsky for the Naval Academy in the neoclassical style. Its distinctive feature is the use of natural stone at the entire height of the facing and decoration of the front facade. It should be noted that for the architecture of St. Petersburg, this is a special and important feature. There are not so many architectural structures in our city, the front facades, which are lined with natural stone to the full height. In most cases, architects tried to skillfully combine natural stone, plaster decoration, and decor (plaster, stucco, ceramic, etc.), which was most likely due to financial reasons and estimates for the construction of an object. In the building under consideration, the low basement is lined with Gangut granite. All other details of the cladding and decor, including rich carved elements above the windows of the second floor, carved capitals of columns, four sculptures in the third floor level, and four sculptures of birds in the attic level, are made of potted stone (Fig. 5).

As part of the restoration work, which became quite active in the early 2000s in connection with the preparation of St. Petersburg for the three-hundredth anniversary, a dispute arose in engineering and design circles about where the potted stone for architectural structures was supplied from. Strangely enough, but at that time there was no unambiguous answer to this question, because various sources of stone receipt were indicated in literary sources. In the 20s of the last century, Vl. Geller, in a review of the stone building materials used in the city, noted that this "wonderful decorative material" was delivered from Sweden. This point of view was subsequently followed by other researchers. In the monograph "Decorative facing stones" published in 1989, M.S. Ziskind pointed to the deposits of talc-chlorite rocks in central Karelia (Listyegubskoye, Kallivo-Murenanvaara, etc.).

Work with literary sources allowed us to identify two main regions in the quarries and deposits of which potstone extraction was potentially possible. Deposits in the east of the central part of the Republic of Finland, located within the so-called Nunnanlakhtinsky field, have been developed since the second half of the nineteenth century. Currently, the deposits are operational. Deposits in the central part of the Republic of Karelia, located on the southern coast of Lake Segozero, were developed by the local population at least since the second half of the nineteenth century.

Finnish deposits of potted stone located in the area of the Nunnanlahtinsky field (modern territory of the Republic of Finland) are indicated as a source of potted stone in the book "The Age of Soapstone 1893–1993" (Kotivuori et al. 1993). It is noted that for the first time the assessment of the potted stone deposits in the area of the city of Nunnanlahti was carried out at the end of the nineteenth century by the Finnish geologist Benjamin Frosterus. It was he who was the first to assess the degree of suitability of the manifestations of talc rocks of the Nunnanlahta region for mining. Already in 1893, an enterprise was created, called in Swedish

"Finska Täljstens AB". The company's work focused on the Nordic countries and the Russian Empire. The volume of production was more than 2000 cubic meters per year, of which 800 cubic meters are construction and industrial stone and up to 1700 m^2 meters of facing tiles. By the end of the nineteenth century, potted stone from this region was widely used in the cladding of facades of buildings built in the "northern" Art Nouveau style. At the same time, one of the main markets for products made of this stone was the Russian Empire.

The transportation of soapstone carried out by barges along the waterway that stretched from Lake Pielinen through the Pielisjoki River and the Saimaa Canal to Vyborg. From Vyborg, the stone was delivered by sea to both St. Petersburg and Helsinki. In winter, transportation is carried out on ice using horses. In 1925, after a number of financial and structural changes, the company received the name "Vuolukivi Suomen Oy". The soapstone of these deposits is a talc-magnesite rock in composition. These rocks lie in layers within the greenstone Archean belt overlain by rocks of the Proterozoic age (Sorjonen-Ward 2002). Currently, in Finland, soapstone is mined at several historical and modern quarries located on the west coast of Lake Pielinen near the settlement and Nunnanlahti.

Karelian deposits of potted stone located on the southern shore of Lake Segozero (modern territory of the Republic of Karelia within the Russian Federation) are indicated as a source of stone for architectural objects of St. Petersburg. The potted stone of the southern coast of Lake Segozero has been known since the second half of the nineteenth century. According to geological descriptions, the potted stone of the Segozersk group of deposits is talc-chlorite schist in composition. Talc-chlorite schists are found in two deposits: Kallievo-Murenanvaara and Turgan–Koyvan–Allusta (Sokolov 1995).

The Kallievo-Murenanvaara deposit was intensively developed from 1925 to 1941 by the explosive method. The upper part of the deposit worked out and flooded. As of 2019, the field is operational (http://atlaspacket.vsegei.ru). The Turgan–Koyvan–Allusta deposit developed in the 1950s. The extraction of the stone was carried out in an explosive way, which led to a decrease in its qualities due to the cracks formed. As of today, there is no information about the extraction of stone at this deposit.

There is a mention that Swedish potted stone was used in the architecture of St. Petersburg. This error is due to the fact that the Swedish company Finska Täljstens AB was engaged in the production of the Finnish Nunnanlahti deposit. The Swedish name of the company gave rise to errors about the Swedish origin of the stone (Shaikh 1972).

Detailed instrumental studies was carried out for samples of natural stone and facing architectural details. The results prove that the soapstone used in the stone decoration of St. Petersburg is most similar in mineral composition and structural and textural features to talc-magnesite stone from quarries near Nunnanlahti (Finland). Unlike Finnish, Karelian soapstone from the southern coast of Lake Segozero has a talc-chlorite composition (Savchenko 2009).

Soapstone from old quarries near Nunnanlahti has an interesting feature: over time, the front surface of the stone changes its color and acquires a yellow–brown hue. On restored buildings, soapstone has a light gray and greenish-gray color.

References

http://atlaspacket.vsegei.ru

Kirikov BM (2006) Architecture of St. Petersburg Art Nouveau. Mansions and apartment buildings. SPb.: Colo

Kotivuori S, Grapes C, Sandstrom T (1993) Vuosisata vuolukivea 1893–1993 (A century of soapstone 1893–1993). Juuka-seura

Savchenok AI (2009) Mineralogy of decorative facing stone in architectural objects of St. Petersburg, its composition, properties and behavior in the ecological situation of the city. Ph.D. thesis

Sokolov VI (1995) Talc-chlorite schists of Karelia and ways of their complex use. Petrozavodsk: Karelian Scientific Center of the Russian Academy of Sciences, 125 p

Shaikh NA (1972) Geology of the Lauttakoski soapstone deposit, northern Sweden Kirja Sveriges geologiska undersökning

Sorjonen-Ward P (2002) Geological setting of the Nunnanlahti soapstone deposits. In: Niemelä M (ed) Talc-magnesite deposits in Finland, 10–15 Sept 2002

Natural Stone in Modern St. Petersburg

Anna Tutakova

Wide usage of various natural stones, including those from the quarries of the Karelian Isthmus, played a significant role in creating the unique image of St. Petersburg. Since the first half of the eighteenth century, granites have been quarried on the Karelian Isthmus and the coast of the Gulf of Finland (the territory of modern Finland) for the construction of St. Petersburg. This is facilitated by the unique geographical, geological, and historical position of the city (Petrov 2017). It is a great pleasure to observe that the fashion for natural stone is reviving in the modern architecture of St. Petersburg (Fig. 1) (Tutakova et al. 2011; Tutakova 2014).

Geologically, the Karelian Isthmus is located in the southern part of the Baltic (Fennoscandian) Shield near the border with the Russian Plate. The Baltic Shield is represented by metamorphosed rocks of the Proterozoic age. These are predominantly gneisses intruded by intrusions of various compositions: granites, granosyenites, diorites, and gabbro. Their age according to modern radioisotope data is 1600–1900 million years. The southwestern part of the Karelian Isthmus between the Gulf of Finland and the Vuoksa River is occupied by the multiphase Vyborg rapakivi granite massif, a significant part of which is located in Finland. This granite was one of the first building stones to be used in St. Petersburg.

Examples of using highly decorative red and pink ovoid rapakivi granites of the Vyborg massif at the end of the eighteenth and in the nineteenth centuries are the majestic exterior colonnade of St. Isaac's Cathedral, the interior colonnades of the Kazan Cathedral and the New Hermitage, the Alexander Column on the Palace Square, embankments in the center of St. Petersburg (Bulakh 1999, 2009, 2012; Bulakh and Abakumova 1987,1993, 1997; Bulakh and Voevodsky 2007; Bulakh et al. 2004, 2007, 2017, 2018; Ziskind 1989; Danil'ev et al. 2021; Ivanov and Popov 2021).

Currently, pinkish-gray and pink rapakivi granites with a small amount of ovoids are quarried at the Vozrozhdeniye and Ala-Noskua quarries in the Vyborg district of the Leningrad region. The quarries are located in 2 km and 6 km from the railway station Vozrozhdenie (St. Petersburg–Vyborg–Sortavala railway), not far from the town of Vyborg. The Vozrozhdeniye quarry (Kavantsaari until 1948) has been in operation since the end of the nineteenth–beginning of the twentieth centuries. Nowadays, this quarry produces cladding rapakivi granite and crushed stone. Pinkish-gray rapakivi granites from the Vozrozhdeniye quarry are well known in St. Petersburg and other cities. In our city, many metro stations are decorated with rapakivi granite from the Vozrozhdeniye quarry: when you walk along the platform just look down at your feet and you will see this stone. The lower vestibule of the Dostoevskaya metro station (columns and floor) is almost completely decorated with this granite.

Rapakivi granites from the Vozrozhdeniye quarry in modern St Petersburg (Figs. 2, 3 and 4).

- Leningrad Hero City Obelisk (1985) in Vosstaniya Square;
- Monument to "Military Medics" at the crossroads of Bolshoi Sampsonievsky Prospekt and Botkinskaya Street;
- Pedestals of the monuments to I.E. Repin and V.I. Surikov (1999) in Rumyantsev Garden on Universitetskaya Embankment; pedestal of the monument to I.S. Turgenev (2001) in Manezhnaya Square;
- A memorial sign "To the Capture of the Nyenschanz Fortress" (2000) at the mouth of the Okhta River and "Message Through the Ages" (2002) in the form of an open book with the words of A.S. Pushkin on University Embankment;
- Obelisk "300th anniversary of the establishment of the Order of the Holy Apostle Andrew the First-Called" (2001) at the crossroads of Bolshoy Avenue and 6–7 lines of Vasilyevsky Island;
- Monument to "Warriors-aviators" (2018–2019) in the park named after Lev Matsievich in the form of a miniature chapel and pedestals of seven monuments to the first Russian aviators.

A. Tutakova (✉)
Department of Geology and Mineral Exploration, Saint-Petersburg Mining University, Saint-Petersburg, Russian Federation
e-mail: Tutakova_AYa@pers.spmi.ru

© The Author(s), under exclusive license to Springer Nature Switzerland AG 2023
E. Panova (ed.), *The History of Natural Stone in Saint-Petersburg*, Geoheritage, Geoparks and Geotourism,
https://doi.org/10.1007/978-3-031-18861-9_13

Fig. 1 Scheme the Karelian Isthmus deposits. ■—deposits of facing stone

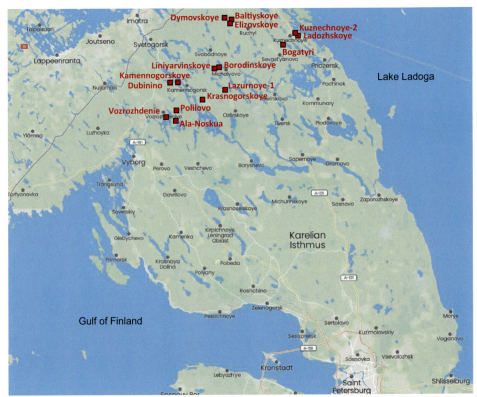

The scheme of deposits of facing stone of the Karelian Isthmus

Fig. 2 Memorial sign "Message through the centuries" on the University Embankment, opened in 2002: rapakivi granites of the Vozrozhdenie deposit

Fig. 3 Reconstruction of the sidewalks of Nevsky Prospekt in 2008: rapakivi granites of the Vozrozhdenie deposit and granosienites of the Baltiyskoye deposit

Fig. 4 Monument to the "Aviator Soldiers" in the Lev Matsievich Square between Bogatyrsky Avenue and Aerodromnaya Street, opened in 2019: rapakivi granites of the Vozrozhdenie deposit

Pink and brownish-pink rapakivi granites with rare ovoids have been quarried at the Ala-Noskua quarry since 1999. This cladding stone is used for the pedestal of the monument to Alexander Nevsky (2002) in the square of the same name, and the monument to K.E. Tsiolkovsky (2005).

The Kamennogorsk quarry (Antrea until 1948) is located in 2 km from the town of Kamennogorsk. The quarry has been known since the nineteenth century. The hotel Astoria (1911–1912) and Bolsheokhtinsky Bridge (1908–1911) are cladded with granites from this quarry. Such granites were used for the memorials at the Piskarevsky (1960) and Serafimovsky cemeteries (1965), during the reconstruction of the bus station (2002) on the Obvodny Canal embankment. Nowadays, cladding granite of gray color with a faint pink tint with a fine-grained and medium-grained texture and granite for the production of crushed stone is quarried at the Kamennogorsk quarry. Many metro stations in St. Petersburg are decorated with these granites.

Five quarries of cladding *granosyenites of the Ojajärvi massif* were explored in the 1980s–1990s (Figs. 5, 6, 7 and 8). All of them are located at a distance of 0.5–2 km from each other, 9 km from the Ojajärvi railway station in the Vyborg district of the Leningrad region. Currently, pinkish-brown granosyenites are quarried at the *Baltiyskoye* (Fig. 9), *Elizovskoye, and Dymovskoye* quarries. This beautiful cladding stone is widely used in the architecture of St. Petersburg.

- Pedestal of the monument to Prince A.D. Menshikov (2002) on Universitetskaya embankment near the Menshikov Palace;
- Monument to the Victims of Radiation Accidents and Catastrophes (2003) at the crossroads of Piskarevsky Avenue and Marshal Blucher Avenue;
- Alley of memory of the perished Leningraders (2001–2004) in Victory Park in Moskovsky Avenue;
- Pedestals of monuments to A.A. Sobchak (2006) at the crossroads of 26th line and Bolshoi Avenue of Vasilyevsky Island, A.A. Akhmatova (2006) on Robespierre embankment; A.P. Karpinsky (2010) in 21st line of Vasilyevsky Island near №21;

Fig. 5 Monument to Prince A.D.Menshikov on the University Embankment, house 15, in front of the Menshikov Palace, opened in 2002: granosienites of the deposits of the Ojajarvi massif

Fig. 7 Monument to A.P.Karpinsky on Vasilievsky Island, 20th line, house 21, opened in 2010: pedestal—granosienites of deposits of the Ojajarvi massif

Fig. 6 Engineering building (academic building No. 3) of St. Petersburg Mining University, opened in 2015: in the photo, granosienites of the Ojajarvi massif of deposits

- Monuments to N.K. Roerich (2010) in the garden "Vasileostrovets" near 25th line of Vasilyevsky Island and to the Teacher at the crossroads of Uchitelskaya and Ushinsky streets;
- Shopping and office center "Olympic Plaza" (2011) at the crossroads of Marata and Stremyannaya streets;
- Triumphal Arch in honor of the 70th anniversary of the Victory in the Great Patriotic War (2015) in the square of Military Glory in Krasnoye Selo
- Together with rapakivi granites from the Vozrozhdeniye quarry, they were used in the construction of "Lighthouse" and the fountain complex (2003) in the park of the 300th anniversary of St. Petersburg, in the construction of new buildings of the Mining University (Engineering Building and the "Gorny" Multifunctional Complex, 2015).

Fig. 8 Monument to N.K.Roerich on Vasilievsky Island (25th line) in the garden "Vasileostrovets", opened in 2010: granosienites deposits of the Ojajarvi massif

Fig. 9 Reconstruction of the embankment of the Griboyedov Canal in 2011: rapakivi granites of the Vozrozhdenie deposit and granosienites of the Baltiyskoye deposit

Gray-red, red, and pink coarse-grained granites of the Kuznechensky (Kaarlahti) massif from 1950 to 1994 were quarried at the Perkon-Lampi quarry, which was located in 1 km from the Kuznechnoye railway station (Kaarlahti until 1948). Granites from this quarry were used for the decoration of Liteyny (reconstruction of 1965–1967), Grenadersky, Kamennoostrovsky, and Nalichny bridges in Leningrad in the 1950s–1970s. Robespierre, Arsenalnaya, and partially Sverdlovskaya embankments are cladded with these granites. Pedestals of monuments to A.S. Pushkin (1957) in the Arts Square, V.I. Lenin (1970) in Moscow Square, M.V. Lomonosov (1986) at the crossroads of Universitetskaya embankment and Mendeleevskaya line of Vasilyevsky Island are made of granite from the Perkon-Lampi quarry (Ziskind 1989).

Since 1998, "Kuznechensky" granite has been quarried at the Ladozhskoye quarry (Figs. 10, 11 and 12), which is located in 4 km from the village of Kuznechnoye and 13 km from the town of Priozersk. These are granites of gray, pinkish-gray, pink, and less often reddish-pink color with a coarse-grained texture and a massive, sometimes gneissic structure. Such structure creates a beautiful slightly wavy pattern. This granite is used in the following buildings:

- Memorial sign "300th anniversary of the city, port and customs" (2003) at the Spit of Vasilevsky Island;
- Interior decoration of Ladoga railway station;
- Exterior cladding of the building of the Main Office of the Central Bank for St. Petersburg (2004) at the crossroads of Lomonosov Street and the Fontanka River Embankment;
- Pedestal of the monument to Peter Bagration (2012) in the park in Marata street.

All the named varieties of the Karelian Isthmus granites can be seen in the fountain complexes near Finland railway station (2005) and in Moskovsky Prospekt near the Moskovskaya metro station (2006).

Rapakivi granites from the Vozrozhdenie quarry and granosyenites, predominantly from the Baltiyskoye quarry, are actively used in the reconstruction and improvement of many streets, avenues, and squares in the center of St.

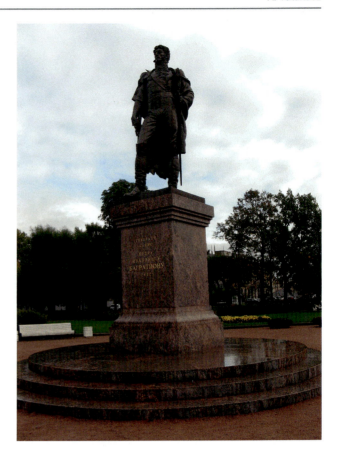

Fig. 10 Monument to Peter Bagration on Marata Street, between houses 86 and 90, in the square behind the Theater of the Young Spectator, opened in 2012: granites of the Ladozhskoye deposit

Fig. 11 Commemorative sign "300th anniversary of the city, port and customs" on the spit of Vasilievsky Island; opened in 2003: granite deposit Ladozhskoye

Fig. 12 Reconstruction of the Pirogovskaya embankment in 2010–2012: granites of the Ladozhskoye deposit

Petersburg, including the replacement of the old asphalt pavement with granite slabs: Nevsky Prospekt (2001, 2008), the Arts Square (2000–2001), part of Primorskaya Embankment near Primorsky Prospekt (2008), Furshtatskaya st. (2009), Bolshaya and Malaya Konyushennaya Streets (2011, 2014), Griboyedov Canal Embankment (2011), Chernyshevsky Avenue (2011), Kirochnaya st. (2013), Vosstaniya st. (2014), Marata st. (2014), Rubinshtein st. (2014), Karavannaya st.(2014), Pushkinskaya st. (2015), Sadovaya st. (2015), Italian st. (2015), Mayakovsky st. (2015), Malaya and Bolshaya Morskaya streets (2016, 2017), first Sovetskaya st. (2018, including the basement for a monument to the carriage), Bolshoy Prospekt of the Petrograd side and Dobrolyubova Prospekt (2019), Armor Fedorov Street (2020), Gangutskaya (2020), and Mokhovaya (2021) streets. Granites from the Ladozhskoye quarry were used during the reconstruction of the Pirogovskaya embankment from Liteiny Bridge to Maly Sampsonievsky Prospekt in 2010–2012.

These are just some examples of the use of the Karelian Isthmus granites in the architecture of St. Petersburg. You can see many interesting monuments, palaces, cathedrals, commemorate plaques, offices, and residential buildings, which were created using a variety of natural stones. More and more books appear about this unique building material—beautiful and durable. These books tell where and what kind of natural stone was used in the construction of St. Petersburg from the first years of its foundation to the present day.

References

Bulakh AG (2012) Kazan Cathedral in St. Petersburg (1801–2012): stone decor and its restoration. St. Petersburg, "Nestor-History" (in Russian)

Bulakh AG, Abakumova NB (1987) Stone decoration of the center of Leningrad. LSU publishing house, Leningrad (in Russian)

Bulakh AG, Abakumova NB (1993) Stone decoration of the main streets of Leningrad. St. Petersburg, publishing house of St. Petersburg State University, 1993 (in Russian).

Bulakh AG, Abakumova NB (1997) Petersburg stone decoration. City in an unusual perspective. St. Petersburg, "Sudarynya" (in Russian)

Bulakh AG, Voevodsky IE (2007) Porphyry and marble and granite ... / Stone decoration of St. Petersburg. St. Petersburg, publishing and cultural center "Eclectic" (in Russian)

Bulakh AG, Borisov IV, Gavrilenko VV, Panova EG (2004) Petersburg stone decoration. Travel book. St. Petersburg. "Sudarynya" (in Russian)

Bulakh AG, Popov GN, Ivanov MA, Yanson SYu, Gavrilenko VV, Platonova NV (2017) Mineral composition and architectonics of the pedestal of the "Bronze Horseman" in St. Petersburg. In: Proceedings of the Russian Mineralogical Society, vol 6, pp 111–125 (in Russian)

Bulakh AG, Popov GN, Ivanov MA (2018) Block structure of the granite pedestal of the Bronze Horseman and its model. In: Open Air Museum. Strategy for the preservation of sculpture in the urban environment. St. Petersburg: "SIGN", pp 23–26 (in Russian)

Bulakh AG (1999) Petersburg stone decoration. Etudes on Miscellaneous. St. Petersburg, "Sudarynya" (in Russian)

Bulakh AG (2009) Stone decoration of Petersburg. Masterpieces of architectural and monumental art of the Northern capital. Moscow, Centerpolygraph (in Russian)

Danil'ev SM, Danil'eva NA, Bulakh AG, Ivanov MA, Popov GN (2021) New data on the state of the stone base of the Bronze Horseman monument in St. Petersburg according to geophysical data. In: Open Air Museum. Problems of preservation of monuments in the urban environment. Collection of scientific papers of the V scientific-practical conference "Museum under the open sky". SPb: MediaComfort, SPbGUPTD, pp 19–21 (in Russian)

Ivanov MA, Popov GN (2021) The nature of the fracturing of the granite of the Alexander Column in St. Petersburg—the geological aspect. In: Open Air Museum. Problems of preservation of monuments in the urban environment. Collection of scientific papers of the V scientific-practical conference "Museum under the open sky". SPb: MediaComfort, SPbGUPTD, pp 22–25

http://www.vozr.ru/. Non-commercial partnership "Group of design and construction companies" Vozrozhdenie.

Petrov DA (2017) Geoculturological research in the North-West of Russia as an example of interdisciplinary cooperation (in memory of Professor V.V. Gavrilenko). In: Geology, geoecology, evolutionary geography: proceedings of the international seminar, vol XVI. Publishing house of the Russian State Pedagogical University named after A.I. Herzen, St. Petersburg, pp 311–314 (in Russian)

Tutakova AYa (2014) Natural stone of the Karelian Isthmus in the architecture of St. Petersburg. St. Petersburg, Russian Collection (in Russian)

Tutakova AYa, Romanovsky AZ, Bulakh AG, Lear YuV (2011) Cladding stone of the Leningrad region. Granites of the Karelian Isthmus in the modern architecture of St. Petersburg. Committee for Natural Resources of the Leningrad Region. St. Petersburg, Russian Collection (in Russian)

Ziskind MS (1989) Decorative facing stones. Leningrad: "Nedra" (in Russian)

Where and How Did Stone Mine Near St. Petersburg

Where and How Did Stone Mine Near St. Petersburg

Andrey Bulakh and Elena Panova

Abstract

St. Petersburg is located in a unique geological situation, which determined its unique stone appearance. To the north of the city, rocks of the Baltic Crystal Shield come to the surface. These are igneous and metamorphic rocks (granites, marble, quartzites, gneiss, crystalline shales). To the south of St. Petersburg, you can see a lot of sedimentary rocks (limestone and tuff). All the listed rocks have a variety of colors and could have been delivered by water for the construction of the city.

St. Petersburg is located in a unique geological situation that has determined its unique stone appearance. To the north of the city, rocks of the Baltic Crystal Shield are exposed on the surface. These are igneous and metamorphic rocks (granites, marbles, quartzites, gneiss, crystalline shales, etc.). To the south of St Petersburg, you can see a variety of sedimentary rocks (limestone and tuff). All the listed rocks have a variety of colors and are first delivered by water. The position of the main places of stone extraction is shown in Fig. 1.

The first and most important natural stone used for building purposes in St. Petersburg was the plate limestone from Putilovo quarries. Initially, this rock was used for the construction of fortresses. The first stone fortresses and cities on the Russian Plain were founded in the places where these rocks came out (Koporye, Staraya Ladoga, Veliky Novgorod, Izborsk, and Pechory). In St. Petersburg, this stone was used for laying foundations, floors, windowsills, and so on.

In the Peter the Great's time, the demand for building stone was growing very fast. The Tsar gave orders to encourage and reward any new discovery of stone deposits. The tsar ordered to reward the new discovery of stone deposits. All visitors to St. Petersburg must bring the stone in the form of a fee. The decrees of Empress Anna Ioannovna contributed to search for local sources of stone.

Karelian marbles had been long used by the people of Karelia and Novgorod to obtain lime for local needs. Decorative marble mined near Ruskeala village. Gray striped marble was used for lining the walls of the Marble Palace in 1766. Extensive developments started when the construction of St. Isaac's Cathedral went under way. Decorative stone was required for construction until 1830.

Granite deposits are known not far from St. Petersburg on the Karelian Isthmus. Initially, boulders were used for construction. As an example, there are Solovetsky Monastery and Vyborg. The extraction of granite from bedrock began in the early eighteenth century. The lack of skills to work with such a strong stone slowed down its use. The large weight of the breed contributed to the appearance of the first quarries on the islands and shores of Lake Ladoga and the Gulf of Finland.

Gray and gray-pink granites have been delivered from the vicinity of Sortavala city (Serdobol) since the 1740s. The rock was mined on the northern islands of Lake Ladoga (Tulolansaari, Riekkalansaari, Vanisenssaari, and Cape Impiniemi), from where it was transported on barges to St. Petersburg. It was originally used for foundations. Later, it was widely used in the construction of monuments, sculptures, pedestals, and portico columns for the construction and decoration of fountains.

Since the end of the eighteenth century, gray and red granites have been delivered from the quarries of the Valaam Monastery from the northern part of Lake Ladoga (Puutsaari and Syyskuunsaari islands). Initially, large blocks of granite were used for the construction of foundations, and later—as a decorative material.

At the same time, red rapakivi granite appeared in St. Petersburg. It was mined in Finland near the town of

A. Bulakh
Department of Mineralogy, Saint-Petersburg State University, Saint-Petersburg, Russian Federation
e-mail: a.bulakh@spbu.ru

E. Panova (✉)
Department of Geochemistry, Saint-Petersburg State University, Saint-Petersburg, Russian Federation
e-mail: e.panova@spbu.ru

Fig. 1 The place of the stone mining site in the vicinity of St. Petersburg (Bulakh and Abakumova 1987). 1–6—Limestones; 7–17, 20—Granites; 18–19, 25, 28, 29—Marbles; 21, 22—Sandstones; 23, 24—Quartzite; 26—Solomino breccia; 27—Aspid slate. Deposits: 1—Saaremaa Island; 2—Revelskoye, Vasalemma, Kirnovskoye; 3—Pudostskoe; 4—Tosnenskoe; 5—Putilovskoe; 6—Volkhovskoe; 7—Nishtadtskoe; 8—Gangutskoe; 9—Peterlaks; 10—Rogolev and Bykov; 11—Monrepos; 12—Kovantsari; 13—Antrea; 14—Tiurula; 15—Heinyasenmaa; 16—Putsari; 17—Riekkalansari, Tulolansari, Impiniemi, Yakkima, Yanisari; 18—Ruskeala; 19—Juvenile; 20—Syuskuyansari; 22—Brusnenskoe; 23—Shokshinskoe; 24—Kamennoborskoe; 25—Big Vaara; 26—Solomenskoye; 27—Nigozerskoe; 28—Krasnogorskoye, Lizhmozerskoye, Paloselgskoye, Kariostrovskoye; 29—Pergubskoye

Fredrikshamn (Hamina). Other red granites were mined near the Antrea village and Lake Kovantsaari. The stone was transported along the Vuoksa River and the Saimaa Canal to the Gulf of Finland and then by sea to St. Petersburg.

The deposit of red quartzite is known in the Onega district near Shoksha village. The stone became known as Shokshinsky quartzite, or Shokshinsky porphyry, and was previously called Shohan. This stone is not found in large blocks and is therefore very expensive. It was used mainly for monument pedestals.

A unique Karelian stone is a black shungite slate. The only deposit is located in the northern part of the Onega district, near Lake Nigozero. Slabs for windowsills, doorframes, and window frames were made of this stone.

At the end of the nineteenth century, the development of railways contributed to the appearance of natural stones brought to St. Petersburg from afar. These are marble from Revel, Estonian limestone, and sandstones from Poland and Germany. These rocks have good decorative properties and are easy to process. Talc-chlorite shale came from Finland via the Saimaa Canal. During the period from 1896 to 1914, more than 200 buildings were built in St. Petersburg lined with natural stone from Finland, Sweden, Poland, Germany, and deposits of Karelia.

After the October Revolution of 1917, natural decorative stones were used very sparsely. Since the early 1950s, natural stone has been gradually returning to the decoration of city buildings, sculptures, and memorials. New sources of natural stone have appeared. The most popular were dolomite from Estonia (Saaremaa island) and Karelian granite from the Kuznechnoye, Kamennogorsk, and Vozrozhdenie districts.

Currently, granite from the Vozrozhdenie quarry and from the Syyskuunsaari island in the northern part of Lake Ladoga is widely used in St. Petersburg. A number of joint Russian–foreign corporations provide stone access to St. Petersburg from all over the world.

References

Bulakh AG, Abakumova NB (1987) Stone decoration of the center of Leningrad. L.: LSU Publishing House, 145 p

Master of Columns

Valentina Stolbova

Abstract

The reign of Alexander I was marked by the formation of grand architectural ensembles in the northern capital. Imitating the best examples of antiquity, St. Petersburg was decorated with majestic and solemn classical buildings with colonnades. Famous architects, engineers, and sculptors worked on the creation of the "city of columns", and thousands of ordinary Russian artisans embodied their ideas in stone. Due to the incredible work and high skill of stonebreakers and stonecutters, St. Petersburg acquired its elegant image. One of these masters was a talented self-taught stonecutter Samson Sukhanov. The son of a poor shepherd became a famous stonecutter and left a noticeable mark in the history of the construction of the northern capital. There was no person in Russia, or in the whole world, under whose leadership or by himself about 400 columns were processed and erected, not counting the bases and capitals to them.

The reign of Alexander I was marked by the formation of grand architectural ensembles in the northern capital. Imitating the best examples of antiquity, St. Petersburg was decorated with majestic and solemn, massive and powerful, light and graceful classical buildings with colonnades. Stone colonnades outside the buildings were erected in the form of porticoes or galleries. Colonnades decorated ceremonial interiors, vestibules of mansions, and palaces, they framed or divided large halls of cathedrals.

In the imperial capital, in addition to the colonnades of buildings, there are many single columns. Free-standing columns, installed on a pedestal and crowned with sculptures, served as monuments in honor of a significant event or historical figure. Passing by the granite colonnades of St. Isaac's Cathedral and the Alexander Column in the main square of St. Petersburg, one involuntarily wonders how the huge monoliths were quarried, separated from the rock, and delivered to St. Petersburg and how the columns acquired their appearance.

Famous architects, engineers, and sculptors worked on the creation of the "city of columns", and thousands of ordinary Russian artisans embodied their ideas in stone. Due to the incredible work and high skill of stonebreakers and stonecutters, St. Petersburg acquired its elegant image.

One of these masters was a talented self-taught stonecutter Samson Sukhanov. The son of a poor shepherd from a remote village became a famous stonecutter and left a noticeable mark in the history of the construction of the northern capital. The outstanding master Samson Sukhanov stood out among all the stone masters for his skill. There was no person in Russia, or in the whole world, under whose leadership or by himself about 400 columns were processed and erected, not counting the bases and capitals to them.

Samson Sukhanov received the first invaluable experience in carving and processing columns from natural stone, as well as bases and capitals for them in Peterhof during the reconstruction of the Lower Park when Samson Sukhanov and his crew took part in the construction of Voronikhinsky colonnades in 1801–1803. They installed 40 marble columns and 12 columns of Serdobol granite, about 3 m high and 45 cm in diameter at the base (Fig. 1).

In 1803, the grandiose construction of the Kazan Cathedral, designed by Andrei Voronikhin, began in St. Petersburg. Only Russian masters took part in this construction. Here, Samson Sukhanov's natural talents were fully revealed. He was appointed the foreman over the stonecutters, as the best craftmaster.

Picturesque granite cliffs on the islands and along the coastline of the Gulf of Finland inspired the architect A. Voronikhin to erect load-bearing columns of long-lived and decorative pink rapakivi granite inside the cathedral. After the approval of the project by the emperor in the quarry on the island "Sorvali" in the estate of Baron Ludwig Heinrich

V. Stolbova (✉)
Department of History and Culture of the Northwestern Region, Cultural and Historical Center «Svetoch», St. Petersburg, Russia
e-mail: rugosamuseum@yandex.ru

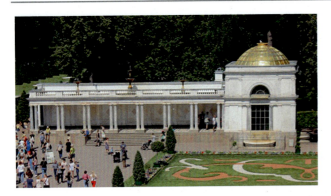

Fig. 1 Voronikhinsky colonnades. Lower Park. Peterhof

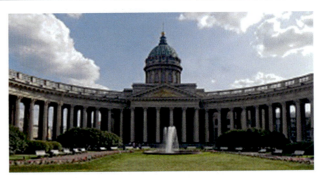

Fig. 3 The outer colonnade of the Kazan Cathedral

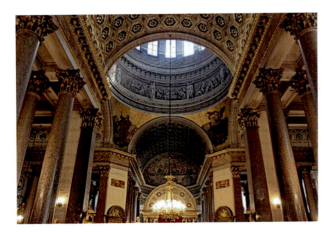

Fig. 2 Granite colonnade of the central nave of the Kazan Cathedral

von Nikolai near Vyborg, quarring of 56 solid columns, each 8.89 m high, started. The monoliths were shipped to St. Petersburg. At the embankment opposite the Hermitage, they were reloaded into river boats and transported to the Catherine Canal. From there, with the help of ropes and rollers made of birch logs, the workers moved the columns for cutting to a wooden shed in Malaya Konyushennaya Street. For 3 years, every day in winter and summer, about 500 stonecutters, under the supervision of Sukhanov, processed the granite columns: first roughly, then grounded with sand, and finally polished with crushed emery (Skrebkov 1929). At the beginning of 1806, all 56 granite columns were placed in rows inside the cathedral, dividing the temple hall into three naves (Shurygin 1987) (Fig. 2). The installation of such a large number of solid stone columns was carried out in Russia for the first time and required tremendous skill. Beforehand, to protect the surface from scratches, the columns were wrapped in felt, covered with boards on top, and tied with ropes. Then, with the help of capstans, pulleys, ropes, rollers, and other devices, the columns were rolled from the workshop in Konyushennaya Street, brought into the building, and placed on pylons at the bases. After installation, the final gloss was induced on the columns. According to old beliefs, the readiness of polishing was checked in the dark or twilight with the help of a lighted candle. The reflection of the flame on the surface of the granite had to be, as in a mirror, so clear that it would be impossible to distinguish it from a real candle flame.

At the same time, the outer colonnade of the temple was being erected from lime tuff, quarried near Gatchina. Due to the high natural moisture content, the lime tuff was easily cut with a saw immediately after extraction, but over time it hardened in air and became equal in strength to marble. Sukhanov's workshop made 138 external columns, as well as capitals for them. Each column 10.3 m high was assembled from several blocks of stone (from 15 to 23) with lead gaskets and trimmed with vertical grooves. At the beginning of 1808, all 138 columns were placed in 2 wings of a semicircular colonnade in front of the northern facade of the cathedral facing Nevsky Prospect, 3 porticoes, and 2 driveways of the Kazan Cathedral (Bulakh 2012) (Fig. 3).

The fortune of the granite columns, which turned out to be unsuitable for the interior decoration of the Kazan Cathedral, is of special interest. Four of them were sent to Pavlovsk to build a portico of the Mausoleum in the form of a majestic ancient temple. For this, the columns were shortened on one side. The Mausoleum was decorated with a powerful granite base with a wide staircase of nine granite steps and the portico with four massive monolithic columns of rapakivi granite (Fig. 4).

One of the column parts 1.4 m long was used for the tombstone in the form of a granite column to the architect A. N. Voronikhin at the Lazarevskoye cemetery at the Alexander Nevsky Lavra (Kurbatov 1906) (Fig. 5).

Another granite column remaining from the construction of the Kazan Cathedral was delivered to the Academy of Arts and installed as a monument in the courtyard of the Academy (Belonozhkin 2018). The monument was dedicated to the memory of the Russian monarchs who benefited the Academy: Elizabeth I, Catherine II, Emperor Paul I, and Emperor Alexander I. The erected column stood in the round courtyard for about 10 years. Over time, due to the problems with drainage, the round courtyard was flooded and the column

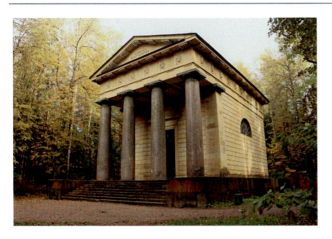

Fig. 4 Mausoleum "To the Spouse-benefactor" in Pavlovsk Park

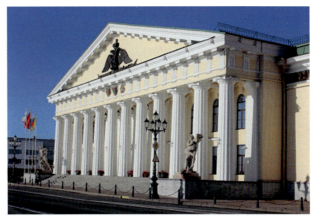

Fig. 7 Colonnade of the Mining Cadet Corps (St. Petersburg Mining University)

Fig. 5 A tombstone in the form of a column on the grave of A.N. Voronikhin at the Lazarevskoye cemetery

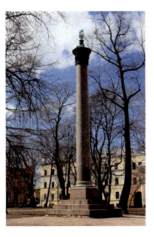

Fig. 6 A column in the garden of the St. Petersburg Academy of Arts

was removed. Thirty years after oblivion, the column acquired new life. In 1847, the year of the 90th anniversary of the Imperial Academy of Arts, the granite column was installed in the center of the academic garden (Fig. 6).

In 1806, on the right bank of the Neva River, not far from the place where it inflows the Gulf of Finland, the construction of the monumental building of the Mining Cadet Corps (now the Mining University) began. Architect A. Voronikhin designed a magnificent building in the form of an ancient Greek temple. The main entrance, facing the Neva, was marked out by a portico with 12 strong, powerful Doric columns supporting a high heavy triangular fronton. The workers of Sukhanov's artel produced and assembled 12 columns from the lime tuff blocks. Between the blocks in the columns were placed "spacer circles" with a thickness of 6.6–9 cm (5 spacers per column) of limestone. Then they were fastened with staples and filled with lead. After grinding with sand and "crushed emery", the columns were rubbed with alabaster and painted with lime paint. The master personally carved 12 capitals on the columns from Pudost tuff. In 1811, the majestic building of the Mining Cadet Corps in the style of classicism arose on the embankment of the Neva River between the 21st and 22nd lines of Vasilyevsky Island (Fig. 7).

For his skill and reliability, S. Sukhanov was engaged in large state construction projects. From 1805 to 1811, he participated in the creation of an architectural ensemble on the Spit of Vasilievsky Island. The site of the ensemble is in the eastern part of the island, washed by the Bolshaya and Malaya Neva, and belonged to a commercial seaport since the times of Peter the Great. The grandiose ensemble in the style of classicism was designed by architect Jean François Thomas de Thomon. It included the Stock Exchange building, rostral columns, and a semicircular embankment with a front pier. During the construction of the ensemble, pink and gray rapakivi granite was used in abundance. "Marine Finnish granite" was quarried near Vyborg. All masonry work during the construction of the architectural complex was carried out by the artel of Samson Sukhanov.

The colossal building of the Stock Exchange in the form of an antique temple makes the center of the entire ensemble. The building is enveloped by a Doric colonnade. For 44 brick columns, the masons carved massive bases with a

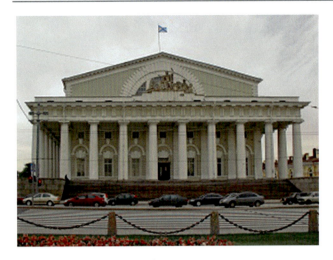

Fig. 8 The main facade of the Exchange

Fig. 9 Semicircular embankment with Rostral columns opposite the Exchange

diameter of about 2 m from gray granite monoliths (Svinin 1818) (Fig. 8).

At the same time, in front of the main building of the Stock Exchange, facing the Neva, a square with a semicircular embankment was being built. The site was designed as the front dock of the seaport. To smooth the bank and create a pier with a deep fairway thousands of piles were driven into the bottom of the river, a huge mass of soil was piled up and, as a result, the coastline extended 123.5 m into the Neva. Two Rostral columns each 32 m high were erected at the slopes to the river on both sides of the square. They symbolize naval victories and serve as beacons. The columns are in the Roman-Doric order and made of lime tuff and bricks, the bases of the columns are made of pink rapakivi granite, and the stepped base is made of blocks of gray rapakivi granite. The columns are decorated with metal rostra - the bows of old ships. Spiral staircases with 256 steps are arranged inside the columns. Huge allegorical figures of the great Russian rivers (the Volga, Dnieper, Volkhov, and Neva) were placed at the foot of the columns (Fig. 9).

The Main Admiralty, founded by Peter I as a shipyard and fortress, is located in the city center. Reconstruction of the building started at the beginning of the nineteenth century according to the project of Andrey Zakharov (Shuisky 1995). Samson Sukhanov participated in the decoration of the Admiralty Tower. About 115 m^3 of lime tuff was used for its decoration to make tower columns and allegorical figures of 6 Russian rivers and four parts of the world (Fig. 10).

Opposite the buildings of the Main Admiralty, in 1817–1820, one of the most famous mansions of St. Petersburg was erected for Lobanov-Rostovsky by the project of Auguste Ricard de Montferrand. "The House with Lions" became famous after it was mentioned by the Russian poet A.S. Pushkin in the poem "The Bronze Horseman". With its impressive size and luxurious architectural design, the

Fig. 10 The Tower of the Main Admiralty. Photo by N.V. Lobanova

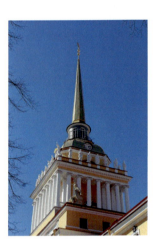

building surpassed all ordinary mansions and even some palaces. The two solemn facades of the three-story building facing the Neva and St. Isaac's Square are accentuated in the center by powerful porticoes of eight Corinthian columns, placed on the arcades of the first floor. Protruding forward arcades form a covered driveway to the front entrance. Marble figures of lions decorate both sides of the central arch at the main entrance opposite the Admiralty.

Samson Sukhanov had a contract on granite works for this building. In a relatively short period of time, his artel cladded the basement of the house along its entire perimeter and massive stylobates under the arcades with slabs of rapakivi granite. Internal works included manufacturing of eight granite columns polished to a mirror-like luster placed on square granite curbstones in the main lobby near the main entrance and granite steps of the main staircase leading to the second floor (Fig. 11).

Samson Sukhanov and the future creator of St. Isaac's Cathedral, Auguste de Montferrand, met at the construction of the Lobanov-Rostovsky mansion. In 1818, Alexander I approved the project of a grandiose cathedral with 36

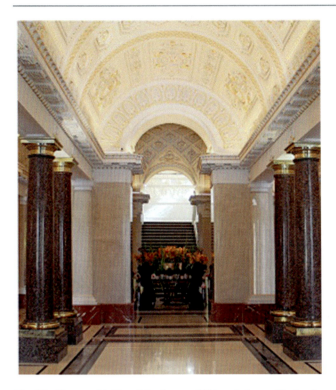

Fig. 11 The grand lobby of the house of Prince Lobanov-Rostovsky

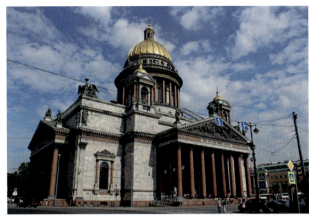

Fig. 12 The southern facade of St. Isaac's Cathedral

columns. The construction commission decided to make huge solid columns for porticos from Finnish granite. None of the contractors, except for Samson Sukhanov, ventured to take on this work. No one in Russia had ever cut out such colossal solid granite monoliths 17 m high (Montferrand 1820).

Samson Sukhanov made first experiments on cutting out the columns at his own Vilkila quarry on the western coast of Virolahti Bay, in the north of the Gulf of Finland. The gifted master developed his own manual method of separating colossal granite monoliths from the rock along natural cracks using drills, wedges, and a system of levers without using gunpowder. Assured in the success, he began the preparation of columns in the state quarry at the Halnemi cape (Hailiniemi peninsula), located across the strait opposite the Vilkilsky quarry (Ekesparre 1832). In the summertime, the quarry employed from 200 to 405 workers. In total, Sukhanov broke 13 columns to varying degrees of processing.

After rough cutting in the quarry, the columns were rolled down the slope to the pier, loaded onto a ship, and delivered by water to St. Petersburg to a temporary wooden pier at the pontoon Isaac's Bridge. Up to 200 people were engaged in rolling the columns from the pier to the "column barn" at the construction site of St. Isaac's Cathedral. The construction of the cathedral took 40 long years. The cathedral was consecrated on May 30, 1858 (Fig. 12).

In 1817–1818, Sukhanov's workshop was engaged in the manufacturing and processing of columns, bases, and capitals for the Church of the Icon of the Mother of God "Joy of All Who Sorrow" and the building of St. Petersburg Theological Academy (Svinin 1818). The history of this church dates back to the time of Peter the Great. However, in 1817 Alexander I approved the plan and facade of the new church according to the project of the architect Luigi Rusca (Rudneva 1997). The church was designed in the form of a cube, with a high attic crowned with a large flattened dome. Inside the rectangular stone case, like in a casket, there is a classic rotunda—a spacious round hall with 24 columns of the Ionic order, cladded with artificial marble. The main facade of the church is decorated with the Ionic portico of six columns. Monolith bases and capitals for these columns were carved from pink rapakivi granite. Granite blocks were used for the base of the portico, the basement of the building, and the steps (Figs. 13 and 14).

Fig. 13 The Church of the Icon of the Mother of God "Joy to all who mourn"

Fig. 14 The main facade of the St. Petersburg Theological Academy

Then came the turn of arranging the Palace Square of the capital and construction of the General Staff building. At the beginning of the nineteenth century, the Winter Palace had an unattractive view of a square with multi-story houses on the opposite side. In 1819, Emperor Alexander I commissioned Carlo Rossi to design the buildings to accommodate the most important state institutions and reconstruction of the main square of the capital (Zhilinsky 1892). The architect built the grandiose bow-shaped General Staff building 580 m long opposite the royal residence, which embraced the square from the south in a smooth arc. The building consisted of two huge buildings connected by a triumphal arch.

Samson Sukhanov worked on the exterior decoration of the building with his 74 stonecutters. They used Finnish rapakivi granite for the basement of the building and two balconies, the bases of columns, and half-columns in the central part of the façade (Fig. 15).

To complete the ensemble of the Palace Square C. Rossi, according to his plan in 1819, was supposed to erect a monument in the center of the square (Taranovskaya 1980).

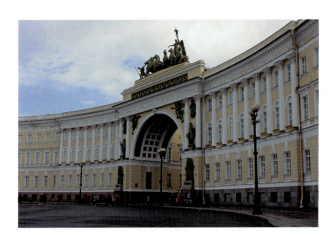

Fig. 15 The central part of the General Staff building with a triumphal arch

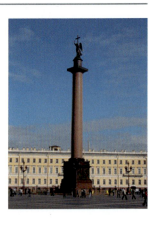

Fig. 16 Alexander column on Palace Square

The architect's idea came to fruition in 1834 when the Alexander Column was solemnly unveiled in honor of Alexander I and the victory of the Russian army over Napoleon.

The construction of the monument was commissioned by Auguste de Montferrand. A huge monolith of red rapakivi granite for the column was quarried by the contractor V. Yakovlev according to Sukhanov's method at the Puterlax quarry. The Alexander Column topped with a statue of an angel holding a cross is the world's tallest monolith monument. The total height of the column together with the pedestal and the figure of the angel is 47.5 m. The height of the polished fust is 25.6 m; its diameter: below—3.66 m and above—3.15 m; its weight is 612 tons. The grandiose free-standing column is set so neatly that no attachment to the base is needed and it is fixed in position by its own weight alone (Fig. 16).

There are also other works of the "column master".

In the summer of 1824, the Molvinskaya column was installed by Sukhanov's workers in the old park "Yeka-teringof" founded by Peter the Great in 1711. This column has survived to this day. It is a small classical column, mounted on a high rectangular pedestal with three wide steps (Fig. 17). All parts of the monument are cut out of red rapakivi granite. The total height of the pedestal and steps is

Fig. 17 Molvinskaya column

Fig. 18 Petrovsky Bridge in Shlisselburg

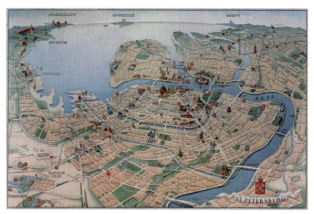

Fig. 19 Panorama plan of the center of St. Petersburg with an indication of the structures in which Samson Sukhanov took part based on the map of St. Petersburg from the site webmandry.com

6 m, and the side length of the square base is 4 m. Archival documents evidence that the column was a "granite pillar, marking the border of the city."

Petrovsky bridge in the town of Shlisselburg makes a special category of constructions with columns built with participation of the famous stonecutter. Samson Sukhanov cut the granite columns supporting the bridge. By its architecture, the unique bridge resembles ancient propylaea - the main passage formed by porticoes and colonnades.

"Bridge on Columns", now called Petrovsky, was built in 1824–1832 at the mouth of the Staroladozhsky canal during the reconstruction of the lock basin. The project envisaged the construction of a bridge with two coastal supports, each including four semi-columns and four columns, and a channel support with eight columns. The structure of the bridge, made in the style of classicism, with supports in the form of monolith granite columns of the Doric order had no analogues in Europe. "Bridge on Columns" has retained its original appearance to this day (Fig. 18).

Many buildings and monuments of the first third of the nineteenth century in St. Petersburg were built by S. Sukhanov and his artel (Fig. 19). In total, he installed 386 columns from marble, calcareous tuff, granite, and brick and cut out a huge number of bases and capitals for them. Sukhanov and his works were admired in the capital's magazines (Fig. 20). Contemporaries believed that Sukhanov revived in Russia the ancient Egyptian art of cutting out giant monoliths from granite and carving colossal columns out of them. Recognizable all over the world, iconic symbols of St. Petersburg, such as the ensemble of the Spit of Vasilyevsky Island with the Exchange building and Rostral columns, the buildings of the Main Admiralty and the General Staff, Kazan and St. Isaac's Cathedrals, have become worthy monuments not only to outstanding architects but also to talented masters, such like Sukhanov.

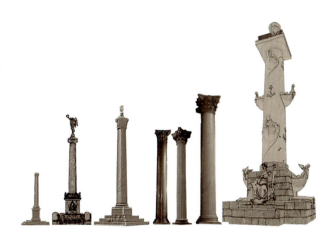

Fig. 20 The most famous columns of Samson Sukhanov

Contemporaries spoke about Samson Sukhanov as of the most experienced stonecutter of the first third of the nineteenth century. He operated six own and state-owned granite quarries. Rapakivi granite was quarried on the northern coast and on the islands of the Gulf of Finland in the Baltic Sea. One of them was located on Sorvali Island in the Vyborg Bay. Four other quarries were developed by Samson Sukhanov in Virolahti Bay: his own—on its western coast near the village of Vilkilya and on the island of Sumari, state-owned—on Cape Hailiniemi and Tugolm Island. The Serdobolsk granite was quarried in the "Menshelskayi quarry" on the Tulolansaari island in the Northern Ladoga area, not far from Serdobol (now Sortavala).

At the beginning of the nineteenth century, the technique was at a primitive level and did not differ much from the mechanisms of ancient times. Simple hand tools and physical strength of workers were employed at granite quarries. Before Sukhanov, a cheap, but rather "barbaric" method of

extracting granite with gunpowder was widely used in Russia. The result of explosions was a great amount of tiny stone particles and large fragments of irregular shape, inconvenient for processing, with microcracks that reduced the quality of the material. Such a method of quarring made it impossible to obtain giant granite blocks.

Samson Sukhanov introduced a method of separating huge granite blocks from the host rock, basing on the old method of cutting out stone blocks with the help of drills and wedges. This method was not novel, in ancient times it was used to extract huge granite monoliths in Ancient Egypt and Phenicia.

Starting the cutting of monoliths at the granite quarries, he considered the peculiarities of the Finnish rapakivi granite. Sukhanov noticed that the rock mass was divided by a system of natural cracks into large horizontal parallelepipeds and split in these directions.

Architect Auguste de Montferrand, who annually visited the granite quarries of Samson Sukhanov, impressed by the grandiose work in 1820, devoted a separate essay to the quarring of granite monoliths.

First, a stonecutter chose a suitable site to quarry the granite. Then the surface of the stone was cleared of moss, alluvial soil, and the upper weathered layer. To detect hidden cracks, water was poured onto the surface of the rock, and as it dried, the cracks appeared. In winter, cracks were detected by a thin layer of frost. The cleaned surface was additionally tapped with a mallet. The granite without defects emitted an even sonorous sound; if there were cracks in it, the sound was muffled. Then the stonecutters started rough processing of the front sheer part of the rock to the height of the future monolith. At the same time, with the help of a stretched rope and paint or a piece of coal on the upper surface of the mountain, they outlined the contours of monoliths according to the number and size of columns with a margin of more than 2 m from each end.

After that, shallow grooves 10 cm wide and 25 cm deep were cut along the outlined lines with the help of kiuras and chisels. Then, holes were made in the grooves at a distance of 15 cm. Holes with a diameter of 5 cm were punched with drills or crowbars of various lengths made of hardened iron. As the holes deepened, the drills were replaced with longer ones. One worker held the drill, turning it with each blow, while two others alternately hit the blunt end of the drill from above with heavy sledgehammers weighing 20 kg. It was necessary to pour water all the time to avoid heating of the metal and dust coming out of the hole. When all the boreholes were punched through the entire thickness of the future block, the workers proceeded to the most crucial moment—the breaking off of the monolith from the rock. For this, iron wedges about 40 cm long were inserted into the drilled holes. The workers were placed along the groove so that each had three wedges in front of him. Then, according to the sign of the master, all the stonecutters simultaneously hit the wedges with heavy sledgehammers with full swing, and, after a few blows, the granite block in the form of a four-sided prism broke off the mountain. Then they started to move the monolith away from the mountain. In the gap, 8 large, about 5 m long, iron levers were laid with ropes of equal length threaded through the ring at the top. There were 40 people at each end of the rope. At the signal of the master, the ropes were simultaneously pulled and swayed, pushing aside the granite block. When the gap widened, workers descended into it and punched holes in the lower edge of the block. They inserted four iron hooks with ropes tied to them. The number of hooks corresponded to the number of winches placed in front of the monolith. Then the workers pushed and pulled the granite block with the help of iron levers and the winches and overturned it onto a wooden platform prepared in advance.

Later, many stonecutters used Sukhanov's method to break off granite blocks. Using this method, Vasily Yakovlev quarried a granite monolith at Pyterlahti for the Alexander Column. The length of the "granite mass" reached 30 m.

References

Belonozhkin AE (2018) Column in the garden of the Academy of Arts. In: 200 years of the construction of St. Isaac's Cathedral: a collection of scientific articles of the international scientific and practical conference. Kafedra; no XXI, vol 1. SPb., pp 41–56

Bulakh AG (2012) Kazan Cathedral in St. Petersburg: stone decoration and its restoration, 1801–2012. SPb., 94 p

Ekesparre A (1832) About Puterlax granite quarry in Finland. Severnaya Pchela 241/242:3–8

Kurbatov VYa (1906) Essays on the history of Russian architecture. Architect 37:369–372

Montferrand A (1820) About the extraction of 36 granite columns, assigned for the porticoes of St. Isaac's Cathedral in St. Petersburg. SPb., 44 p

Rudneva I (1997) The Church of the Mother of God of all the Sorrowing joy. SPb., 15 p

Skrebkov A (1929) Stone cutting craftmanship. M.-L., 84 p

Svinin PP (1818) The adventures of Sukhanov, Russian Natural Sculptor. Otechestvennye zapiski. SPb., vol 1, pp 188–219

Shuisky VK (1995) Andreyan Zakharov. SPb., 224 p

Shurygin YaI (1987) Kazan Cathedral. L., 189 p

Taranovskaya MZ (1980) Carlo Rossi. Architect. City planner. Artist. L., 224 p

Zhilinsky J (1892) Building of the general staff. Historical sketch. SPb., 46 p

Granite Industry (End Nineteenth–Early Twentieth Centuries)

Maria Svetoch (Ivanova)

The history of the mining industry connects with the Vyborg province, the former Grand Duchy of Finland. This region, being the richest in granite reserves, has been supplying building materials for the construction of St. Petersburg since the second half of the eighteenth century. By the beginning of the twentieth century, this fact played a great role in the architectural grandeur of the Northern capital.

The first decade and a half of the mining industry in Finland at the stage of transition from craft to industry are considered from the perspective of contemporaries, who characterize the main market participants, areas of activity, and production problems they faced. The main source for writing the article was the materials of the monthly magazine "Ekonomist Finlandii", published by the editorial offices of "Kauppalehti" and "Mercator" in the period from January 1912 to November 1917.

Construction of St. Petersburg triggered the development of the granite industry in Old Finland. Until then, the richest resources of the natural stone "rested in a deep sleep under a thick layer of moss, under the protection of the spruce forests" ("Ekonomist Finlandii" 1915 № 6–7) (Figs. 1 and 2). The bold ideas of the best European and Russian architects required exceptional building materials for their embodiment. Peter the Great issued a number of decrees that promote the search for new deposits and encourage the delivery and use the stone suitable for construction. His successors continued this policy (Tutakova 2019).

At the turn of the nineteenth and twentieth centuries, exploitation of the Finnish granite was of decisive importance for the formation of the architectural image of the Grand Duchy of Finland. Finnish national romanticism today is the hallmark not only of Finland but also of Vyborg, a border city of the Russian Federation with a rich history of changes in its state affiliation.

M. Svetoch (Ivanova) (✉)
Research Department, Museum «Vyborg Castle», Viborg, Russian Federation
e-mail: kris-titova@mail.ru

Of course, granite had been used for construction in this area in the old times. The largest proof of this that has survived to this day is the Vyborg castle and ramparts, built of almost untreated stone. But never before has granite been quarried here on an industrial scale.

Today, the role of Finnish granite as a building material in the construction of St. Petersburg is well known, and understanding the scale of its contribution to the creation of the young capital makes the image of a developed and prosperous industry. It seems that already at the beginning of the twentieth century during the peak demand for Finnish granite in St. Petersburg this industry occupied one of the leading positions in the economy of the Grand Duchy of Finland. But was it really so? And what role did the granite industry play in Finland's foreign trade?

The industrial revolution touched Finland in the 30s of the nineteenth century and consistently accelerated throughout the nineteenth century. During this period, the population of Finland, previously oriented towards crafts, gradually changed its attitude towards life and work—work became year-round and paid, the population moved to cities. A new lifestyle dictated new landmarks in art, where railway engineers, architects, and industrial workers became heroes of the time (Klinge 2005).

Timber industry and agriculture, already well known to the Finns, easily adapted to the industrial revolution, but it was more difficult with the extraction and processing of granite. The first firms and associations offering services for the extraction, processing, and supply of granite appeared only at the end of the nineteenth century. Until then, St. Petersburg was supplied with building stone in a private way. Russian merchants were the main driving force in developing granite industry in the Vyborg province in the eighteenth and nineteenth centuries due to the contracts for the supply of building stone to St. Petersburg. These single contracts were reduced to the supply of material for a particular object in a certain amount. The periodical "Suomen Teollisuuslehti" describes the system of agreements regarding the granite quarrying and transportation to Russia from

Fig. 1 The coast near Vyborg. Picturesque Russia. Our fatherland. Volume 2. 1882

Fig. 2 Landscapes of Finland. Picturesque Russia. Our fatherland. Volume 2. 1882

Pyterlahti at the end of the nineteenth century as follows: "The extraction of natural stone usually takes place in such a way that a contractor from Russia signs a contract for the extraction of the required amount with a foreman, who in his turn receives the required amount of material from the landowners. Without exception, all stones are transported without cutting to where they will be used. Undoubtedly, this activity could have developed here on an industrial scale long ago". («Suomen Teollisuuslehti» 1889 № 17). In the brochure "The Grand Duchy of Finland. Statistical Notes", published in 1882, we read that, in the end of the nineteenth century the stonework craft, as an independent craft, took place only in Helsinki and Vyborg, and mainly for the production of tombstones.

Local population in certain districts and parishes of the Vyborg Province was also engaged in stone deliveries to St. Petersburg. This concerned, first of all, the residents of coastal areas, conveniently located for loading and delivering stones by water. For example, residents of the Koivisto parish (Primorsk) began exporting stone for sale to St. Petersburg in the 1760s, after the introduction of a number of restrictions on the timber export. In 1846, ships from the parishes of Koivisto and Johannes (Sovietsky settlement) made 388 trips to St. Petersburg and Kronstadt with firewood and 199 trips with stone (Engman 2005). It is noteworthy that there have never been any granite outcrops in the Koivisto area. All that the locals had for sale were granite boulders of glacial origin abundantly scattered over the forests and fields. They collected boulders in huge heaps - 10–20 m wide, up to 60 m long, and 11 m high, split them, and sent them for sale (Balashov 2002). Thus, they managed to earn money by selling stone and, at the same time, clearing fields for agricultural activities. Also, there is information about some families that traded in the stone sale to St. Petersburg. For example, there is information about the Hovi family, who lived in Vilajoki (Baltiets settlement) since 1818. The Hovis were influential and had their own schooner, by which they shipped timber and stone to St. Petersburg and Kronstadt (Nikitin 2011).

The leader of the granite industry was the famous Pyterlahti quarry, located in Virolahti, near the modern border between Finland and Russia (Figs. 3 and 4). St. Petersburg was supplied by building stone from these places starting in the eighteenth century and to the beginning of the twentieth century. Today, these rock massifs are an open-air quarry and industrial museum. Pyterlahti granite was the first proof that Finnish granites could also be marketed, but, as mentioned above, the Finnish granite industry started only at the end of the nineteenth century.

The largest firms engaged in granite quarrying and processing at the beginning of the twentieth century were: Joint-Stock Company "Granite" (Aktiebolaget Granit), Joint-Stock Company of the Finnish Stone Industry (Suomen Kiviteollisuus Osakeyhtio), East Finland Joint-Stock Granite Company (Itä-Suomen Graniitti Osakeyhtio). In addition to granite, deposits of talc-chlorite schist, also known as soapstone or pot stone, were exploited in Eastern Finland. Talc-chlorite schist was widely used in construction for cladding facades. Due to its high thermal conductivity, it

Fig. 3 Granite breaks in Pyuterlakhti. Picturesque Russia. Our fatherland. Volume 2. 1882

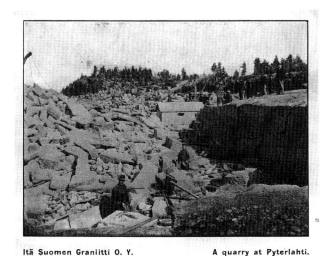

Fig. 4 Itä Suomen Graniitti quarry in Püterlaks. Mercator. 1911

Fig. 6 Warehouse of products of the Joint-Stock Company "Granit" in Hanko. Mercator. 1911

was used for laying stoves and fireplaces—both as a filler and for decoration. Schist was used to make dishes and tombstones. The largest company involved in the extraction and supply of this rock was Vuolukivi Joint-Stock Company on processing pot stone (Suomen Vuolukivi O.Y.).

The first large company in the stone industry was the Joint-Stock Company "Granite" (Aktiebolaget Granit), founded in 1886 (Ekonomist Finlandii 1915 No. 6–7). The main office of the company was in Gangut (Hanko) in the Nyuland province of the Grand Duchy of Finland (Figs. 5 and 6). Later its branches were opened in Helsingfors (Helsinki), St. Petersburg, Moscow, Riga, and Warsaw ("Mercator the trade journal of Finland" 1911 № 10). In the

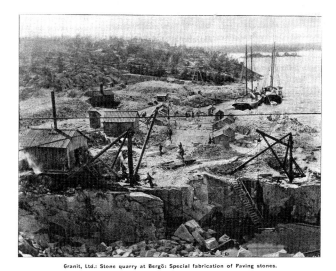

Fig. 5 The quarry of the Joint-Stock Company "Granite" in Hanko. Mercator. 1911

first decade of the twentieth century, the Joint-Stock Company "Granit" had at its disposal at least 20 quarries in different parts of the country, including Gangut and Antrea (Kamennogorsk). The main material for quarrying and processing was red and gray granite. Among the most famous works created with the help of the company: monuments to Alexander III in Moscow, Irkutsk, and St. Petersburg, a monument to Russian soldiers in Gdansk, as well as the facade of the bank of the Northern Joint-Stock Company in Vyborg and the buildings of railway stations in Helsinki and Vyborg ("Ekonomist Finlandii"1916 No. 4).

Joint-Stock Company of the Finnish Stone Industry (Suomen Kiviteollisuus Osakeyhtio) was founded in 1900. The main office of the company was in Helsinki. The company quarried grey and red granite for export to England and Russia and cobblestones for the pavements and harbors of the Baltic Sea. Among the most famous projects of the company was the facade of the Finnish National Theater, the National Museum, and the building of the Mortgage and Telephone Society in Helsinki ("Ekonomist Finlandii" 1915 No. 6–7).

East Finland Joint-Stock Granite Company (Itä-Suomen Graniitti Osakeyhtio) was founded in 1904. The main office of the company was in Vyborg with a branch in Saint Petersburg. The company produced stone for bridges, embankments, plinths, facades, and monuments. The most famous projects brought into life with the help of materials supplied by the East Finland Joint-Stock Granite Company: the Hackman and Co. trading house, the foot of the monument to Peter I in Vyborg (made of a whole stone weighing 32 tons), Troitsky and Anichkov bridges in St. Petersburg and others. However, already in 1914–1915 the company was declared insolvent ("Mercator the trade journal of Finland" 1911 № 12).

Vuolukivi Joint-Stock Company on processing pot stone (Suomen Vuolukivi O. Y.- Finnish soapstone) began its activity in 1898. In the same year, the pot stone was used for cladding the building of the "Falken" JSC in Helsinki. The company's quarry was in Nunnalahti on the shores of Lake Pielsjavrvi in the Juuka region to the north of the Vyborg province (modern Finland). The main office of the company was in Helsinki, and later, was moved to Vyborg ("Ekonomist Finlandii" 1915 No. 6–7).

"Ekonomist Finlandii" published articles detailing various aspects of the commercial market in Finland and neighboring countries. A separate series of articles was devoted to the economic aspects of the mining industry. It contained detailed information on the financial figures of the granite trade, as well as on the total volume of products exported from Finland for the period from 1899 to 1912.

The article written by Jacob Johannes Södergolm, the director of the Geological Commission of Finland, "Granite industry in Sweden and Finland. Comparison" ("Ekonomist Finlandii" 1912, No. 3) deserves a special interest. The professor analyzed the dynamics of the development of the granite industry in Sweden from 1887 to 1908, taking into account the volume of production, types of products, sales markets, and the cost of maintaining manufacturing enterprises, comparing similar data for Finland. Due to this analysis, we can compare the results of the first decade of production development in terms of various indicators - the total gross value of the granite industry in the Finnish economy, the dynamics of development, and the export value of the granite industry (Table).

According to the "Ekonomist Finlandii", from 1899 to 1912 the gross value of granite production increased from 1.01 million Finnish marks to 4.1 million ("Ekonomist Finlandii" 1915 No. 6–7). The share of exports of granite products from 1899 to 1903 was no more than 50%. In 1904, there was a leap, and the share of exports reached 95% of the total value of production, and from 1906 to 1912 it fluctuated between 40 and 80% (see Table 1). In 1911, the columnist for the "Ekonomist Finlandii" recorded an increase in demand for granite, iron products, leather, and fish, noting that: "… there is enough stone in Finland, but so far the stone is still being exported to the empire in an insignificant amount. At the very least, new markets should be found to sell in larger quantities, for example to Sweden."

The sales leaders in Finland's foreign trade at the beginning of the twentieth century were timber, paper industry, and agricultural products. By 1911, the columnist for the "Ekonomist Finlandii" noted an increase in sales in the above-mentioned categories ("Ekonomist Finlandii" 1912 No. 2). It is important to note that the difference between the value of the exported building stone and other leading groups of goods was in dozens of times (Table 3). According to the preliminary calculations of the value of foreign trade published in the magazine, for example, the value of vegetable oil exported in barrels in 1910 and 1911 was 28.2 million marks against 33.1 million marks; export of timber and wood products—161.4 million marks against 167.1 million marks in 1911 (Table 4). The value of the exported materials in the category "Mineral Industry" was estimated at 3.4 million marks in 1910 against 4.2 million marks in 1911 (Table 3). Except granite, it included sand, lime, and limestone.

In total, the value of Finland's foreign trade in 1910 and 1911 was 672.9 million Finnish marks against 761.9 million in 1911. Thus, the contribution of the mineral raw mineral industry in 1910 and 1911 was no more than 0.5%.

Why, despite all the wealth in raw materials, development of the quarry industry in Finland failed to make a breakthrough? The director of the Geological Commission of Finland, Professor Jakob Johannes Södergolm tried to answer this question. Comparing the dynamics of the development of the granite industry in Sweden and the Grand Duchy of Finland, Södergolm drew attention to the fact that, with similar indices at the first stages of production and export of granite, in two decades Sweden was far ahead of Finland in terms of economic and production indices.

In 1887, the productive value of imported granite in Sweden was 1 million crowns (or 1.4 million Finnish marks). In 1908, the value increased to about 20 million crowns (28 million marks), which is 7.5 times higher than in 1908 in Finland ("Ekonomist Finlandii" 1912, No. 3).

Analyzing the reasons for the failure of the Finnish granite industry, Södergolm examined in detail how it worked in Sweden. At the beginning of the twentieth century, this country worked for the marketing of products, but the main markets for the Swedish granite were European countries. Most of the stone production went to Germany, England, and Denmark. Industrial enterprises in Sweden

Table 1 Sales of granite from the Grand Duchy of Finland and Sweden (rel.%)

Importing countries	Grand Duchy of Finland	Sweden
The Russian Empire	90	4
Germany	2	70
England, Scotland	8	10
Other countries	–	16

were engaged in the extraction and processing of granite products and the Swedish market was subdivided according to the areas of work. The quarries were equipped with the necessary machines, such as steam cranes, rails, and steamers to transport stone. Investments were also made in providing working conditions for workers: improving their homes and workshops. Thus, the investment in one quarry was at least 35,000 Finnish marks. The granite industry in Sweden involved no less than 12,000 workers, whose payments were about 10 million marks (in total), and the transporting costs were estimated at about 6 million marks.

Comparing these figures with the Finnish granite production and sale, Professor Södergolm noted that there was no extra money in Finland to invest in the technical equipment of enterprises. The number of workers employed in the granite industry in 1911 was 1492, and the number of workers engaged in the granite transporting barely exceeded 700 ("Ekonomist Finlandii" 1913 No. 12). At the same time, salaries were not stable and depended on the type of work and profits. The only promising market for Finland, due to its geographical position, was the Russian Empire.

According to Professor Södergolm, in order to increase the income from the granite industry, Finland needed to expand production, which required large investments in the technical equipment of the quarries and simplification of transportation. He recommended focusing on the development of the manufacturing industry. For the successful development of the business, the division of enterprises into different spheres of production was required. If the existing large companies could share the load and specialize in different types of production, this would lead to an increase in production as a whole. However, the main obstacle to such a distribution of forces was the "heterogeneity" of the services market. Professor Södergolm notes the high competition that existed between the enterprises of that time. Against the background of a small number of large firms, new, small ones appeared, and in the struggle for orders, they pursued a policy of lowering prices, which, in general, lowered the market value of the entire industry. In 1908, 48 companies working in the field of the stone industry were registered on the territory of the Grand Duchy of Finland ("Ekonomist Finlandii" 1915 No. 6–7). According to the 1911 statistics in the monthly magazine "Ekonomist Finlandii", in Finland there were 26 quarries: 13 of them belonged to joint stock companies, 2—to cooperative companies, and 11—to private individuals ("Ekonomist Finlandii" 1912, No. 3).

This explains the fact that, while studying the history of the construction of Vyborg buildings, it is often impossible to find information about the suppliers of building stone. Therefore, at the beginning of the second decade of the twentieth century, a few large enterprises engaged in the supply of granite to the Russian Empire were under the threat of bankruptcy. Competition among the firms was fierce in areas where demand exceeded productivity. It concerns the market of paving and rough stone ("Ekonomist Finlandii" 1912 No. 12). Paving stone processing is one of the few areas in which work could be carried out all year round. But at the turn of the first and second decades of the twentieth century, the number of workers employed in this industry in Finland did not exceed 200 people. Paving stone was in demand, but the cost from its sale was low. Therefore, in order to increase the income from the sale of paving stone, it was necessary to increase the scale of its marketing. The demand was also high for processed stone: for monuments, facades, and embankments, which required the development of the manufacturing industry. It is more convenient to accept large orders in advance. However, in practice, the final drawings of the facades and cladding parts were provided during the manufacturing and processing of the material. Thus, the timing of work and the speed of delivery were of decisive importance.

Besides, the transportation fees of stone products by rail were exceptionally high, which caused certain restrictions on the stone export to the Russian Empire ("Ekonomist Finlandii" 1912 No. 12). A separate problem was the quality of Finnish granites. As it turned out, not all of them were equally well suited for wide use ("Suomen Teollisuuslehti" 1989 No. 16–17; "Ekonomist Finlandii" 1913 No. 12; 1915 No. 6–7). In practice, it turned out that the red rapakivi granite could not be used for monuments and other works requiring a high level of executive quality. However, it remained in demand for such purposes as cladding, paving, construction and rubble. At the same time, in the Grand Duchy of Finland, there were also many deposits of solid medium-grained red granite, which gained recognition in England, displacing the Swedish granite ("Ekonomist Finlandii" 1912, No. 3). There were also deposits of black granite (gabbro) popular in Germany, but the extraction and delivery of this stone at that time was too expensive for the Finnish industry.

Today the territory of the former Grand Duchy of Finland is divided by the state border between Russia and Finland. On both the sides, the exploration of granite continues to this day, and many large quarries, where work had been stopped, turned into unique man-made landscape monuments of the nineteenth–twentieth centuries. Researchers' interest in the history of the granite industry in the Grand Duchy of Finland continues to this day. A number of international projects are involved in the research of historical quarries. Russian and Finnish specialists in the field of regional history and geology work in the frame of these projects. The scope of the tasks of these studies is extremely wide. They consider the

possibility of resuming the exploration of historical quarries for the use of stone in the restoration of architectural monuments; some projects concern museumification of monuments of mining and industrial heritage, development of thematic tourist routes.

References

Balashov EA (2002) Western sector: Koivisto-Primorsk. The Karelian Isthmus is an unknown land. SPb

Engman M (2005) Finnish people in St. Petersburg. SPb

Exhibits of the Geological Commission of Finland at the All-Russian Industrial and Art Exhibition in 1896 in Nizhny Novgorod (1896). Helsinki

Finland in the Russian Press (1902) Materials for bibliography collected by M. Borodkin. SPb

Klinge M (2005) Imperial Finland. SPb

Klyarovskaya GV (2000) Granite quarries of the Karelian Isthmus (XVIII–XIX centuries). Pages of the Vyborg history. Local history notes. Vyborg

Lahermo P (2017) Suomamainen kivi. Vanhan Pietarin rakennuksissa ja monumenteissa. Helsinki

Nikitin VV (2011) Northwest sector: Syakkiyarvi [Kondratyevo]. The Karelian Isthmus is an unknown land. Part 11. SPb

Semenov PP (1882) Picturesque Russia. Our homeland in its land, historical, tribal, economic and everyday meaning. Volume two. North-Western outskirts of Russia. The Grand Duchy of Finland. SPb

Tutakova AYa (2019) Granites on the Karelian Isthmus and their use in the architecture of St. Petersburg Environment. № 2

Digital Resources of the National Library of Finland

«Ekonomist Finlandii». https://digi.kansalliskirjasto.fi/aikakausi/titles/fk20100877?display=THUMB&year=1917

https://digi.kansalliskirjasto.fi/etusivu«MercatorthetradejournalofFinland». https://digi.kansalliskirjasto.fi/aikakausi/titles/fk01455?display=THUMB&year=1911).

https://digi.kansalliskirjasto.fi/aikakausi/titles/1458-6711y?year=1889).

Granite Weathering Under Urban Condition

Granite Weathering Under Urban Condition

Elena Panova, Dmitry Vlasov, Marina Zelenskaya, and Alexey Vlasov

Abstract

Various aspects of the granite destruction in urban environments were studied in Saint-Petersburg. Granite is commonly used to create monuments, buildings, and embankments. Rock degradation is associated with physical, chemical, and biological factors. In this chapter, the main forms of granite destruction are described and a classification of biofouling granite is developed. Features of granite biological colonization were established. Rapakivi granite is most strongly subjected to damage by abiotic weathering processes as well as biological colonization, which can be explained by the peculiarities of the mineral composition and texture of these rocks.

Granite is considered one of the stone symbols of St. Petersburg, which has been used since the eighteenth century. Peter and Paul Fortress, embankments of the Neva River was dressed with rapakivi granite, curved granite bridges and bridges over rivers and canals, staircases and ramps for descending to the water appeared. The bases of many palaces and houses are lined with rapakivi granite. Huge granite monoliths are used as pedestals of monuments. The Alexander Column, the colonnades of St. Isaac's and Kazan cathedrals adorn St. Petersburg.

E. Panova (✉)
Department of Geochemistry, Saint-Petersburg State University, Saint-Petersburg, Russian Federation
e-mail: e.panova@spbu.ru

D. Vlasov · M. Zelenskaya
Department of Botany, Saint-Petersburg State University, Saint-Petersburg, Russian Federation
e-mail: d.vlasov@spbu.ru

M. Zelenskaya
e-mail: marsz@yandex.ru

A. Vlasov
Research Department, The Archive of the Russian Academy of Science, Saint-Petersburg, Russian Federation
e-mail: alex_vlasov@mail.ru

Later, during the Soviet period, the granites of the Karelian Isthmus (Sortavala, Kuznechnoye, and Kamennogorsk areas). These granites can be seen in the embankments of the Neva River, modern buildings, and in the lining of metro stations. In the modern period, sidewalks of Nevsky Prospekt and other central streets of the city were dressed in granite.

Granite is a durable stone, but it also collapses, gets sick, and is covered with mosses and lichens. We need to know and be able to heal the stone from destruction in order to preserve our city, preserve history. The problem of stone destruction is of great interest to modern architects, designers, and restorers, as well as stone mining companies.

The destruction of granite in the northern cities is a result of interrelated physical, chemical, and biological processes. Initially, surface defects formed under the influence of mechanical weathering. Biogenic weathering is connected with the impact on the rock surface by microorganisms (bacteria, fungi, and microalgae), lichens, and mosses. They form lithobiont communities that contribute to its mechanical destruction. The release of organic acids enhances chemical degradation.

Due to the extremely heterogeneous and coarse-grained structure, rapakivi granite is most susceptible to weathering compared to other types of granite. In natural conditions, during a long (geological) time, rapakivi decomposes into ovoids and a fine-grained mass. Rapakivi granite was the first to come to our city and has been weathering for more than 300 years.

Descriptions of the defects of the stone allowed us to draw up a scheme of its destruction (Table 1). Indexes according to Fitzner et al. (1995) are indicated in parentheses.

During nature observations, rapakivi granites of St. Petersburg (embankments, pavements, buildings, bridges, etc.) were described. Splinters that fell out of the constructions were taken for analysis. Descriptions of the defects of the stone allowed us to create the scheme of its destruction (table). Indexes according to Fitzner et al. (1995) are

Table 1 Granite weathering in the city environment

	I. Abiotic (physical–chemical)	II. Biotic	III. Antropogenic
	IA. Surface roughening (Rr)	IIA. Biofilms (Bi)	IIIA. Atmospheric pollution (I-C)
		IIB. Lichens fouling (Bi)	IIIB. Cementation of stone's defects
	IB. Hollows and deepening (R)	IC. Vascular plants (Bh)I	IIIC. Efflorescences (E-C)
	IC. Exfoliation (S)		IIID. Stains from metal corrosion constructions (D-C)
	ID. Fissures (L)		
	IE. Loss of rock fragments (O)		IIIE. Deformations
			IIIF. Vandalism (aO, aR, aI)
	IF. Chemical weathering		IIIG. Catastrophic destructions

Note Indexes according to Fitzner et al. (1995) are indicated in parentheses

indicated in parentheses. Some types are absent in his classification.

Weathering is the process of destruction and alteration of minerals and rocks under the influence of physical, chemical, and biotic factors. Weathering is divided into physical (or mechanical), chemical, and biogenic. The destruction processes of natural stone in an urban environment can be accelerated and are caused by the complex effects of physical, chemical, and biological factors that are closely interrelated.

1 Abiotic (Physical and Chemical Weathering)

Physical weathering is the disintegration of a rock without a significant change in the composition of the debris. Physical weathering occurs under the influence of temperature changes, freezing–thawing of water, and wind. Physical weathering includes the following types: temperature, frost, and shock effects of wind. The polluted atmosphere is one of the permanent factors affecting the stone in large megacities. Dust has a destructive effect on the stone.

Physical weathering is represented by the following types: IA surface coarsening; IB depressions and depressions; IC peeling; ID cracks; IE chips and loss of fragments.

IA Surface coarsening is characteristic of exposed granite surfaces. It develops with different intensities depending on the position of the surface in relation to the direction of the wind rose, and the vertical or horizontal position of the stone (Fig. 1).

IB Hollows and deepening appear on the surface as a result of deep weathering and the loss of several grains of minerals. The appearance of rounded depressions in the rock as a result of the precipitation of large crystals is characteristic (Fig. 2).

IC Exfoliation leads to the appearance of thin plates on the surface of the stone, consisting of granite and the products of its destruction. Peeling occurs as a result of heating the surface of the stone to a certain depth (Fig. 3).

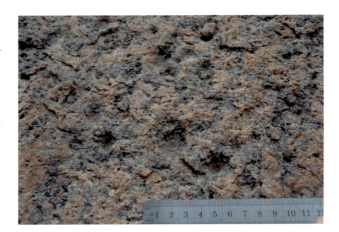

Fig. 1 Surface coarsening

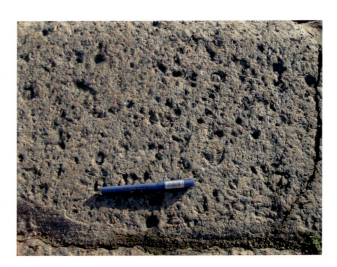

Fig. 2 Hollows and deepening

ID Fissures can be hidden and visible. They accumulate moisture, biota settles in them (Fig. 4).

IE Loss of rock fragments. Chips form at the site of cracks, which leads to the loss of fragments. The loss of fragments causes aesthetic damage to architectural buildings, which is enhanced by careless restoration (Fig. 5).

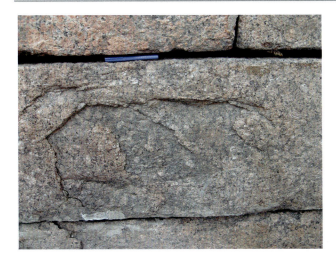

Fig. 3 Peeling

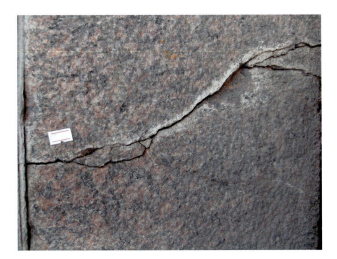

Fig. 4 Cracks

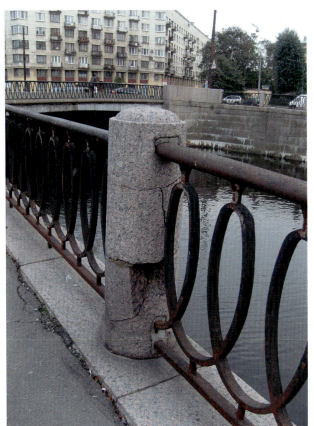

Fig. 5 Chips and loss of fragments

Fig. 6 Oxidation of sulfides (brown color)

IF Chemical weathering. This type of weathering accompanies other types of weathering. Under the influence of water, wind, and temperature differences, mechanical bonds between stone particles are destroyed. Water penetrates through cracks in the rock, creating a favorable environment for chemical reactions. Gases and substances in the air and water have a harmful chemical effect. When the carbon dioxide of the air is dissolved in rainwater, carbonic acid is formed, which destroys the rock. Due to the oxygen in the air, the oxidation and transition of chemical elements into nitrous forms occur. The presence of sulfides in granite leads to their oxidation in an urban environment and the appearance of brown spots on the surface of the stone. On the vertical walls, the brown color flows down, forming vertical stripes (Fig. 6). This effect can be avoided by choosing the right stone for construction—with the absence of sulfides.

During the transition from an unchanged rock to a weathered crust, grains of minerals become more fractured. Cracks and spaces between grains are filled with brown iron hydroxides (Fig. 7). During weathering of mica, pyroxenes, amphiboles, and feldspar turn into clay minerals and are washed out of the rock. The processes of oxidation and

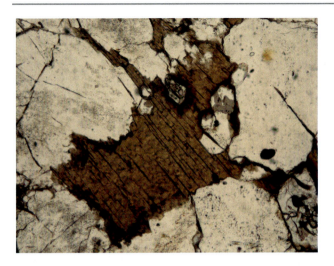

Fig. 7 Brown borders of iron hydroxides around zircon and biotite

substitution of minerals lead to the appearance of additional microcavities and microcracks, increasing mechanical destruction.

To assess the degree of chemical weathering of granite, the crust and relatively unchanged granite were analyzed for the content of petrogenic oxides and trace element composition. From the reference sample in the center of St. Petersburg, pairs of samples (granite-crust) were selected, which have the most visible surface changes (Table 2).

The crust is enriched with silica, aluminum oxide, and sodium and depleted of potassium and calcium compared to unchanged granite. It is possible to estimate the intensity of the chemical weathering process based on the calculation of the weathering index (Chemical index of alteration, CIA) (Law, Hesbitt, etc. 1991).

$$\mathrm{CIA} = \frac{Al_2O_3}{Al_2O_3 + Na_2O + K_2O + CaO} \times 100 \quad (1)$$

The value of this index is higher for crust samples, compared to unchanged granite.

2 Biotic Weathering

Biofouling means the development or accumulation of living organisms (microorganisms, plants, fungi, and animals) on a solid substrate. Often this term is replaced by the term "biological colonization" to designate the biological objects on the surface of monuments in the open air (Guiamet et al. 2012; Rossi et al. 2012; Frank-Kamenetskaya et al. 2019). Macro- and microfouling are distinguished depending on the composition and size of biological objects. Macrofouling includes higher plants, as well as large lichen thalli (for example, fruticose), while microfoulings include biofilms or individual colonies formed by microorganisms. The process of biological colonization can have a different duration and be accompanied by substrate deterioration. Biodeterioration is a special type of destruction of materials associated with the impact of living organisms or their metabolic products. The development of biodeterioration can lead to the loss of the properties of the stone material and its subsequent destruction.

The widespread use of granite in urban architecture has drawn attention to the problem of biofouling and biodeterioration, especially in northern Europe (Mattsson and Oftedal 2004; Panova et al. 2014). Organisms that can deteriorate the granite include bacteria, microscopic algae, and microscopic fungi, mosses, lichens, higher plants, invertebrates, and vertebrates. They usually form a lithobiotic community that can cover a significant surface of granite and has a biochemical and physical effect on the stone. Lithobiotic organisms affect granite by releasing various metabolites, primarily organic acids, into the environment. Some metabolites contribute to the extraction of mineral components from granite, which affects its destruction. Subsequently, bioinert interaction can lead to the formation of primitive soil and the settlement of the stone by higher plants. The process of biofouling is accompanied by the absorption of chemical elements from the destroyed rock by vegetation. These elements include P, S, Cl, K, Ca, Mg, Na, Sr, B, and to a lesser extent Si, Al, and Fe.

To understand the mechanisms of granite biodeterioration, it is necessary to know the composition of lithobitic organisms capable of settling on the rock, as well as the nature of their impact on the stone.

Algae usually play an indirect role in the weathering of minerals and rocks. They are often considered as a supplier of nutrient sources for more aggressive heterotrophic organisms (micromycetes and bacteria) (Scheerer et al. 2009). Also, algae biofilms are able to accumulate moisture on the surface and in the rock, thereby contributing to the weathering associated with the freeze–thaw cycle (Hall and Otte 1990).

Micromycetes have both physical and chemical effects on the stone. Micromycetes penetrate and grow between stone

Table 2 Average content of petrogenic oxides in granite and its crust, mass%

Oxides		SiO_2	Al_2O_3	K_2O	Na_2O	CaO	Fe_2O_3	MgO	TiO_2	P_2O_5	MnO	Total
$n = 10$	Granite	67.90	13.50	5.11	2.93	2.35	6.39	0.41	0.720	0.193	0.066	99.57
	Crust	69.00	15.60	4.49	3.60	1.98	3.39	0.21	0.342	0.092	0.032	99.73

crystals, causing disintegration of the surface layer (Gorbushina et al. 1994). Oxalic acid, produced by fungi, is the most dangerous for stone material. Its interaction with the substrate leads to a noticeable change in the surface layer, the formation of secondary minerals—oxalates (De la Torre et al. 1993).

Lichens, which are a symbiosis of fungus and algae, can play a significant role in the destruction of rock. As micromycetes, they have a physical and chemical effect on the stone (Schiavon 2002). The role of lichens is connected not only with the weathering of rocks and the biosynthesis of new minerals but also with the formation of primary (primitive) soils (Jones et al. 2014). To understand the role of lichens in stone weathering it is important to study lichen crusts, mineral particles in the thallus, and the surface of the stone directly under the thallus after the removal of the lichen. It is known that due to their biochemical activity (release of organic acids), lichens can leach Mg, Na, K, Ca, Fe, and even Si from rocks (Adamo and Violante 2000). The method of scanning electron microscopy can be used for the estimation of the impact of lichens on a stone substrate.

Most of the microorganisms on the stone exist in the form attached to the surface structured communities—biofilms. The formation of biofilms is one of the main strategies that increases the resistance of microorganisms to adverse effects, as well as allowing them to obtain the nutrients necessary for their development (Vlasov et al. 2020). Biofilms can have the greatest destructive effect on the stone and usually consist of representatives of one or different species of microbes (Warscheid and Braams 2000; Cutler and Viles 2010; Grbic et al. 2010). Cells of microorganisms in a biofilm are immersed in an organic matrix of microbial origin, which is represented by polymeric substances: polysaccharides, lipopolysaccharides, proteins, glycoproteins, lipids, glycolipids, fatty acids, and enzymes (Dakal and Cameotra 2012). This organic matrix performs an integrating function, and also promotes adhesion—attachment to the substrate. Substances of vital activity of microorganisms (mucus and other extracellular polymeric substances, cell debris) can stick together with mineral particles. In this case, a kind of "biomineral" surface layer is formed (Frey et al. 2010). The size and structure of biofilms are largely determined by the properties of the substrate, as well as a combination of external factors (Mitchell and Gu 2000; Sanjurjo-Sánchez et al. 2012). Often biofilms selectively settle on minerals. For example, granite biofilm most actively develops around feldspar grains, as well as on biotite. At the same time, surface contamination of stone material can change the properties of biofilms and the peculiarities of stone settlement (Gleeson et al. 2005). In general, various types of biofouling (biofilms) on granite can have a noticeable effect on stone: significantly accelerate biogeochemical reactions, contribute to the processes of weathering of granite, which is expressed in the shedding of the surface layer of the stone, the formation of heterogeneous surface, surface deposits (crusts), as well as different types of patina.

The classification of granite biofouling is shown in Fig. 8. It includes three groups and seven subgroups, for each of which we provide typical images and a brief description.

The presence of algae on stone is reflected primarily in the discoloration of the surface of the stone. For example,

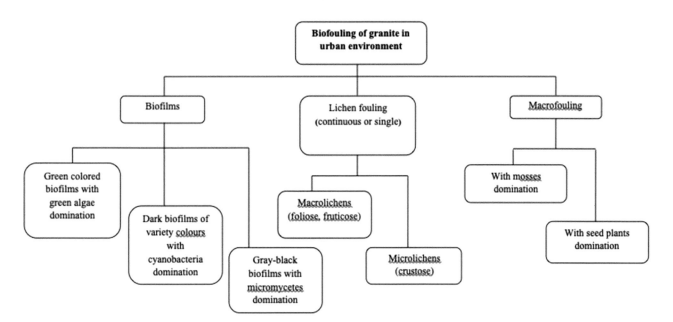

Fig. 8 Classification of granite biofouling in an urban environment

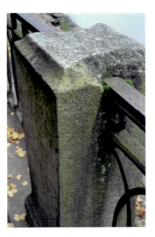

Fig. 9 Biofilm with algae dominance on the granite embankment in the Vyborg city

Fig. 11 Algae-dominated biofilm on the granite facade of a building in the Vyborg city

biofilms dominated by algae of genus *Trentepohlia* stain the stone surface rusty red or orange due to carotenoids, while biofilms dominated by algae of genus *Desmococcus* stain green due to the presence of chlorophyll. Green biofilms on granite are usually characterized by the domination of algae from the Chlorophyta division. Often such algae are called aerophilic. Their growth can often be observed on granite embankments (Fig. 9), pedestals of monuments (Fig. 10), and building facades (Fig. 11).

Distribution of algae-dominated biofilm over the granite can be continuous or local, often depending on the surface of microrelief. Algae-dominated biofilms develop most actively in zones of increased moisture in granite, especially at the base of granite buildings (Fig. 12). Biofilms also contain atmospheric pollutants (Fig. 13), and have a complex composition. In addition to algae, microfungi and organotrophic bacteria are often isolated from such habitats. Algae-dominated biofilms usually cover the granite with a

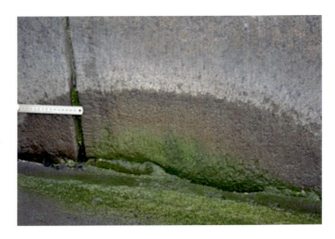

Fig. 12 Biofilm with dominance of green algae at the base of the granite facade of the Exchange building. St. Petersburg

Fig. 10 Algae-dominated biofilm on a granite pedestal of a monument in the Museum Necropolis of the eighteenth century, St. Petersburg

Fig. 13 Green algae-dominated biofilm associated with atmospheric pollution on the granite surface. St. Petersburg

Fig. 14 Growth of filamentous algae (SEM image) on the surface of a granite pedestal in the eighteenth-century Museum Necropolis. St. Petersburg

continuous layer. Often the growth of green biofilms can be observed in the direction of rainwater movement. In this case, clearly visible green streaks are formed on the surface of the stone. SEM analysis of green biofilms often shows extensive growths of algal filaments over the granite surface (Fig. 14).

Cyanobacteria (blue-green algae) often develop on the surface of granite along with algae. They usually dominate in places of moisture infiltration (Fig. 15) and form biofilms of various colors and densities in the direction of moisture movement. Cyanobacteria are generally considered to be the pioneers of colonization of rock substrate in various ecological conditions. As algae, they retain moisture and contribute to the accumulation of organic matter on the granite surface. Cyanobacterial biofilms can be thick. On monuments and structures made of granite, they usually have a dark green, brown (Fig. 16), or almost black color (Fig. 17). Besides, a characteristic feature of such biofilms is the formation of mucus containing the metabolic products of these organisms. Cyanobacterial biofilms can accumulate atmospheric pollution and particles of granite destruction.

Surface layers of gray-black color are widely found on granite monuments and structures in the historical part of St. Petersburg. They often include atmospheric dust pollution. Studies of the microbial composition of such layers showed the domination of microscopic fungi (micromycetes). Also, bacteria, including cyanobacteria, are widely represented in such biofilms. Gray-black biofilms usually form in the direction of moisture movement (Fig. 18) and cover the vast surface of granite in places of increased moisture (Fig. 19).

Dark-colored microscopic fungi are usually dominated in gray-black biofilms. They can develop extensive surface mycelium (especially in places of increased granite contamination), as well as form limited microcolonies that occupy "microzones" in the surface layer of the stone. For

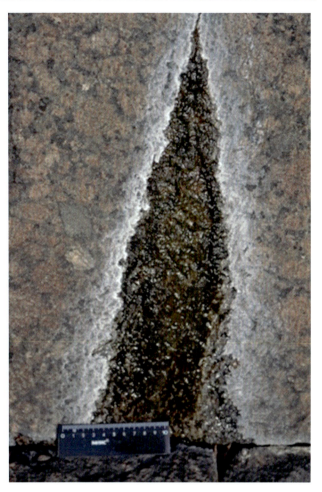

Fig. 15 Slimy brown biofilm with dominance of cyanobacteria on the surface of granite in the zone of moisture movement. Peter-Pavel's Fortress. St. Petersburg

example, microcolonial yeast-like fungi form black compact colonies, consisting of rounded homogeneous cells, which usually occupy microcracks or depressions on the surface of granite. Penetrating hypha extends from colonies and contributes to the successive colonization of the stone substrate (Fig. 20). Often these fungi form short chains of cells of the same size (Fig. 21). Such picture is more often observed on feldspar, the structure of which allows fungi to gain a foothold on this mineral. The number of micromycetes in fungal-dominated biofilms can reach 10,000 colony-forming units per 1 g of the sample. At such values, fungi are able to damage the surface layer of the stone material due to the processes of biochemical leaching, as well as the growth of hyphae between crystals. The development of biofilms with the dominance of fungi can cause a noticeable disintegration of the surface layer of granite. Microscopic fungi are often associated with organotrophic bacteria, among which spore-forming bacteria of the genus *Bacillus* predominate. The number of bacteria in gray-black biofilms can exceed 10^6 cells per 1 g of substrate.

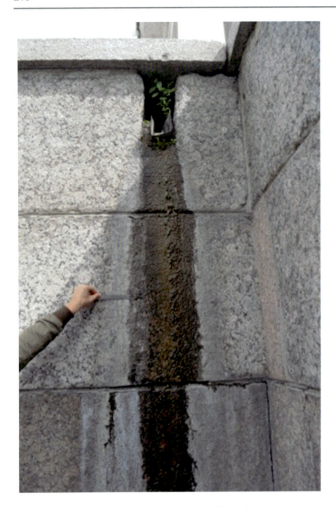

Fig. 16 Biofilm with dominance of cyanobacteria on the granite facade of the Exchange building. St. Petersburg

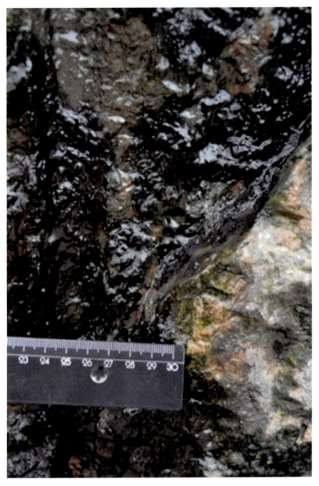

Fig. 17 Slimy biofilm of black color with dominance of cyanobacteria on granite in the central part of the city of Vyborg

In the course of mycological studies of biofilms with the dominance of fungi on granite in St. Petersburg, dozens of micromycete species were identified (Panova et al. 2014). Obvious dominants on granite monuments, buildings, and structures in St. Petersburg include dark-colored fungi *Alternaria alternata, Aureobasidium pullulans, Cladosporium cladosporioides,* and *Coniosporium* sp. It should also be noted that microscopic fungi often accumulate in places with mosses growth, which enhances the destruction of the surface layer of the stone. Species of the genera *Penicillium* and *Fusarium* dominate in such habitats.

Lichens are perfectly adapted to life on rocky substrates. Crustose and foliose lichens are widely found on granites under various conditions. In the urban environment, crustose lichens, which form thallus fused with the substrate predominate on monuments, buildings, and structures (Fig. 22). Distribution of crustose lichens on the substrate can be very different. For example, one species of lichen can cover a significant surface of granite, forming biofilms of a certain color. At the same time, several types of lichens can develop in small areas of the stone, which gives the surface a variegated color. During the initial colonization of granite, lichens use weathered places, grain boundaries, microcracks, and depressions in the surface layer of the stone. Often, the colonization of granite by lichens begins with biotite, as the softest mineral subject to weathering. However, it is possible to observe the localization of lichen fruiting bodies on K-feldspar (Fig. 23). They can be located in the microcracks and deepenings with colonies of microcolonial fungi. Lichens often prefer to colonize the cement inserts between granite blocks. They are also can be concentrated at the places of contact between granite and metal structures (Fig. 24).

The biological colonization of granite in the urban environment involves spore plants (mosses, ferns) and seed plants (herbaceous, shrubby, and woody). In some areas, they develop locally or form abundant communities. Most frequently, plants are localized in the spaces between granite elements (Figs. 25, 26 and 27). In such places, conditions allow plants to gain a foothold. This is especially noticeable

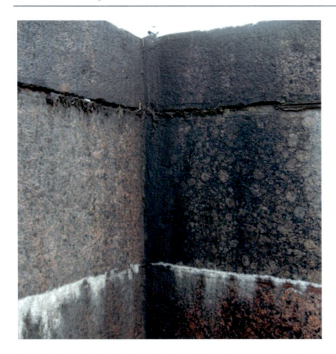

Fig. 18 Gray-black biofilm dominated by microscopic fungi on a granite embankment in St. Petersburg

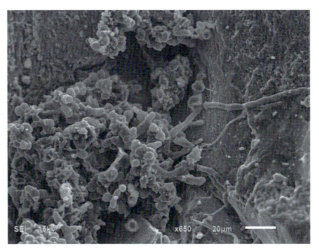

Fig. 20 Fungal microcolonies and penetrating hyphae in a recess on the granite surface. Granite embankment. St. Petersburg

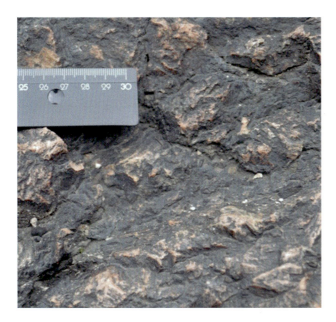

Fig. 19 Gray-black biofilm with dominance of microscopic fungi on granite in Vyborg

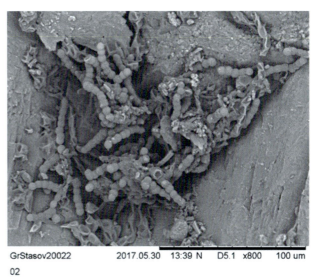

Fig. 21 Short chains of fungal cells on the surface of granite in the zone of damage of the surface layer. Monument to Stasov V. V. Necropolis of the Masters of Arts. St. Petersburg

on the granite embankments of St. Petersburg, as well as on the facades of historical buildings. Often plants are localized in places of cement inserts between blocks of granite. Mosses and herbaceous plants usually predominate here. On the granite embankments of the central part of St. Petersburg, 110 plant species have been identified. Mosses of 3 species are found everywhere: *Ceratodon purpureus*, *Pohlia nutans*, and *Physcomitrium* sp. They retain moisture and create conditions for the gradual destruction of granite stone. Under the mosses, there can be observed the formation of a thin layer of primary soil, which includes dead fragments of the mosses, particles of deteriorated granite, as well as particles of sand and dust brought in from the external environment. Chemical elements pass from granite into the soil, and then enter the plants, accumulating in them. The most noticeable accumulation of chemical elements occurs in herbaceous plants such as *Poa pratensis*. The root system of plants has a destructive effect on granite. The roots penetrate into the spaces between the stone blocks, through macro- and microcracks, which causes the physical destruction of

Fig. 22 Crustose lichens on the surface of granite. Granite embankment. St. Petersburg

Fig. 25 Mosses and seed plants in the spaces between the granite steps. Exchange building. St. Petersburg

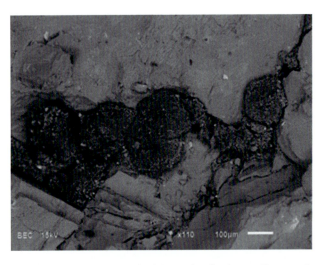

Fig. 23 Fruit bodies (apothecia) are localized according to the microrelief of the granite surface (SEM image)

Fig. 26 Growth of ferns on a deteriorated granite facade. Exchange building. St. Petersburg

Fig. 24 Lichen fouling in the zone of contact between granite and cast-iron grating. Granite embankment. Vyborg

Fig. 27 Growth of mosses between blocks of granite. Exchange building. St. Petersburg

the stone. In addition, the presence of plants contributes to the accumulation and development of microorganisms that cause biological damage to granite.

Thus, granite biofouling in the urban environment is widespread. The dominance of the most adapted species, which form the basis of lithobiotic communities, is especially noticeable in the city. They contribute to biodeterioration and weathering of the rock. Mineral fragments are often retained in lithobiotic communities. In the course of the conducted research, the dependence of the nature of the biological colonization of granite on its mineral composition was revealed. The selectivity of the organisms' settlement on granite is connected with the fact that morphology, the nature of the cleavage of minerals, and their hardness are not the same. Biodestructors are distributed in the surface layer of the stone depending on the structural features of minerals and the state of the surface. Thus, microorganisms in quartz can only inhabit microcracks, which leads to their small number and lack of biodiversity. In K-feldspar, they use the cleavage ledges that are characteristic of this mineral. In such places, microcolonies of fungi, as well as crustose lichens, are frequently concentrated. In biotite, microorganisms find a place between layered flakes. Continuous biofilms, dominated by microscopic algae or fungi, usually form in zones of increased moisture and surface contamination of granite. Spore and seed plants usually use large surface defects, macrocracks, and spaces between stone blocks to colonize granite. Various types of granite biodeterioration are often linked with each other and accompanied by chemical and physical effects on the stone. This fact must be taken into account while developing methods for protecting granite monuments, buildings, and structures against biodeterioration.

3 Anthropogenic Destruction

Anthropogenic weathering (from Greek. *anthropos*—man) defines the human impact on various elements of the environment, including stone. Usually, anthropogenic impact is destructive. Unintended changes are changes in the gas composition of the atmosphere, climate, acid rains, smog formation, ozone layer disturbances, environmental disasters as a result of major accidents, etc. Destruction occurs under the influence of vandalism.

Among the anthropogenic destruction of stone, the following types are distinguished: IIIA—atmospheric mud layers (I-C); IIIB—cementation of stone defects; IIIC—salt deposits (E-C); IIID—deposits from metal constructions (D-C); IIIE—deformations; IIIF—vandalism; IIIG—catastrophic destruction (Table 1). Indexes according to Fitzner et al. (1995) indicated in parentheses.

Fig. 28 Atmospheric mud layer

IIIA Atmospheric mud layers are associated with blackening of the stone caused by sooty layers. They cover the stone unevenly, settling in the recesses of the surface and on horizontal sections. The film has a rough surface and a matte sheen (Fig. 28).

IIIB Cementing of stone defects occurs when the joints between granite blocks are filled with cement mortar. Cement has a more alkaline environment than granite. At the contact of the two media, a chemical interaction occurs, leading to further destruction. In recent years, putties of different colors have been used instead of cement (Fig. 29).

IIIC Salt layer occurs when cement dissolves. The carbonate component is washed out of the seams to form gypsum. The smudges look unsightly (Fig. 30).

IIID Smudges from metal details have a brownish-brown color. They consist of iron oxides and hydroxides. In the case of using copper alloys, secondary copper minerals with a blue-blue color appear on the granite surface (Fig. 31).

IIIE Deformations are associated with the irregularities of the base and the lifting of nearby blocks relative to each other. The protruding parts of the plates are most exposed to physical destruction, chipping of large crystals, and a gradual increase in the gap between the plates.

IIIF Vandalism. Inscriptions on stone spoil the appearance of architectural structures and violate its integrity.

IIIG Catastrophic destruction is associated with fires. On the defense islands in the Gulf of Finland, granite has melted to plagioclase glass, which hangs from the arches in the form of transparent icicles.

Fig. 29 Cementing of stone defects

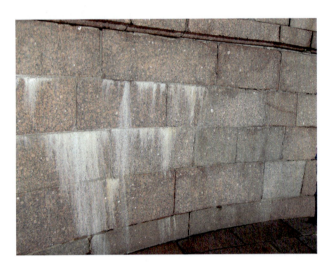

Fig. 30 Salt layer when cement dissolves

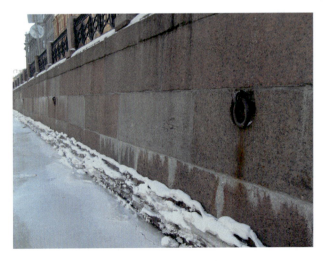

Fig. 31 Smudges from metal details

Thus, all types of anthropogenic weathering lead to an acceleration of mechanical and chemical destruction. New defects contribute to biological colonization. Inscriptions on the surface of the stone spoil the aesthetic integrity of the architectural object. Possible measures of struggle can be—smooth and dense installation of paving slabs, regular cleaning of surfaces, careful individual selection of cementing solutions and a legislative ban on the application of inscriptions with paints.

References

Adamo P, Violante P (2000) Weathering of rocks and neogenesis of minerals associated with lichen activity. Appl Clay Sci 16:229–256

Cutler N, Viles H (2010) Eukaryotic microorganisms and stone biodeterioration. Geomicrobiol J 27(6–7):630–646

Dakal TS, Cameotra CC (2012) Microbially induced deterioration of architectural heritages: routes and mechanisms involved. Environ Sci Eur 24–36

De la Torre A, Gomez-Alarcon G, Vizcanio C, Garcia MT (1993) Biochemical mechanisms of stone alteration carried by filamentous fungi living in monuments. Biogeochemistry 19:129–147

Fitzner B, Heinrichs K, Kownatzki R (1995) Weathering forms—classification and mapping. Denkmalpflege und Naturwissenschaft. Natursteinkonservierung I, 41–88

Frank-Kamenetskaya OV, Vlasov D, Rytikova VV (eds) (2019) The effect of the environment on Saint Petersburg's cultural heritage. In: Results of monitoring the historical necropolis monuments. Geoheritage, Geoparks and Geotourism. Springer, 218 p

Frey B, Rieder SR, Brunner I, Plotze M, Koetzsch S, Lapanje A, Brandl H, Furre G (2010) Weathering-associated bacteria from the damma glacier forefield: physiological capabilities and impact on granite dissolution. Appl Environ Microbiol 76:4788–4796

Gleeson DB, Clipson N, Melville K, Gadd GM, Dermott FP (2005) Characterization of fungal community structure on a weathered pegmatitic granite. Microb Ecol 50:360–368

Gorbushina AA, Krumbein WE, Hamman CH, Panina L, Soukhajevski S, Wollenzien U (1994) Role of black fungi in color change and biodeterioration of antique marbles. Geomicrobiology 11:205–221

Grbic ML, Vukojevic J, Simic GS, Krizmanic J, Stupar M (2010) Biofilm forming cyanobacteria, algae and fungi on two historic monuments in Belgrade, Serbia. Arch Biol Sci Belgrade 62(3):625–631

Guiamet PS, Rosato V, de Saravia SG, García AM, Moreno DA (2012) Biofouling of crypts of historical and architectural interest at La Plata Cemetery (Argentina). J Cult Herit 13(3):339–344

Hall K, Otte W (1990) A note on biological weathering on Nunataks of the Juneau Icefield, Alaska. Permafrost Periglac Process 1(2):189–196

Jones OA, Sdepanian S, Lofts S, Svendsen C, Spurgeon DJ, Maguire ML, Griffin JL (2014) Metabolomic analysis of soil communities can be used for pollution assessment. Environ Toxicol Chem 33(1):61–64

Mattsson J, Oftedal T (2004) Research on biodeterioration of cultural heritage in Norway. Euro Res Cult Heritage State Art Stud 2:477–480

Mitchell R, Gu JD (2000) Changes in the biofilm microflora of limestone caused by atmospheric pollutants. Int Biodeterior Biodegr 46(4):299–303

Panova E, Vlasov D, Luodes H, Vlasov A, Popova T, Zelenskaya M (2014) Weathering of granite under urban conditions. In:

Panova EG, Vlasov DY, Luodes H (eds) Evaluation of the durability of granite in architectural monuments. Geological Survey of Finland, Report of Investigation, Espoo

Rossi F, Michelettia E, Bruno L, Adhikary SP, Albertano P, Philippisa R (2012) Characteristics and role of the exocellular polysaccharides produced by five cyanobacteria isolated from phototrophic biofilms growing on stone monuments. Biofouling 28(2):215–224

Sanjurjo-Sánchez J, Vidal Romaní JR, Alves C (2012) Comparative analysis of coatings on granitic substrates from urban and natural settings (NW Spain). Geomorphology 138(1):231–242

Scheerer S, Ortega-Morales O, Gaylarde C (2009) Microbial deterioration of stone monuments—An updated overview. Adv Appl Microbiol 66:97–139

Schiavon N (2002) Biodeterioration of calcareous and granitic building stones in urban environments. Geol Soc Lond Spec Publ 205 (1):195–205

Vlasov DYu, Panova EG, Zekenskaya MS, Vlasov AD, Sazanova KV, Rodina OA, Pavlova OA (2020) Biofilms on granite rapakivi in natural outcrops and urban environment: biodiversity, metabolism and interaction with substrate. In: Frank-Kamenetskaya OV, Vlasov DYu, Panova EG, Lessovaia SN (eds) Processes and phenomena on the boundary between biogenic and abiogenic nature. Springer, pp 535–559

Warscheid Th, Braams J (2000) Biodeterioration of stone: a review. Int Biodeterior Biodegradation 46:343–368